HOUDINI

ON THE SPOT

HOUDINI
ON THE SPOT

POWER USER TIPS AND TECHNIQUES

by Craig Zerouni

Routledge
Taylor & Francis Group

NEW YORK AND LONDON

First published 2007
This edition published 2013
by Routledge
711 Third Ave, New York, NY 10017

Simultaneously published in the UK
By Routledge
2 Park Square, Milton Park, Abingdon, Oxfordshire OX14 4RN

First issued in hardback 2015

Routledge is an imprint of the Taylor & Francis Group, an informa business

Library of Congress Cataloging-in-Publication Data
(Application submitted)

British Library Cataloguing-in-Publication Data
A catalogue record for this book is available from the British Library.

ISBN 13: 978-1-138-13321-1 (hbk)
ISBN 13: 978-0-240-80862-8 (pbk)

Dedication

This is harder than it looks, especially for the people
who watched me disappear for months to get it done.
So to Jaqui, Phoebe, and Grace thank you.

And to Lottie, who got a lot fewer walks
than she was used to.

Contents

There are lots and lots of cunning ways to navigate around Houdini, as well as useful shortcuts for setting up and creating the effects and animations you're after.

SOPs are the heart and soul of The Houdini Way, and this chapter has lots of useful idioms and known shortcuts for getting the most out of them.

Few things are as instantly gratifying as setting up and running a particle simulation, and Houdini's POPs are still the standard for these kinds of effects.

Dynamics are the latest addition to the Houdini arsenal of powerful tools, and with Houdini 9, they've added fluids and gases to the mix. Here's a whole bunch of useful tips for getting these simulations under control.

Lots of good information about creating and using digital assets, which are a tool that extends the power of Houdini by wrapping up complex ideas into simple packages.

How to set up renders with Mantra, the Houdini renderer, as well as with any other renderer you care to use.

Channel operators are the least-used part of Houdini, which is a shame, because they give the artist some amazing capabilities. Here's a handful of good ideas to get you started.

VEX is Houdini's own expression language, and you can use it, along with its graphical sibling VOPs, to create shaders, geometry operators, and any other kind of Houdini operator.

The compositing editor is an extremely useful tool for doing quick test composites as well as final comps for delivery. And because it's just another editor, you can hook the image processing aspects directly into whatever else you are doing.

You don't have to use the software the way it comes. There are many, many configuration options dealing with workflow, looks and performance. Here are some of the more useful ones.

Not everything fits into a neat classification system, so this is the Lucky Dip chapter, full of interesting and useful tidbits that just don't quite fit anywhere else.

Houdini ships with dozens of smaller standalone applications. This chapter goes through some of the most useful ones.

Credit Where Credit is Due

A book like this cannot be written by one person – it's just not possible to know every aspect of a product as deep and wide as Houdini. I had lots of help, and I'd like to acknowledge the individuals who contributed to the tips in this book:

Peter Bowmar Peter Bowmar is an Effects TD at Framestore-CFC in London. He continues to be a thorn in the side of SESI's R&D department.

Alex Budovski Alex Budovski is a student presently studying Software Engineering with a particular interest in 3D production and rendering. He currently lives in Australia.

George ElKoura George ElKoura is currently a Software Engineer at Pixar, prior to which he worked on Houdini at Side Effects Software.

Kenneth Ibrahim Kenneth Ibrahim has worked on a number of feature films using Houdini including Peter Pan, Superman Returns, Flags of our Fathers, and Pirates of the Caribbean III. His CG career began a decade ago while working at SEGA and Alias in Tokyo and he is currently on the FX team at Digital Domain.

Andrew Lyons Andrew Lyons is an Effects TD at Laika, and has used Prisms/Houdini since 1995.

Ken Ouellette Ken Ouellette is currently the CTO for C.O.R.E. Digital Pictures (Toronto, Canada) and is also juggling the Modeling Supervisor position (character/

environmental) for C.O.R.E. (Feature and Toons divisions). He was the Character Supervisor on the Wild (a Houdini-centric pipeline with modeling, rigging, animation, lighting all done in Houdini). Ken has been a user since Houdini 1.1, memory leak and all.

Dave Robert David Robert likes connecting things together in weird ways. His experiments in plant consciousness have led him to use Houdini's CHOPs to make a singing tree in a sculpture park in Sweden. He started his career in the last century, using Prisms and Houdini 1.0 on feature film and creative R&D projects.

And I'd especially like to give extra super-duper credit to Peter Bowmar, who volunteered to proofread this book. Without his amazing effort, and his complete attention to detail, this would be a less accurate, less complete volume. Nice one, Peter.

Introduction: Why This Book?

A few years ago, while I was working at Side Effects Software, the creators of Houdini, I saw an e-mail from one programmer to another, explaining how to use a particular feature of the software. The recipient wrote back saying "Thanks" and then he wrote "I never knew you could do that!"

And that was the inspiration for this book. I thought, if the people who write the software are still capable of learning new things about it, just think how much there is to learn for everyone else. So I started collecting tips from users – and the developers – wherever I found them. Originally, I thought this would be a thin, short volume with a few interesting Houdini hacks in it. In fact, the original concept was for something called 100 Houdini Hacks – short, sweet and nicely alliterative. But it grew and morphed – and jumped a gigantic version change, from Houdini 8 to Houdini 9 – to become this book.

It became this much larger project (there are over 350 tips and tricks in this book) for many reasons, but one of them is Houdini itself. Houdini is a piece of software that is so wide, and so deep, that it just isn't possible for someone to know everything about all of it. Many people spend years just concentrating in just one aspect of the software, only dabbling in the other editors when they need to. That means that there is plenty to discover, hidden away in the various editors and standalone utilities that Side Effects delivers.

As an example, I once sat down to show a particular aspect of Houdini to another long-time user, who had himself also worked at Side Effects for several years, and before starting I said I doubted I could teach him anything. He said "Every time I watch someone else use Houdini, I learn something."

Which is precisely what happened – within minutes, I used a hotkey that he didn't know was there. And so my goal here is simple: I want to enable any Houdini user, no matter how experienced, to dip into this book and have the fun of learning something new about an old friend.

This is not a book for learning to use Houdini. I am assuming that you already know Houdini well enough to get around and do some useful work. Instead, this is a book for learning to use Houdini better. Because there is almost always more than one way to do something, most people (including me) just fall into the habit of doing something the first way that occurred to them, or that they could make work, or that someone showed them. But in many, if not most cases, there are alternatives, and some of them are more efficient or just more fun.

So, this isn't a textbook. It doesn't begin at the beginning, and move through some logical educational arc to end at the end. This book was always intended as something for readers to dip in and out of at random, flipping back and forth until they find something that seems relevant or interesting. And then they'll try it out, and think "Cool! I never knew you could do that!"

And my work here will be done.

–Craig Zerouni

Author's Note

This book was prepared with pre-release versions of Houdini 9. The text and screen captures are based on versions as recent as 9.0.587. We've tried very hard to keep this text current with the software, but at some point a book has to stop being changed,

while the software continues to evolve. Therefore, there may be inconsistencies between the text and/or images here, and the actual released version of Houdini 9. These inconsistencies are an unavoidable result of trying to prepare a book that is available concurrently with a new version of software, and while we regret them, we cannot be responsible for any differences that may be present.

Conventions

I've tried to adhere to a set of conventions when describing techniques in this book.

Legacy Serif Std-Book	Explanatory text
Courier	Scripting expressions or equations to be typed verbatim
LMB	Left Mouse Button
MMB	Middle Mouse Button
RMB	Right Mouse Button
<shift>-	Hold down the Shift key while doing the action, for example, <shift>-LMB means hold down the shift key while clicking the left mouse button
<ctrl>-	As above, with the Control key
<alt>-	As above, with the Alt key
<letter>	Hold down any letter key

ON THE SPOT

The User Interface
Fully Utilize Houdini's User Interface

It's all different! Houdini 9 has a completely new interface, yet it still follows the basic procedural paradigm set by Side Effects with Prisms, way back in 1987. This new interface is cleaner, prettier, and more directly manipulable. Which means that, ironically, it will probably be existing Houdini users who have more problems with it than new users.

This chapter introduces many of these new features, while also revealing lots of useful things that have always been there, waiting to be discovered.

Instant Objects

New for Nine!

As you no doubt discovered very quickly, clicking an object on the shelf gives you a bounding box in the viewport, where you can place that object. Two useful things to know though: first, by default you are moving the bounding box around in the XZ plane, shown in the viewport. To change the Y value, hold down the <alt>-key while moving the mouse.

And second, if you <ctrl>-click on the tool icon, you will instantly drop that object into the viewport, at the origin. This saves a step if you just want to get the object, but don't care yet where it is positioned.

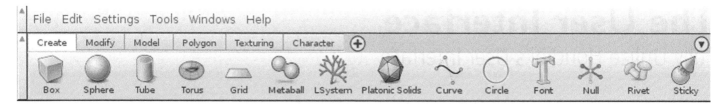

The Parameter Ladder

If you have an expression in a parameter field, you can left click on numbers inside that expression and then use the middle mouse value widget to adjust them. One thing to note is that this won't work for numbers like .5 – they have to be entered as 0.5, with a leading zero.

Diving into Nodes

Let's review all the ways there are for entering the network inside of a node, such as a Geometry Object node or any subnetwork:

1 You can double click on a node to go inside. That's **New For Nine!**

2 You can select the node and then hit <enter>.

3 You can select the node and then hit "i" for inside (and "u" to go back up a level).

4 You can click right mouse button (RMB) on the node and choose Edit Network.

Toggle Display
 Selectable
 Display Origin
 X-Ray
Take Toggle Display
Preview Window...

Parameters...
Animatable Parameters...
Scope Channels Dialog...
Create Nested Channel Groups...
View Dependencies...
Edit Comment...
Edit Delete Script...
Edit Network i or Enter

Customize Your Home

New for Nine!

The label in the upper right corner of the viewport ("persp1" by default) is an active menu (you can tell that by the little yellow triangle) and if you click on it, it gives you access to lots of viewport settings. An interesting one is the Home menu. In there, you can choose to home the view along the conventional axes, such as the Z-axis that was the default in Houdini 8. This also sets the definition of "home" (the "h" hotkey) so that when you home the view, that's the view you get.

(Continued)

The other cool thing you can do there is define a custom home view. Tumble the view to the display you want, then in the Home menu choose "Customize Home" and you've defined a custom home view. Now set the setting to "Custom" and that's the view you'll get when you hit the "a" or "h" hotkey.

Default Values

All parameters can be reset to their defaults by placing the cursor on the parameter's input field and hitting <ctrl>-MMB. If you put the cursor on the parameter's name and do this, you will reset all the values on that line – for example, XYZ translate – at once.

You can do the same thing by holding the RMB down on the parameter's input box (or name) and choosing Revert to Defaults. And you can change what the default is for a parameter by setting some new value, then RMB on that parameter. Choose "Make Current Value Default" from the bottom of this menu. Now any new nodes of this type will have this new default value. You can reset this to the factory defaults with the RMB menu entry "Revert To And Restore Factory Defaults."

Know Your Dependents

When you hold down the RMB on any node, one of the menu entries is "View Dependencies." This allows you to find out:

- What other nodes depend on values in this one

- What other nodes this one depends on.

The listings are color coded. The colors give you additional information about the channel relationships:

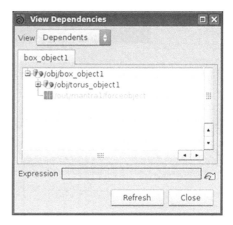

Black: Regular channels are shown in black.
Grey: This happens when a full node has a dependency on it and Houdini can't tell exactly which component it is. That's because some of the dependency tracking is only at the parameter level – for example, Houdini knows it is a Translate parameter, but not whether it's tx, ty or tz. You can see this if you look at the dependencies of the default camera. The channels are shown in grey because the entire camera node is referenced in the Mantra ROP. Since Houdini doesn't know which, if any, actual channels the ROP cares about, they are all colored grey.
Red: All nodes that form a circular dependency are colored in red. A circular dependency is when node A references channels from node B, and node also B references channels from node A.
Yellow: This means that the channel *may* be part of an infinite loop, but since Houdini can't tell for sure (see Grey), the yellow is a warning rather than an error.

Customize the Color Picker

You can add custom colors to the color picker. When you have a new color you want to keep, <alt>-middle mouse on the swatch portion of the color picker (see illustration) will add the current color as a new entry. This gets saved to your $HOME/houdini9.0/.palette file so the new colors are available in future Houdini sessions. If you want to remove these extra colors, the only way to do it is by editing this file – the new entries are at the top of the file. Note that the file name is .palette, with a dot at the start.

Quicker Tab Menus

In the tab operator menu, hitting <shift>-<Letter> will expand the longest word that starts with that letter. So, if you hit <shift>-P in Surface Operators (SOPs) you will get the whole word "Poly" pre-typed. Then you can just hit "e" to choose "PolyExtrude." This is especially handy in the Dynamics editor, where many nodes begin with the same word (for example, there are over a dozen entries that begin with "RBD").

And something else that works in the TAB menu are the up/down arrow keys. Use them to navigate to the node you want, then just hit <enter>.

Easier to see Normals

Sometimes, the normals you want to display aren't long enough to be seen properly. You can adjust this. Put the cursor in the viewport and hit the "d" key, to get the Display Properties menu. In the Misc tab, there is a control for scaling the displayed normals. Dial that up to the length you need. Don't forget that you won't see any normals at all unless you turn on the normal display, on the right-hand edge of the viewport!

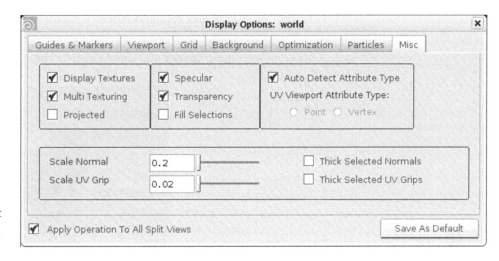

Onion-Skinning

Set up a quick animation in an object by putting the expression sin($F*8) into the Y Translate parameter. Then set the viewport to look through a camera object, say "cam1".

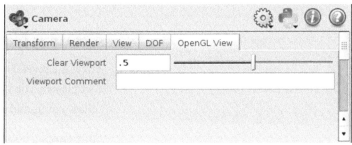

Go to the parameters of cam1, and in the gear icon menu, choose Edit Parameter Interface... and in the dialog that opens, go to the tab on the right labeled Optional Rendering Parameters. Open the Mantra9.0 folder, and in there RMB on the OpenGL View folder. Choose Install Parameters to OpenGL View folder. Hit Accept.

Back in the camera's parameters, a new tab will have appeared called (as you might have guessed) OpenGL View. Go into that tab, and slide the Clear Viewport value to 0.5.

(Continued)

Now play your animation. With the Clear Viewport value set to something less than 1, you can see ghosts of previous redraws – the closer to 1, the fewer the ghost images, and the closer to 0, the more ghost images you will get.

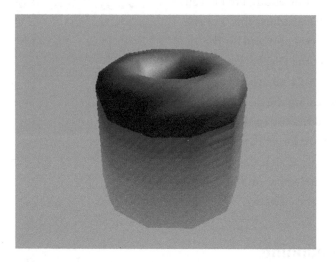

Creating New Viewer Hotkeys

There are several viewer actions that you might like to be able to access with a single key. You can set these up on a function key or a hotkey by using the "alias" command and some of the view commands.

For example, it's useful to load a background image into the image viewer, for lining up animation or modeling or whatever. But once you've set up that image, it would be convenient to be able to toggle this image on and off, rather than go through the display menu. You can do this by binding a hotkey or function key to the viewbackground command:

```
alias F1 viewbackground -b off *
alias F2 viewbackground -b on *
```

(*Continued*)

Unfortunately, it isn't as easy to set this up so that the same key toggles the state on and off, though it is possible. We'll leave that as an exercise, and note that these simple commands are still more convenient than using the display menu.

Similarly, if you want to turn on the point display mode regularly, you can bind a key to turn the points on and another to turn them off, like so:

```
alias F3 viewdisplay -N all m on *
alias F4 viewdisplay -N all m off *
```

Note that you can use a letter key instead, but you run the risk of overriding an existing hotkey mapping, so it's easier to use the function keys. Also note that in the above examples, the * denotes all the viewports. You can name specific viewports – you use a name returned by the `viewls` command, for example:

```
alias F1 viewdisplay -N all m on Build.panel.
world
```

Managing your Desktops

Let's talk about the Desktop Manager. This dialog is found under *Windows →Desktop → Desktop Manager*, or it can be launched with <alt>-D. In this dialog is a list of desktops, with a few columns by each. The "N" column means "no save" – click there next to the name of the desktop you want to protect, and that desktop will be locked.

This puts a ".nosave" suffix on the desktop file name, normally stored in $HOME/houdini9.0/desktop. So an

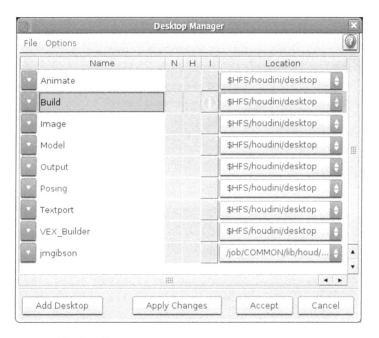

(*Continued*)

alternative method is to simply add this extension yourself without using the Desktop Manager.

As a third option, in the Desktop Manager there is a menu item for Options, and in there is a toggle for Auto-Save Desktops. This is off by default, which is a good thing. But you might want the state of your desktops saved between Houdini sessions – if you are that sort of person, turn this toggle on.

The Shelf

New for Nine!

In Houdini 8, the Tab menu was something you could customize, sort of, and there was no Shelf menu at all. In Houdini 9, one of the biggest and most obvious changes is the tool shelf across the top of the interface.

When you click on a shelf item, you are really executing a script (and by default, the scripts are in python). You can see the script source by clicking RMB on a tool icon, and then choosing "Edit tool." In the dialog that pops up, go to the Script page.

So first thing to know is, you can create your own shelves, and your own tabs within shelves. To create a new tab within an existing shelf, click on the little plus symbol in a circle, and choose New Shelf. To create a new shelf, use the little triangle menu at the end of an existing shelf, and choose New Shelf Set. Now you can put nodes into this shelf (or tab) in a couple of ways. The

(Continued)

simplest is to go get the node in question, and drag it to the shelf. Let go, and voila! A new way to access that node. A simple use of this is to collect together tools you commonly use, so they are right in front of you. Another, more subtle use is to put variations on a single node there, each with different parameter values.

You can also accomplish this by RMB on the tab name, choosing Edit Shelf, and then going to the Tools tab in the dialog that pops up. There you just select the items you want to see appear in your new shelf.

The Tab Menu
New for Nine!

In Houdini 9, the tab menu isn't a separate menu – instead, it's a dynamically built version of the Shelf menu, with a different interface. When the tab menu is built, it is built from the Shelf description that is already there. We can use this to do some nifty things.

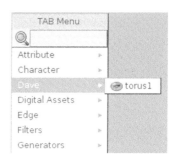

First, create a new shelf by clicking on the little plus in a circle, and choosing "New Shelf." Name your new shelf "Dave." Now we need something in there, so go into the SOP editor and drop a Torus node. Now drag the torus node over to the Dave shelf, and let go. The torus appears there.

RMB on the torus icon in the shelf, and choose "Edit Tool." In the dialog, go to the Context tab. This is where it gets interesting.

This tab lets us define when this new torus will be available. For now, just type "Dave" (without the quotes) in the bottom text parameter box, labeled TAB Submenu Path. Now hit Accept to close the dialog.

If you put the cursor over the network in the SOP editor, and bring up the TAB Menu, you'll see that Dave is now a category, and in there is your torus.

(Continued)

But now it gets extra specially cool. Go back and edit the torus tool, and go back to the Context tab. When you brought up the tab menu in the network, Dave was there. If you'd done that in the viewer, he would not have been. That's because there was no context defined. In the Viewer Pane sub-tab of the Context tab, click on the SOP box and hit Accept. Now, the tab menu will contain Dave even in the viewer, as long as you are in the SOP context.

But, but, but!!! Let's keep going. So far, this is just a tweaked version of an existing node. It could, however, be anything in that shelf – a Digital Asset, a collapsed subnet, a wrapper around any script you want. Whatever it is, we can arrange it so that it only appears in the tab menu, but not on the shelf. Doing this is very simple – just go back up to the Dave tab on the shelf, and RMB. From the menu, choose "Remove from shelf set." And so the Dave tab goes away. But try the tab menu again. Still there!

How cool is that! So you can have custom sets of tools for the tab menu, that don't show up in the Shelf – and vice versa. In this way, you can streamline the workflow for yourself, a group of users such as lighters, or for a particular task.

Connect to Nodes off the Worksheet

If you want to connect a node that is on the worksheet to one that is off it, you can scroll the worksheet while still "holding" the connector. Just drag it to the edge of the network, then hold down the space bar, and use the MMB to scroll the worksheet as you normally do. When you see the node you want, let go of the space bar and make the connection.

Tumble Around Geometry

New for Nine!

Normally when you tumble in the viewport, you are tumbling around the center of the view. But you can shift the pivot point to be anywhere on any geometry. Simply put the cursor over the geometry, and hit "Z." This moves the pivot point to the surface of the geometry under the cursor, without changing the view. Now you can inspect what you really are interested in! Also, the "z" hotkey will set the pivot and also move the view so that it is centered on that pivot.

Easier Node Wiring – Tiny Targets

When you are zoomed out on a node network, it can be hard to hit the little node connector that targets at the tops and bottoms of the nodes. However, if instead of simply clicking, you <alt>-click when making a connection, then the entire node becomes the target. This makes it much easier to wire up nodes when they are small.

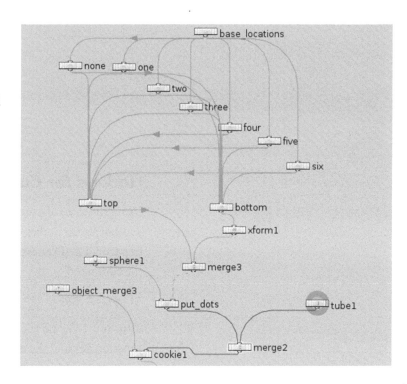

Node Wiring – Multiple Connections

If you need to connect a bunch of nodes to the same place – for example, several nodes need to go into a Merge node – then you can do this in one step. Simply box select all the nodes you want to connect, then click on the connector on one of them, and finally connect the other end of the drag line to the Merge node. Ta da! All the nodes are connected at once.

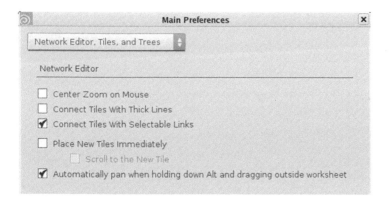

Easier Wiring – Active Lines

If you right click on a connecting line, you will get a menu that lets you move one end of the line or the other, or even delete it. Even better, go to *Edit →* *Preferences → Network Editor, Tiles and Trees*. Set the toggle for "Connect Tiles With Selectable Links," and then you can click on any connecting lines directly, with the left mouse button (LMB), and drag them from one node to another. This is a much faster way of rewiring node networks.

Hotkeys for Custom Desktops

Using the same aliasing trick we described for changing viewport parameters, you can set up hotkeys and function keys to allow jumping between desktops. In particular, if you use the Build desktop layout as your base, then you can put the command:

```
alias F1 desk set Build
```

into your 123.cmd file, or just issue it in the textport. Then just hit the F1 function key and the desktop layout will switch back to the Build layout. You can also use this to jump to custom desktop layouts that you have created. Watch out, though, for pre-defined function keys, like F8.

Quicker Deletes

Instead of doing a right mouse on a node's parameter, and then searching through the resulting menu to find Delete, you can remove the contents of a channel (or a set of channels) with <ctrl>-LMB. So, for example, you put an expression into the Translate channel of an object, and then you want to remove that expression; just <ctrl>-LMB in the channel parameter box, and away it goes! Much, much quicker. And if you do it on the parameter label (such as, in this example, the word Translate), then it clears out tx, ty and tz all at once.

The Places You've Been

The panes remember where you have been while navigating in them, and they give you several ways to quickly move around the various networks.

First, realize that the location bar is active. So if you dive into a Torus object to the SOP network below, you'll see this:

Now to get back up to the object level, you can either use the "u" hotkey, or just click on the "obj" section of the location bar. Or, you can click the Back arrow next to the bar, which works just like the Back arrow in a web browser (as does its sibling, the Forward arrow).

But wait, there's more! Once you've been a few places, the Back and/or Forward arrows change slightly, to add a little triangle. This means that they can now act as a menu of all the places you've been. To access it, RMB on the arrow, and pick off a location directly.

And that's not even all!! The larger arrow on the right end of the location bar is also a menu of places you have been – pull that down with the LMB, and pick off a location. Again, you'll jump right there.

Most of these features were also in Houdini 8, but they were carefully hidden to make discovering them more exciting.

(*Continued*)

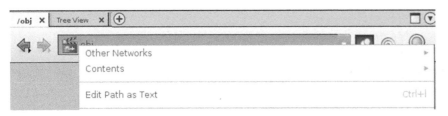

And yes, there is yet another hidden menu. If you RMB on the location bar, you'll get this menu, which lets you jump directly to other networks, among other things.

Save a Click

When dropping nodes onto a network, the default Houdini behavior forces you to click to drop the node. However, if you go to *Edit → Preferences → Network Editor, Tiles, and Trees*, there is an option labeled "Place New Tiles Immediately." If you turn this on, then if you RMB on a node connector, and choose a node from the resulting menu, the new node will be dropped immediately onto the worksheet, saving a click. Some people find this useful, though others hate it. That's why it's a preference!

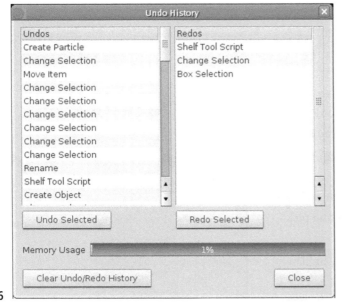

Undo a Block at a Time

Houdini has undo for many operations. The actions are stored in an undo list that you can see and edit, so if you want to undo a set of 10 or 20 operations, you can do this directly. Go to *Edit->Undo History*. The dialog has a list of actions on the left, and you can select any or all of them, and click on Undo Selected. They are moved into the Redo column, so you can redo them if you need to.

Note that you must select a set of consecutive operations, and that the most recent operations are at the top of the list, not the bottom.

Adjust the Brightness

New For Nine!

Apart from the pre-set dark color scheme, you can individually adjust the gamma, contrast, brightness and saturation of the interface. The preference is in *Edit → Color Settings*, and it lets you dial down (or, improbably, up) the brightness of the overall UI.

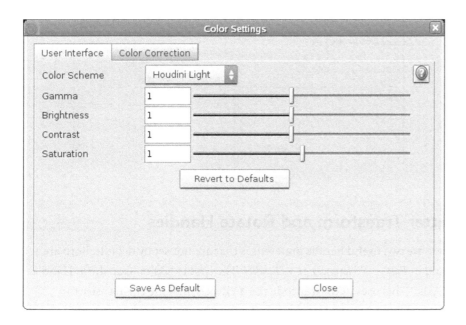

Create a Bundle with Drag "n" Drop

Bundles are a useful way of specifying groups of objects and lights, for lightmasks, renderlists, etc. You can create them when you specify these collections – for example, the Light Mask parameter has a chooser next to it, and you can open that, select the lights you want, and then call them a bundle.

(Continued)

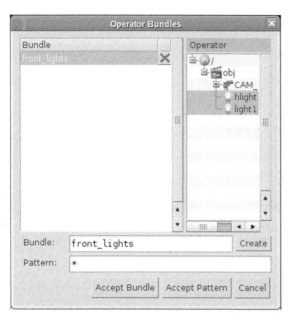

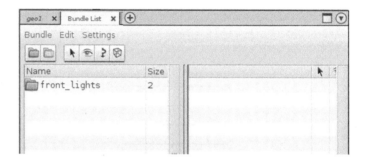

Another way, which may be quicker, is to select the objects you want, and then just drag them into the left side of the bundle pane, and drop them. A new bundle will be created. If you drag the selection to the name of an existing bundle, you can add the selection to the existing bundle, or replace the bundle with the new selection – a small dialog gives you the choice. It's useful in this case to go to the Bundle List pane, and in the *Settings* menu set the toggle labeled *Set bundle filter based on initial node*.

Better Transform and Rotate Handles

There are two useful handle preferences that are not set by default. Both are found in *Edit → Preferences... → Handles*. The first is "Color Transform Handles By Axis." This uses RGB to encode the XYZ axes, making them easier to distinguish in a crowded scene.

The other preference is "Default Transform Handles to Gimbal Mode." In this mode, the rotation axes are transformed when you rotate the transform jack; it is possible this way to align two axes and thus lose a degree of freedom (known in the trade as gimbal lock). The advantage is that you are transforming a single X, Y or Z-axis at a time. So this is the transform handle equivalent of adjusting one of the rotation parameter fields separately.

(Continued)

You can also set this mode for an individual transform jack, without making it the default. If you RMB on the jack, you'll see an option near the middle of the menu for Gimbal Mode.

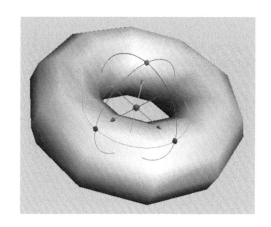

Display Selected Geometry

By default, when you click on the point number or primitive number icons in the viewport, this applies to all the points in your geometry, which can get messy. You can make this display (or any other) dependent on selection, by opening up the display dialog (hit 'd' while the cursor is in the viewport). Then change the menu item from "Normal Geometry" to "Selected". Toggle off the "same as normal geometry" option, and then choose what you want to display for the Selected geometry types. For example, choosing Primitives - Numbers means that Houdini will only display the numbers of the currently selected primitives.

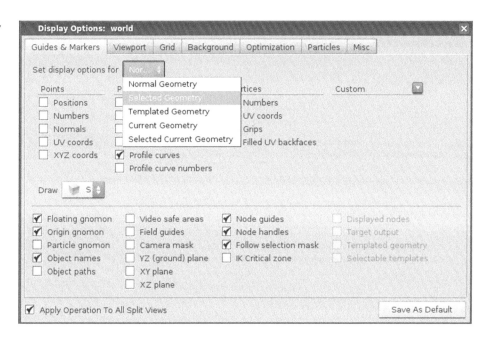

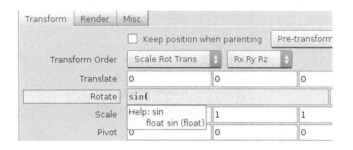

Get Help with Functions

When you type expressions into a parameter box, by default you get a little popup help box that gives you the usage of any functions that you are typing. If you get confused, you can also LMB on the name of the function, in the popup box where it says "Help:", and it will launch the help browser, and navigate to the page describing that function.

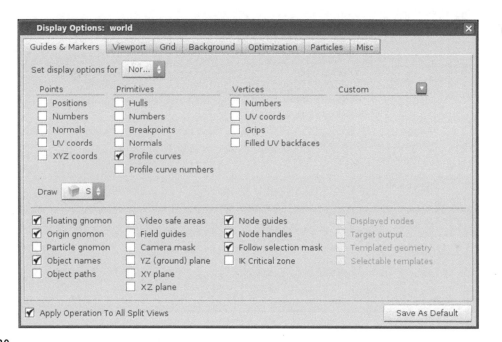

Display Object Names

The Display Options dialog allows you to turn on the names of all the objects in the viewport. Just put the cursor in the viewport, hit "d" (the d key), and then toggle the Name Display button in the lower left corner of the Guides & Markers tab. There is currently no way to make this apply just to selected nodes, so for some scenes the display can become quite dense with object names.

The Pane Path Label is Active

The pane path displays are active, and you can use these to get information and to navigate around the Houdini network hierarchy:

- MMB on the name of a path component, and you will get some information about that component.

- LMB on the name of a Houdini element to get a list of all elements at the same level. Then you can choose one and be taken directly there. For example, if you are in the SOP network of one object, and you click on the name of that object, you will get a list of other objects – choose one, and you will be moved to the SOP network of that object. This is a much faster way of jumping between locations.

- RMB on the item and you get a menu of useful things to do. In particular, this is a good way to open a floating parameter window on the Geo object that you are inside of, without having to navigate up, open the window, and then come back down.

- Finally, an obscure bit of magic – put the cursor on the navigation bar, and hit <ctrl>-l (letter ell). This will allow you simply type the path you want to go to. Hit <enter> and you go to that network, and the bar returns to normal.

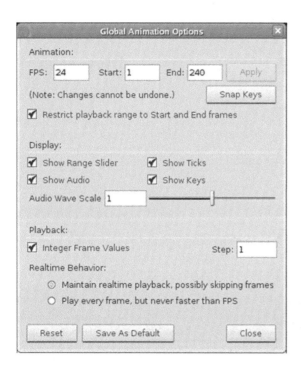

Realtime Playback – An Alternative

Houdini has two versions of "realtime". The default one is to skip frames in order to maintain the currently set frame rate ($FPS). This works great if you are doing things that can't quite keep up with real time. But lots of things in Houdini run faster than real time (such as a Dynamics simulation that has been cached up), and for those, the second option is usually better. In the Global Animation Options dialog, found under the options button at the far right of the playbar, you can choose "Play every frame, but never faster than FPS". This will maintain realtime playback for Dynamic Operators (DOPs) simulations and simple particle systems, as well as other lightweight animations.

Black Viewport

You don't have to have a light grey background in your viewport. If you put the cursor in the viewport, hit the "d" hotkey, and navigate to the Background tab, you'll see a little menu called Color Scheme. Change it to Dark, and the background goes black.

This is separate from the overall color scheme choice, which is in the Global Preferences.

Previous Zoom Level

If you zoom out (or in) on a network, using either the mouse scroll wheel or the RMB, you can recover the last zoom level you were at by hitting the "b" hotkey. This lets you bounce back and forth between two levels of zooming, which can be very handy. You'll also find this near the bottom of the RMB menu.

Expose All	Shift+E
Hide Selected	Shift+D
Collapse Selected Into Subnet	Shift+C
Create Network Box From Selected	Ctrl+n
Previous Zoom Level	b
Display Options...	d

Pinning and Linking panes

New for Nine!

Users of Houdini 8 will probably be more confused than new users by the way Houdini 9 links the panes. Here's the deal:

- The pin icon, if depressed (selected), means that whatever is shown in that pane stays there, no matter what you select next. So if you select a Sphere SOP, normally the Parameter Pane would update to show the parameters of that SOP. If you then pin the Parameter Pane, and then select a Box SOP, you will still see the parameters of the sphere.

- If the pin icon is not depressed, then it will follow whatever the current selection is.

- If you RMB on the pin, you'll see a list of numbers. You use this list to choose a link group. Panes in the same link group will all update together. So if you have four panes open, and you set two of them to group 1, and the other two to group 2, then the two panes in group 1 will update together, and the two panes in group 2 will update together. Existing Houdini users may find this a more natural way to work.

Defining Custom Objects

If you don't like the default Geometry object that Houdini gives you (just to take one example), you can change it. The definition of this object is found at:

```
$HH/scripts/obj/geo.cmd
```

In that directory you'll see definitions for many other objects, and it the scripts directory above it, you'll also see locations where Surface Operators (SOPs), Composite Operators (COPs), etc. are defined.

So to change the default Geo object, copy that script into a directory called:

```
$HOME/houdini9.0/scripts/obj
```

(you'll probably have to create the scripts and obj directories), and then modify it however you like. You could, for example, get rid of the File SOP and replace it with a Torus SOP, because you think that's a better idea.

That .cmd file might look like this:

```
# Default script run when a geometry object is created
# $arg1 is the name of the object to create
\set noalias = 1
if ("$arg1" ! = "") then
opparm $arg1 use_dcolor( 0 )
  opcf $arg1
  opadd -n torus torus1
  oplocate -x 0 -y 0 torus1
  opset -d on -r on -t off -l off -s off -u off torus1
  opcf ..
endif
```

Object List Mode

The "t" hotkey will put any network view into (and out of) List View, which is an alternative way of seeing what you've got. For objects, this can be especially useful, especially when you have a lot of them, and the network is becoming too messy to understand.

Once in List mode, RMB on the list, and look at the entries for List Order and Columns. List Order lets you choose how to order your operators, and Columns lets you choose what aspects of the operators to display. And RMB on the node names gives you the regular operator menu choices.

Eye-dropper Color Selection

To get eye-dropper functionality for choosing colors, MMB on the color swatch in the parameter pane, then drag to the color you want and let go. This works all over the screen, so you can choose colors from anywhere.

Rename Nodes

The label at the top of a parameter pane is editable. So you can change the name of the operator by clicking in there, and then erase and type whatever you want. This is the equivalent of clicking on the name in the network view, and changing that string.

25

Hiding and Exposing Nodes

You can reduce clutter and hide things from your users (and yourself) by making nodes hidden. To do this select one or more nodes, then use the <shift>-d hotkey to hide them. You can expose them again with <shift>-e.

You may wonder – how would I know if I've hidden nodes? Well, you could simply try doing <shift>-e and seeing what shows up. But if you've carefully hidden dozens of nodes, it would be annoying to see them all pop back on, and then have to select them and hide them again. So there is a better way.

The "t" hotkey puts the network into List mode. This shows all the operators at the current level, with columns of information about each. By default, there are not many columns, but if you RMB on the page, near the top of the menu that appears you'll see a menu item called Columns. In there is a huge list of attributes you can expose about the operators in the list. Choose Expose (the top one) and this will give you a new column which shows which operators are exposed and which are not. Also, clicking in that column toggles the operator's exposed status on and off.

(Continued)

Finally, there is the totally obscure <alt>-B (<alt> <shift>-b) which brings up the Operator Browser. This may become obsolete, but at this writing it still worked, shows all operators, and always has an Expose flag as part of its interface.

Protecting Strings

If you have a string field on an operator that you want to protect from yourself ("stop me before I edit again!") or from others who will use your files or operators, then you can RMB on the string field label, and choose "Lock Parameter". This will prevent edits in that field. And yes, you can do the same thing to unlock them later.

27

Local Undo

For all numeric input fields (including sliders), if you <shift>-RMB on the slider or field (don't hold, just click) you will revert to the previous value. So for example, if you had a value of 1 in a field, and then you adjusted (or typed) so that it was 2, you can just <shift>-RMB to get back to 1. And if you <shift>-RMB again, it will toggle back to 2. This is really handy for comparing the results of two different parameter values.

Swapping Inputs

If you have a multi-input node, you can swap its inputs with the "r" hotkey. The node has to be selected, and then the two inputs are swapped. If there are more than two inputs, it cycles through them. Try it out – very cool!

Selecting Groups

If you choose the "Select Primitive Groups" or "Select Point Groups" selection methods while in the viewport, then when you interactively click on the geometry, it will select the group that the picked primitive or point is a member of.

Sadly, this does not help you see what groups some geometry is in.

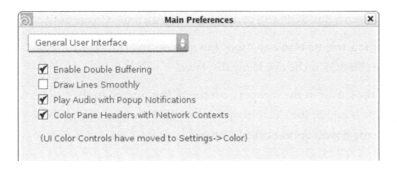

Color Coded Context

In Houdini 8, the various contexts (Object, Dynamics, SOPs, etc.) are color-coded, to help you know where you are. In Houdini 9, this behavior is also available, but it's not there by default. Longtime Houdini users will probably want to use this feature. It can be found in *Edit→Preferences→General User Interface*. Check the box labeled "Color Pane Headers with Network Contexts".

Keyable Strings

New For Nine!

You can now set keyframes (and expressions) on strings. For toggles, just do the regular thing – set a keyframe, set the toggle, move to another frame, set a keyframe, unset the toggle, etc. Then hit play and watch the toggle change. You can get the same result with strings, but it is a bit more awkward – you may find that you have to do it in the curve editor by setting a keyframe, then selecting the curve coming out of the keyframe, and changing the Type to the string you want.

Seeing Custom Attributes

New for Nine!

If you put the cursor in the viewport, and hit the 'd' hotkey, you'll bring up the display options. In the Guides & Markers, tab, there is a menu labeled Custom. You can use this to create new display options for your custom attributes.

For example, do this:

- Put down a Box SOP, and connect it to an Attribute Create SOP.

- Set the attribute Name to "foo" (no quotes) and the Type to Vector. Make sure this SOP is the one being displayed.

- Put the cursor in the viewport, hit the 'd' key, and go to the Guides & Markers tab. In the Custom option menu, choose Create Attribute Vector. A new toggle will appear called vector1.

(Continued)

- RMB on the name vector1, and choose Edit. Type "foo" (no quotes) in the Attribute parameter, and hit Apply. You should see the values of the "foo" attribute appear – in this case, they will all be zero, because we didn't bother to assign any values.

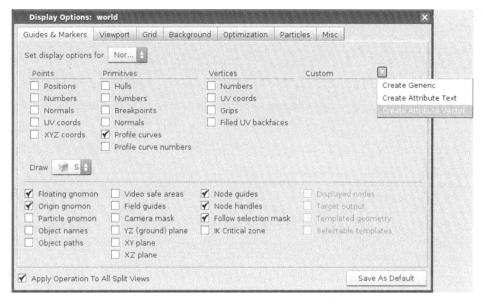

Customize the Shelf

New for Nine!

You can customize the display of the shelf by using the cleverly hidden menu inside the little triangle in the right-hand corner of the shelf. For people who are trying to maximize screen space, one useful choice here is the smaller icons, with or without text. Of course, if you really want the space back, you can keep the shelf stowed until you need it, but that hides a really useful new set of features.

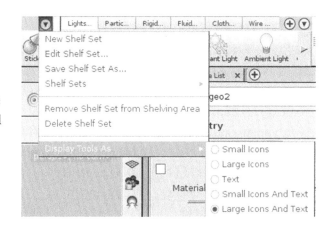

ON THE SPOT

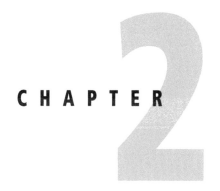

SOPs: The Foundation of Houdini

Modeling with Surface Operators (SOPs) means that you don't build a model –
you build a process for making a model. That makes your model procedural,
and that means building models that can change. They might change because
the director wants triangles instead of circles, or they might change because
motion and deformation is built right into them (like a writhing snake, for
example, or a flapping flag). When you work this way, you get to know lots of
little tricks that are the result of combining a few operations in a certain way.
These idioms are useful shortcuts to quickly building and changing
your models.

The Universal Wondertool

The Copy SOP is a tremendously useful tool, but copy/stamping takes that usefulness to a new level. This is the technique that allows you to do a different thing to each of the many copies of the same geometry. As long as the SOP being manipulated lies in a direct path to the Copy SOP, you can loop through the geometry and modify a new copy of the geometry on each loop.

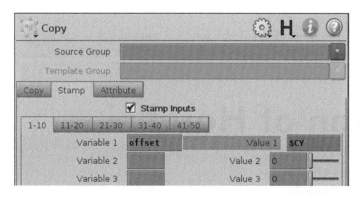

For example, connect a Box SOP to a Transform SOP, and connect that to a Copy SOP. In the Copy SOP, in the Stamp tab, turn on Stamping. Now you can define up to 50 new parameters. Generally, these parameters are based on the copy number that is being processed ($CY), or, if you are copying based on template geometry, the point number of the template ($PT). If you are using particles as input here, you'll use $ID instead.

Now create a new parameter called "offset," and set its value to $CY; in the Transform SOP, you can reference this new "offset" parameter by using the stamp() function. You might put something like this into the Translate X field:

```
stamp("../copy1", "offset", 0)
```

Then the first box will be offset by 0, the second by 1, the third by 2, etc., because these are the values of $CY for each copy in the Copy SOP.

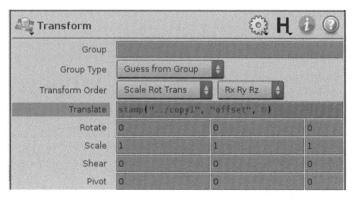

Creating New Points

If you want to create a specific number of points, put down an Add SOP and have it create a single point. Then append a Copy SOP and set the Copy number to be the number of points you want. Note this will work properly for the case of zero points, unlike some other approaches. You can also animate the number of points required. And if you want to connect those points together into a new polygon, see the next tip.

Reconnect Points into Polys

Sometimes you want to take a collection of loose (unconnected) points and connect them into a line or a polygon. The way to do this is with the Add SOP. In the Polygons tab, check By Group option. You can close the shape with the Closed option.

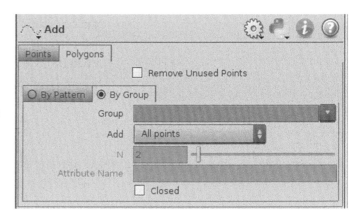

Manually Placing Points

If you want to manually place points in space, an easy way to do that is to use a Curve SOP, which lets you draw out a freeform curve by left clicking all over the screen. Then connect that to an Add SOP and set the Delete Geometry checkbox. The result is just the points, with no connecting geometry.

Sticking Points

Scattering points on geometry, say as a basis for hair or feathers, is a very useful technique. But if you want to scatter points on a surface that is deforming, and make sure that the points are located in the same relative position from frame to frame, here is a quick tip. Put down a Measure SOP on your static geometry and set the Type to "Area." Deform the geometry. Then append the Scatter SOP and generate the points based on the "area" attribute created by the Measure SOP. This means uncheck the "Scatter Based On Primitive Area" option, and in the Alternate Attribute string field put "area" (without the quotes). Don't forget to display points, or you won't see anything in the viewer.

You can scatter based on any primitive attribute and it will "stick" through the deformations; Area just happens to be convenient. Another useful Measure attribute is Curvature; this is intended for scattering points for shaders that can benefit from this, such as subsurface scattering.

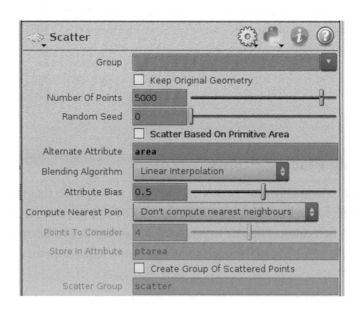

Prepping for Destruction

When you shatter geometry for use in rigid body dynamics (RBD) simulation, you need to put each chunk into its own group. An easy way to do this is by using the Connectivity SOP in conjunction with the Partition SOP, as shown below.

The Connectivity SOP uses the connectivity of the primitives to create an attribute called "class." Class is an attribute that notes that a set of primitives are connected together (meaning, they share vertices). Then the Partition SOP groups primitives by using a rule that involves $CLASS. Remember that $CLASS is the local variable version of the attribute called "class."

The result is a set of groups called brick_0, brick_1, brick_2, etc., where each group contains a set of connected primitives, that is, chunks of geometry. These groups then feed directly into the RBD Fractured Object and the RBD Glue Object nodes.

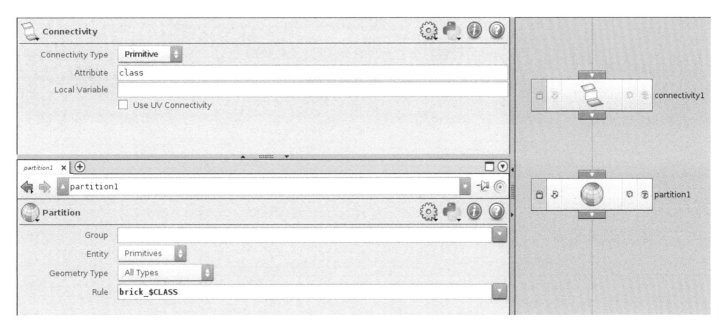

Switching Around Errors

You might want to use a Switch SOP to bypass nodes that may generate errors on certain frames or in certain conditions. One way to do this is to put the following expression in the Switch SOP:

```
if (strmatch("*Error:*",
  run("opinfo " + opfullpath("../" + opinput(".",  1)))),
  0, 1)
```

This works by looking at the opinfo string of the first input.

If the string contains the string "Error:", it sets the switch value to 0 (the first input). You would connect something into that input that was some kind of default geometry.

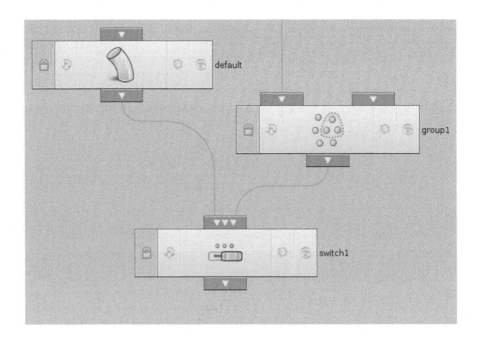

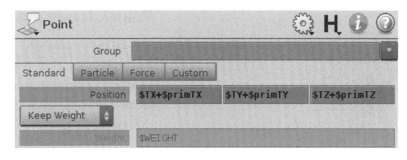

Extra Point Variables

The local variables inside the Point SOP are relative to the point itself. Likewise, the local variables inside the Primitive SOP are relative to the primitive. You can override this, however, by using one of the prefixes "det," "prim," "pt," or "vtx." For example, the Point SOP uses $TX, $TY and $TZ for position. But if you change this to $primTX, $primTY, and $primTZ, it will use the primitive's x, y, z position, and so move each point to the barycenter of the first primitive it belongs to.

This works for all the other Point SOP local variables, so usage such as $primCG is defined as the green value of the first primitive that the point belongs to.

Grouping by Bundles

When specifying objects to bring into an Object Merge SOP, you can (of course) use wildcards to specify multiple objects, for example: /obj/geo?

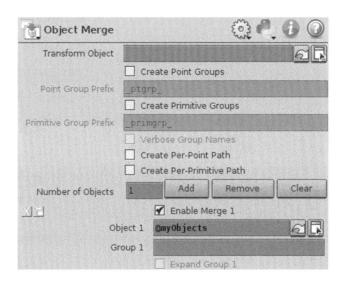

But you can also use bundles, as shown in the illustration. This references the objects specified in bundle1, which could contain any number of objects. This kind of abstraction is a better way of building a procedural system, since you can change the contents of the bundle later, and the whole thing will continue to reference properly.

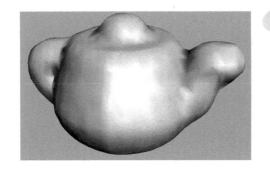

Point Clouds into Geometry

Say you have a point cloud, either because you created one or because one has appeared as a byproduct of what you are doing (for example, a particle simulation that has advanced to the point where it occupies a volume). Now say that you want to create a surface that encompasses those points, a bit like throwing a blanket over a bush. There is a simple way to do this:

- Put down a Platonic Solids SOP, and choose the Teapot as the Solid Type. Append to this a Convert SOP, and convert the teapot to Polygons.

- Put down a Metaball SOP.

- Put down a Copy SOP. Connect the Metaball to the first input of the Copy, and the Platonic Solids SOP to the second input of the Copy.

- Adjust the size of the metaballs to give a reasonable approximation to the shape, say [0.2 0.2 0.2].

- Append a ConvertMeta SOP to convert to polygons.

- Append a Smooth SOP to clean it up.

You'll get a puffy teapot, as shown.

Adding a Frame Counter

Sometimes you want to get a frame counter in the frame as part of your render or flipbook test. A simple way to do this is to use the Font SOP. Put one down, scale the text to fit the frame, and move it to one corner or another. You can do this interactively by putting the cursor in the viewport and hitting <enter>.

Be sure to turn off the "Center Text Horizontally" toggle, or else the text will reposition itself on each frame, which is jarring to watch.

(Continued)

If you put this SOP into a separate Geo Object, parent that Geo Object to your camera, and adjust the Object transform according to your camera, then the text will always appear, and be rendered, in front of whatever else is in your scene. This will save you a compositing step, and is especially useful for flipbook tests.

Interactive Selections

Many kinds of selections require that you select a connected set of edges. Pelting a surface, for example, needs this.

To do edge selections, make sure that you are choosing Edges from the Selection Type menu (hotkey "3" when in selection mode, or right mouse button (RMB) on the selection icon), and select an edge. Note the little arrow that indicates a selection direction. Then use the following hotkeys:

 f – select forward one additional edge

 r – change the selection direction

 l – loop forward, following edges until you come back to the start.

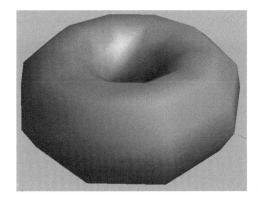

Moving Normally

You can use the Peak SOP to push points outward, or inward, along their normals. The geometry doesn't even need to have the normals calculated first – if there aren't any normals, the Peak SOP will compute them. Attach a Peak SOP to a Torus and wave the Distance slider around to see what the effect is.

Cooking at Another Time

New for Nine!

It sometimes comes up that you want some geometry as it was a few frames ago, or as it will be 10 frames from now. Before Houdini 9, the only way to solve this problem would be to cache the geometry of the object in question (either in memory, or to disk), and then go read in the frame you need.

But in Houdini 9, there is the new TimeShift SOP, which lets you cook the specified geometry at any time. This is a great way to test out a complex setup quickly, and for somethings, this might be all you need. But keep in mind that caching geometry is still going to be more efficient than cooking it at multiple times.

The Font SOP

The Font SOP is very useful for generating text and characters. But you may find that, instead of entering the characters directly, you need to put ASCII code directly into the Font SOP, in order to generate certain obscure characters. You can do this with the backslash character followed by one or more decimal digits. The digits represent the ASCII code for a character. These are offset by 32, so that the first 31 non-printing characters are skipped. For example, the ASCII value of the % character is 37. So putting 5 in the text line will generate a %.

If you want to run through the whole ASCII set, to find obscure characters, use \\$F and single step through the animation. Of course, which characters you get for frames above 93 (i.e., for ASCII values >= 127) are dependent on the font you are using.

Generating Wireframes

There are a few ways to generate wireframe geometry in Houdini. One, of course, is to use the Wireframe SOP. If you attach this to a default Torus, set the Wire Radius to 0.05, and render it with mantra, you get the image shown. This creates primitive tubes, which can be more efficient for rendering.

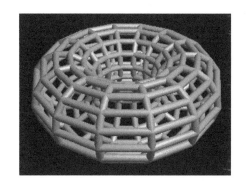

The second way is to use the PolyWire SOP. Append that to the same default Torus, set the Wire Radius to 0.05, and the Divisions to 6, and you get this. This creates polygons which can be subdivided with the Subdivide SOP.

Finally, a third way, which yields a different and possibly more desirable result, is to use the Ends SOP. Set the "Close U" parameter to "Unroll," which makes all the polygons open. You can control the width of these wires by appending an AttribCreate SOP. Name the attribute "width" (without quotes) and put a width of 0.05 in the first Value field. This gives us the image shown lower right.

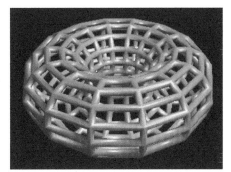

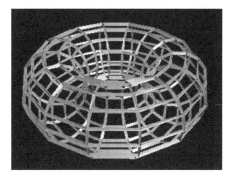

Extended Information

One useful SOP function that is tucked away is the "Extended Information" menu item. Do RMB on the SOP, and midway down the menu is "Extended Information." This gives the usual info, such as bounding box and memory use, plus extra information about the primitives or other geometry in the SOP. One particular use for this is to see a scrollable list of all the primitive and point groups that you have defined for some geometry. Especially in preparing

(Continued)

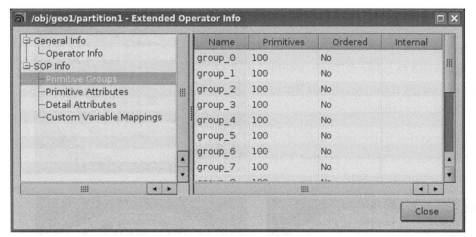

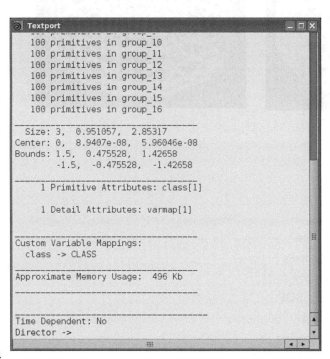

geometry for use in Dynamic Operators (DOPs), you may find yourself having created hundreds or even thousands of groups. If for some reason you want to examine the group names, or make sure that the proper number of primitives is in each group, or whatever, this is the tool you want.

There are two other ways to see the complete list of group names, using the textport. The first, which is not very useful as a list, but is well suited to doing something in a script, is to use one of the grouplist functions, `pointgrouplist` and `primgrouplist`. Something like:

```
echo `primgrouplist("/obj/model/copy1")`
```

will dump out all the group names on one line. Unfortunately, not only is this hard to read, but it forces you to know in advance if you are interested in point groups or primitive groups.

A better, more human-readable approach, is to type:

```
opinfo -v /obj/model/copy1
```

in the textport. Not only is this output easier to read, but the command is easier to type too.

Maintaining Length

It's easy to distort geometry with techniques such as metaballs and softpeak. But what if you want to distort geometry, but retain the original length. For example, suppose you have a set of lines, and you push a bulge into them with a metaball. If you just did that, you would see the bulge appear, but the lines would still end in the same place – thus, they would have been stretched. You can demonstrate that to yourself with the following setup:

1 Put down a Grid SOP. Set the Connectivity to Columns, and the Orientation to YZ plane. Set the Size to 3 × 3, and the Rows and Columns to 50 × 20.

2 Put down a Metaball SOP, and change the Center X value to 1.

3 Put down a Magnet SOP. Connect the Grid to the first input, and the Metaball to the second. Change the Scale to [1.6 1.6 1.6].

4 Now display the Magnet SOP, but select the Metaball SOP. Adjust the Center X value (or animate it) to see the grid bulge out in X. You probably want to rotate the viewport around in Y so that you can see the grid lines.

However, if you add a Resample SOP, you can keep the lines at their original length. To do this, modify your setup:

5 Append to the Magnet SOP a Reverse SOP. This changes the end that the resampling will start at. You can click on the pass-thru flag on this SOP in a moment, and see the difference it makes.

6 Now, the meat of the trick. Append a Resample SOP. Set the Maximum Segment Length to 0.06. Turn on Maximum Segments, and set the value to:

```
ch("../grid1/rows")
```

Now the lines follow the curve of the magnet, but retain their original total length.

Graphical Browsing

Imagine you have a directory full of geometry files, and you want to read them into SOPs. Rather than tediously putting down File SOP after File SOP, and then going through and pointing each SOP to the appropriate geometry, what you'd really like to do is to select all the files at once, and then get Houdini to create a File node for each one.

And, there is a GUI method to do exactly this. Just press ` (backtick) in the network editor, and you'll get a file browser. Select as many files as you want (the usual selection mechanisms work : <shift>-LMB to select a sequence, <ctrl>-LMB to add a file to a set). Click on "OK" and a File SOP will be created for each selected file. If the backtick is too obscure, you can also get the same feature by using the = (equals) key.

This works in other contexts as well. If you do it at the Object level, then an object will be created for each file, and each object will have a File SOP in it. And you can do the same thing in Composite Operators (COPs), with image files, as well as in Channel Operators (CHOPs) with chan files.

Select Files to Create File Operators

Look in /home/craig/Hacks/Hips/

Directories
- Home Folder
- Desktop
- opdef:
- /
- $HIP
- $HFS/demo
- $JOB
- /tmp
- $SITE

teapot.bgeo torus.bgeo SmokeNoShadow. preroll.bgeo

gi.bgeo wisp.tar.gz copinput_noise.hi test1.bgeo

File torus.bgeo

Show files matching *.*,

Accept Cancel

Sensible Group SOP Default

The Group SOP comes in with a default group name of group1, which is almost never what you want, and which will instantly conflict with any other Group SOPs that you haven't yet modified. What many people would like is for the Group SOP to create a group that is the same as the name of the SOP. That way, since each Group SOP comes in with a unique name, so will each group have a unique name. Plus, it means you only have to change one string, not two.

You can do this yourself, and make this new improved Group SOP the default. First, put down a Group SOP. Then change the Group Name field to:

```
`opname(".")`
```

This will reference the name of the SOP and use that for the name of the group it creates. Next, make this the default. To do this, click on the gear icon in the SOP (shown below), and choose "Save as Permanent Defaults." Now every Group SOP you create will have the opname() expression in it. Just change the name of the SOP, and you change the name of the group it creates.

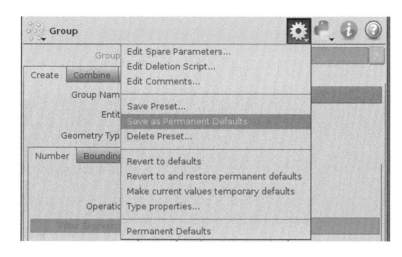

Memory Management

Houdini maintains several caches in order to balance memory usage against interactive response. Most of the time, you won't notice this. But in situations where you are working with large sets of geometry, you may begin to bang up against the limits of your machine's memory. Normally, each SOP in a chain maintains a copy of the geometry that it has worked on. You can see this by creating a torus with 900 rows and 100 columns, then adding a Point SOP, and finally a Transform SOP. If you look at the MMB information for each SOP, you'll see that they are each using about 25 MB, and if you look at the cache window (*Windows→Cache Manager*) you can see that a total of 75 MB is being used to hold the data in these three SOPs.

To give some of that memory back, you can go to SOPs up the chain and unload them. This is an item on the RMB menu on the SOP. Unloading a SOP causes the node to be marked as locked.

Here, we've unloaded the Torus and the Point SOP, and now the cache manager shows that we have given back 50 MB. Of course, if we have to recook something in this SOP chain, all this memory will be used again. So this might only be useful if we combined it with locking the Transform SOP.

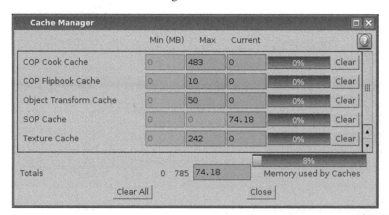

(Continued)

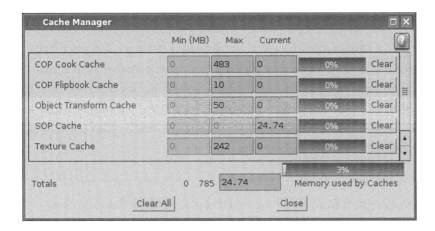

Alternatively, if you look in *Edit → Preferences → Objects and Geometry → SOP Manager*, you can set the unloading to happen all the time. You might want this if you were working with big models that didn't change much upstream, so that you could save as much computer memory as possible. The cost of doing this would be interactive speed, however, so take care. A better option may well be to run down to the store and buy yourself another gigabyte of RAM!

Triangulate 2D

The Triangulate 2D SOP is extremely useful for dividing a surface into irregular triangles, such as you might want to set up a piece of cloth for DOPs, or for setting up some terrain before using the Fractal SOP on it.

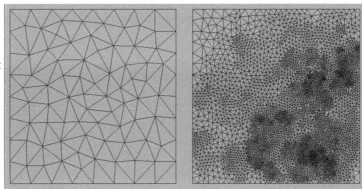

But you can improve the results by using the minimum angle parameter – that's what it's there for. A long skinny triangle will always have a really small angle somewhere inside it; by requiring that all triangles have angles of at least 10 degrees for example, you can get rid of the skinniest ones.

L-System Testing

It's often the case that when experimenting with L-system rules, you'd like to turn a rule off and on, to see what effect it is having. Rather than erase a rule, type it back in, erase it again, etc., you can use the fact that rules can have probabilities attached to them. Just set the probability for a rule to zero, and you remove it from the L-system. This is done by adding a colon (:) to the end of a rule, followed by the probability, for example:

```
B = &FFFA:0
```

Will remove rule B from the L-system. Of course, if you are already using probabilities, this trick won't work.

See the Metaball, Be the Metaball

If you want to see the area of influence of a metaball, you can do this by turning on the hull display, shown here. This gives you the brown outlines shown outside the metaballs themselves.

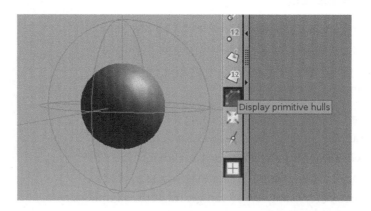

SoftPeak

The SoftPeak SOP is a useful tool for interactive modeling, but it can also be used procedurally to generate some interesting effects.

For example, put down a Torus SOP, and set the Rows and Columns to 50 each. Then append a SoftPeak SOP, and in the Group field put 0-99. This selects only those points. Now play with the distance slider.

As another example, create a breathing sphere by putting down a Sphere SOP, make it polygonal, and change the Frequency to 5. Now interactively select a block of points on one side of the sphere (using the Select mode in the viewer), followed by a Group SOP. Name this group "lung," and append a SoftPeak SOP to the Group SOP. In the Group field, choose "lung's Point selection," and in the Distance field, put this expression:

```
sin($F*8)*.1
```

Now hit play, and watch the sphere breathe. You can experiment with the Soft Radius and Tangent Angles values to get variations on the theme, as well as turning off the Translate Along Lead Normal option.

SoftTransform, when used with a group of points, is also interesting. Try that with the lung selection and see what kind of shapes you can make.

Animating PolyReduce

If you are animating (deforming) a piece of geometry, and are also using PolyReduce on the result, then the third input, cryptically named "Reference Mesh," will be useful. If you plug in a third input, then the PolyReduce process is applied to it, and then the result is used as a guide to how to reduce the poly count in the first input. For example, if edge 25 in the reference mesh is removed, then the corresponding edge 25 will be removed in the input mesh. Of course, in order for this to work, edge 25 in both inputs has to represent the same edge. In other words, the two inputs have to be topologically equivalent.

You can think of the third input as a kind of "rest position" for the input to be processed. In this way, deforming geometry that would otherwise flicker as it deformed (because changing edge lengths would lead to different polygons being removed), will be reduced in a consistent, non-flickering way.

The "Frame" option specifies that a particular frame be used either from the input or the reference geometry.

Layering Attributes

Most of this book is about nifty things you *can* do with Houdini. Here's a tip about something you *can't* do. Just so you'll know it isn't broken.

You can use the Layer SOP to specify that, for example, the upcoming UV Projection is meant to create UV values on layer 3. That works.

What doesn't work is trying to use the Layer SOP to specify that your upcoming Attribute Create or Attribute Promote SOPs are going to apply to some layer other than layer 1. You can't do that, because the Layer value does not affect the AttribCreate nor the AttribPromote SOPs. The Layer value only affects implicit choices of attributes. When you list an attribute by name, as you must do in, for example, an AttribCreate SOP, then that name is used literally. Bummer.

Delete Empty Groups

If you want to delete groups that are empty, then do this:

- Put down a Delete SOP.

- Turn on Number Enable.

- Set the pattern to −1.

You will get a warning about −1 being a bad pattern (Bad pattern! Bad!), but because the "Delete Unused Groups" toggle is on by default, any empty point or primitive groups will be deleted anyway.

Attribute Arithmetic

Sometimes you want to know the average, or the min and max range of a point or primitive attribute. To get this kind of information, use the AttribPromote SOP to promote the attribute to Detail level, using the appropriate Promotion Method to get the calculation you want. Then just use the detail() expression to access the result.

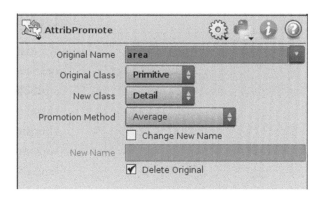

Averaging Normals

Here's a neat trick to average the normals of a bunch of coincident points. First, get some geometry – say a torus. Then:

- Put down a Facet SOP. Turn on Unique Points, and Post-Compute Normals.

- Append an Attribute Transfer SOP. Plug the Facet SOP into both inputs.

- In the Attributes tab, turn on the Points toggle. Set the Attribute to N.

(Continued)

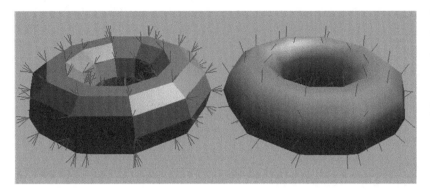

This will allow you to average the normals overall. You could do this for specific point groups as well.

For models that are more complex than a torus, you will want to find a radius to average within that gives you the result you want, as well as a Distance Threshold.

Unloading SOPs

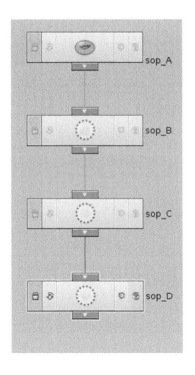

When a SOP "cooks," the result is stored in memory, in order to speed up the next cook of the SOP network. For large networks, this memory use can become a problem. Your first line of defense is to manually go to SOPs and unload them, that is, give back their memory. You do this by RMB on the node, and choosing "Unload" from near the top of the menu. SOPs which are unloaded stay unloaded – that is, when they next cook, they do not store the result. You have to do the RMB again, and choose "unload" again, in order to change them back to the default behavior.

Generally, when you do this though, you do it in conjunction with locking the SOP at the end of the chain. That keeps Houdini from cooking the upstream nodes, and so everyone is happy. Consider this SOP chain:

If we lock node D, then nodes A, B and C won't be cooked. So we can unload their memory, since it is serving no purpose.

You can also use the M/m options of sopcache to force unloading after a certain memory threshold is reached. And there is a -U option, to control the unload

(*Continued*)

flag behavior of SOPs. You can use this to just force all SOPs to unload via a script command.

For more detailed information, open a textport and type:

```
help sopcache
```

And now, we can up the ante in the next tip.

Checkpoints and SOP Unloading

Now that we have that background, we can get more sophisticated. Houdini allows you to set "checkpoints," which are markers in the SOP cook process. A checkpoint has a name and depth. The depth means the number of times that a SOP has to not have cooked, before it is unloaded automatically.

For example, you have a SOP chain that goes A→B→C. Now you cook the whole chain. And then you use the sopcache command to create and set a checkpoint:

```
sopcache -W foo 1 1      # Checkpoint named "foot" is
                         # turned on and set to depth 1
sopcache -w foo          # The foo checkpoint is set
```

so that the # characters are lined up

Now you cause nodes A and B to cook. Then, you set the checkpoint again

```
sopcache -w foo
```

At this point, the "depth" is 1, and so any SOP that has cooked less than 1 time since the last time "foo" was set, will be unloaded. That means that SOP C is unloaded, because it has cooked zero times since the last time the checkpoint was set.

Relative Editing

You can use the Edit SOP to modify, by hand, the points and faces of your geometry. But if that geometry is animating (at the SOP level), then you'd like your edits to be relative to that animation. Imagine, for example, that you've pulled up the points on a grid, but that grid is also rotating. If you pull up the points in Y on frame 1, then as the grid rotates around, you'd like the points to continue to move "up" in the correct direction.

You can achieve this by connecting the unrotated geometry to the second input of the Edit SOP. Then the edit will be applied relative to this reference geometry.

You can build a simple example to understand this. Put down a Grid SOP, and connect it to a Transform SOP. Connect the Transform SOP to an Edit SOP. Using the Edit SOP, grab a few points on the grid and pull them up and around. Now go back to the Transform SOP and in the Z Rotate parameter, put the expression $F*2.

Now slide the time slider, and notice that your edit is always going up in Y, even though now the grid is rotating around. This is bad. To fix this, simply connect the original Grid SOP to the second input of the Edit SOP. Problem solved!

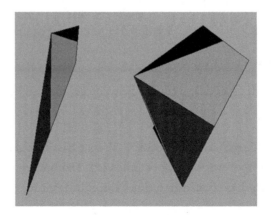

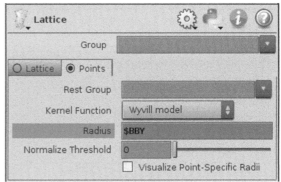

Modeling with Pictures

One of the great joys of using Houdini is in creating things just for the fun of it, because the toolkit nature of the software makes that kind of fooling around so easy and rewarding. For example, you can use the pic() function to extract information from an image, such as the luminance, and then use that to modify (or create) geometry. You can create a halftone image based on colored circles, or a version of those toys made out of pins where you push something into the pins and it registers a three-dimensional (3D) surface.

For example, say you put a File node into COPs, then in SOPs you create a grid in XY. Then append a Point SOP, set it to hscript mode, and in the Z Position field put this expression:

```
pic("/img/img1/default_pic", $BBX, $BBY,   D_CLUM)*0.5
```

Sneaky Lattice Attributes

The Lattice SOP allows you to distort one shape and have that distortion affect another. It does this by creating metaballs, internally, at each point in the controlling geometry. In the Lattice SOP, there is a control for adjusting the radius of virtual metaballs.

But what you can also do is use all the regular local variables within the Lattice SOP, to control the weight on a per-point basis.For example, $PT, $NPT and $CR all work in the Lattice SOP.

To see this, set the Lattice SOP to Points mode, and put $BBY in the Radius parameter. Now when you distort the control input, the effect will be modified from none at the bottom (minimum Y value) to full deformation at the top (maximum Y value).

Of course, in a real modeling situation, you probably want something a bit more useful. How about painting the weight with a Paint SOP, or using the Red value of the incoming geometry to control the weight, by putting $CR into the Radius parameter? Both of those would be interesting variations on a theme.

Fun With Measurements

So you have a NURBS curve, and what you want is to map UV values to it such that the U value represents the distance along the curve in the U direction. The NURBS itself is, of course, unlikely to be a straight line. What to do?

The first, simple approach is:

- Connect a UV Texture SOP

- Set Texture Type to Arch Length Spline

- Set Apply To to Point Texture

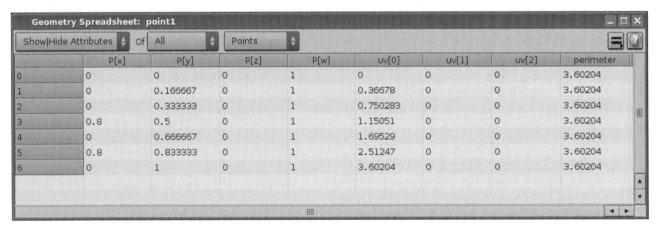

Geometry Spreadsheet: point1

Show|Hide Attributes Of All Points

	P[x]	P[y]	P[z]	P[w]	uv[0]	uv[1]	uv[2]	perimeter
0	0	0	0	1	0	0	0	3.60204
1	0	0.166667	0	1	0.36678	0	0	3.60204
2	0	0.333333	0	1	0.750283	0	0	3.60204
3	0.8	0.5	0	1	1.15051	0	0	3.60204
4	0	0.666667	0	1	1.69529	0	0	3.60204
5	0.8	0.833333	0	1	2.51247	0	0	3.60204
6	0	1	0	1	3.60204	0	0	3.60204

(Continued)

If you open a spreadsheet on this node, you'll see that the U values are the basis as the curve goes along. If you want the U value to range from 0 to 1, as you might well do, you should first change the basis of your curve, with a Basis SOP. Go to the Map tab, turn on the Length and set it to 1. You may also have to set the Origin to 0.

Geometry Spreadsheet: texture

Show|Hide Attributes | Of | All | Points

	P[x]	P[y]	P[z]	P[w]	uv[0]
0	0	0	0	1	0
1	0	0.166667	0	1	0.101826
2	0	0.333333	0	1	0.208294
3	-0.8	0.5	0	1	0.319405
4	0	0.666667	0	1	0.470648
5	-0.8	0.833333	0	1	0.697513
6	0	1	0	1	1

Now, if you want the U value to contain the actual distance along the curve, not the linear distance from one point to another, you have to measure the total length of the curve and use that to adjust the point values. You would do this by putting down a Measure SOP. This will give you a "perimeter" attribute at the Primitive level – that's the length. Use an Attribute Promote to get that value into each point of your curve, then use the Point SOP to multiply the perimeter by the U value to get the true length.

Extracting Edges

How do you get the edge that is the outline of a shape? Say, just for a simplistic example, you have a grid and all you want is the perimeter edge?

The simple trick for this is to use the Divide SOP with Remove Shared Edges turned on. If the result is an open curve, and you want to close it, use the Ends SOP to do that.

MetaMerge

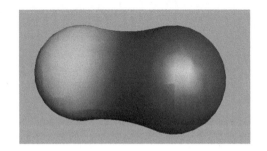

Metaballs can be used to blend point attributes. It's easy and instantly gratifying. For example, create a metaball SOP, and append a Point SOP to it. Add point color, and set the color some value that you like.

Now do the same thing again with a new metaball, and choose a different color. Connect both Point SOPs to a Merge SOP, move one metaball away from the other slowly, and notice the color transition.

What's especially cool about this is that it works with any attributes, including ones you create yourself. You just have to make sure that every metaball has the same attributes attached to it.

Knitting for Polys

You can use the PolyKnit SOP to fix holes in geometry, or to stitch together two pieces of geometry. The easiest way to do this is to put the SOP down, and then interactively select the points or edges or faces that you want to stitch together. When selecting points, just select 3 points to make a triangle, then hit RMB. Then go on to select the next one.

Scaling the Copies

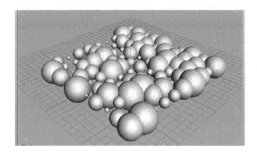

If you use a template object to control a Copy SOP, and the template points have a pscale attribute, the copies will be scaled by that attribute. To see how this works, connect a sphere to the first input of a Copy SOP. Now create a grid, make its size 10 by 10, and connect a Point SOP to it. In the Point SOP, in the Particle tab, set the Scale parameter to "Add Scale," and then in the parameter field, enter the expression:

```
rand($PT) + 0.1
```

(Continued)

Now connect the Point SOP to the second input of the Copy SOP, and make sure you are displaying the Copy SOP.

You should see a field of randomly sized spheres. You can experiment with putting other more interesting expressions in the Scale field – for example, grab the Red value from an image, using the pic() function, and base the scale on that.

Save "n" Go

When you are building complex models, you can save memory and increase your interactivity by essentially tying off what you have done so far, writing it out, and then reading it back in. To do this, add a Null SOP to the end of the branch you are working on, and name it OUT_Part_1 (or something more meaningful, like OUT_left_arm). Then RMB on the Null, and save out the geometry as OUT_Part_1.bgeo (or whatever you called your Null). Or, if you are not using Houdini Apprentice, use a Geometry ROP (Render Operators) in the /out editor. It's a better, more self-documenting way to generate geometry.

Either way, the next step is to put down a File SOP, and read back in the file you just wrote out. This bakes out your geometry, and then loads it back in so you can continue working. Of course, you lose some proceduralism when you do this, but you gain simplicity and memory. There may be times for making this trade-off.

Controlled Scattering

The Scatter SOP can be used to scatter points over a surface based on any attribute you like. For example, you can use an image to control the density.

Doing this is pretty simple. First, you use COPs to read in the image. In this example, we've just used the default butterfly image. Then you start with your geometry, say a grid. Append a Point SOP to the grid, and turn on the color attribute. In the parameter area for red, green, and blue, use the pic() function to grab the image, as shown.

The append a Scatter SOP, and change the defaults by:

- Turning off Scatter Based on Primitive Area

- Type "Cd" (no quotes) in the Alternate Attribute field

- Set the Bias to 1.

And then you get the image shown.

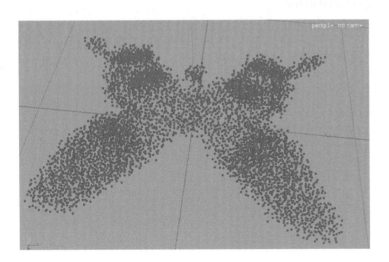

Splitting Hairs

You can use copy/stamping to remove information as well. As a slightly contrived example, say you have a single line segment that has 100 points in it. And what you want is 99 line segments; that is, points 0&1 will make a new primitive line, points 1&2 will make a second line, etc.

A simple way to do this is to attach a Delete SOP to your line, and set the Operation to Delete Non-Selected, and the Entity to Points. Then enable Numbers, and in the Pattern space, put the following:

```
`stamp("../copy1", "copynum", 0)` - `stamp("../copy1",
   "copynum", 0)+1`
```

Note that there can't be any spaces between the backtick, the dash, and the next backtick.

Now append a Copy SOP, and set the number of copies to 99. Go into the Stamp tab, turn on Stamp Inputs, and type "copynum" (no quotes) in the first Variable field. For the value, put $CY.

That's it! You can test to see if this is working by appending a Primitive SOP, and setting the Translate X value to $PR. Home the view, and you should see a bunch of disconnected lines marching off in X.

Metaball Math

You can create fairly arbitrary expressions describing how to combine metaballs and groups of metaballs. To do this, you now have the sum() function, min() and max(). Each of these can take a comma-separated list of metaball primitive numbers and/or metaball group names, such as:

```
sum(max("group1", "group2"), max("group3", "group4"), 0, 1)
```

(Continued)

Note the mixture of group names and primitive numbers. Note also that these expressions can be nested. Sadly, there is no subtract() function. But you can do some other cool stuff. For example, sum(0, 0) means that you merge metaball 0 twice, as two distinct metaballs.

To see how this works, create a Metaball SOP, and then append an AttribCreate SOP to it. Then

- Name the attribute "metaExpression" (without the quotes)

- Set the Class to Detail and the Type to String

- In the String field, put your expression, such as:

  ```
  sum(0, 0)
  ```

which will add the first metaball together twice.

Matching Maya Subdivision Surfaces

Given the same cage and crease weights, Houdini's Subdivide SOP can match Maya's subdivision surfaces. The secret is to successively apply Subdivide SOPs to your geometry to match the subdivision depth value in Maya.

For example, if you are subdividing to a depth of 3 in Maya, you just can't duplicate this with a single Subdivide SOP with a depth of 3. You have to append three Subdivide SOPs each set to a depth of 1.

On the other hand, this cascading of Subdivide SOPs accentuates the curvature in the model, and can be quite useful just as a trick on its own. If you want to pull more detail out of your sub-d cage, cascade Subdivide SOPs.

However, the hierarchical subdivision is a Maya thing, and can't be matched in Houdini.

What Am I?

You may find that you need to have your geometry go down a different SOP branch depending on whether it is a spline surface or not. The best way to do this test is to use the function isspline(), which will return 1 if the geometry is a spline, in a Switch SOP. This is preferable to using techniques involving opinfo(), which returns a string, that you then have to compare with the magic words "NURBS" or "Polygons."

Note that in some cases isspline() may not force an update – in that situation, you can always use the trick of adding:

```
+ $F * 0
```

to the expression. This makes it time-dependent, and forces it to reevaluate at every frame.

Filtering Primitives

You might find yourself wanting to grab all the polygons with a certain number of vertices. For example, say you want to split out all the polygons with four vertices, so that you can break them up into triangles in a specific way.

There is a simple way to do this – just create a group based on the number of vertices in the primitive. Put down a Group SOP, and set the Operation to "Group by Expression." Then put this expression:

```
$NVTX == 4
```

into the expression field. All done!

Extra Magnetism

The Magnet SOP is useful for deforming geometry in a bendy, squishy sort of way. But you can also use it to modify other attributes of the geometry, such as color. Try this:

- Put down a Grid SOP. Make the grid 4 × 4 in X and Z.

- Connect that to a Point SOP. Set the SOP to Add Color, then RMB on the Color label and Delete Channels. Set the color to black.

- Connect that to a Magnet SOP.

- Put down a Metaball SOP, and connect it to the second input of the Magnet SOP. Set the metaball radius to [0.5 0.5 0.5]. Make sure the expression language is set to hscript for this node, then set the Center X value to,

 `cos($F*5)`

 and the Center Z value to:

 `sin($F*5)`

- In the Magnet SOP, in the Attributes tab, turn off Affect Position and turn on Affect Point Color. Then in the Deform tab, set the Translate parameter to [1 0.5 1]. This is the RGB value the magnet will use to deform the color.

- Now move the time slider, and watch the magnet move around the grid, changing the color where it moves.

Auto-Magic Editing

You have this geometry. And you have this other version of the same geometry, that's been deformed somehow. What you would like to do is have a procedural way to describe the deformation (assuming you aren't the one who deformed it in the first place, of course). What to do?

Use the magic sopcreateedit command. In a textport, navigate to the SOP network where (ideally) the two SOPs holding the two versions of the geometry reside. Let's call them "before" and "after." Then issue the command:

```
sopcreateedit new_edit before after
```

and you will get an Edit SOP that describes the edit necessary to transform "before" into "after." The only real restriction is that, of course, "before" and "after" have to have the same number of points. It would help if they had the same topology as well, but strictly speaking, that's optional.

ON THE SPOT

POPs Hacks

POPs are Particle Operators, and Houdini's particle system has a well-deserved reputation for allowing artists to build very complex simulations very quickly and very controllably. The particles can then be used as a basis for everything from fire to smoke to fireworks to fluids to swarms of locusts to works of abstract art. POPs provide the backbone for many, many effects – and they are fun to work with as well!

Setting Births per Frame – 1

One thing people quickly want to do with POPs is to control the number of particles birthed on a per-frame basis. One way to do this is with the Impulse Birth Rate parameter, which is in the Birth tab of both the Source POP and the Location POPs. If you set this to "1," and set the Const. Activation to 0, then 1 particle will be born each "impulse," which by default is each frame. Set this to 5, and you'll get 5 particles each frame.

The one tricky thing about this is that if you set the oversampling of your particle system to a number other than 1, it won't work any more. For example, if you set the oversampling to 2, then you'll get two "impulses," or cooks, per frame, and so you'll get twice the number of particles you were after. You can correct for that by dividing by the oversample rate, as shown, but that's kind of messy. I've got a better way.

Setting Births per Frame – 2

Here's a method I like better. In the Source and Location POPs, the Const. Birth Rate is measured in "particles per second." So if the current Frames per Second ($FPS) is 24, and you put a 24 in the Const. Birth Rate, you'll get 1 particle born each frame.

And that information tells us how to specify the birth rate in particles per frame – just multiply by $FPS. For example, a constant birth rate of 10*$FPS would give you 10 particles per frame. You can verify that this is happening by single stepping through the frames with the right arrow key. The great thing about doing it this way is that it no longer is affected by the oversampling rate, because we are measuring our particles in Frames, not Impulses (or cooks).

Accurate Sub-Frame Births

New for Nine!

If you are reading in geometry with the File Surface Operator (SOP), and using that to birth particles, you can run into problems interpolating sub-frame positions when you are oversampling. You may find, especially with fast-moving geometry, that the particles are clumped around certain frame positions, rather than smoothly distributed along the geometry's motion.

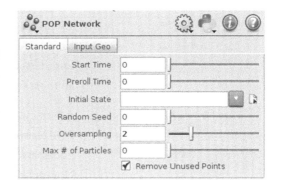

In Houdini 8.1 and before, you would solve this problem with two File SOPs and a Blendshapes SOP. But in Houdini 9, there is the TimeBlend SOP, which lets you create sub-frame geometry where you had none before. All you do is append the TimeBlend to the File SOP, and then use the TimeBlend as input to your particle system. You can also use the new TimeWarp SOP to modify the timing of your deformations.

You can verify the sub-frame animation: hit the parameter icon in the bottom right-hand corner of the frame bar to pull up the "Global Animation Options" box. Turn "Integer Frame Values" off and change the "Step" value to 0.5 or whatever corresponds to the inverse of the oversampling setting you are using.

Also, this whole thing only works if the geometry has the same point count and same point order on each frame.

Avoiding Pre-Roll

Imagine you have a simulation that needs a long pre-roll to set up properly, say 150 frames. In this situation, you could set the Preroll Time in the POP Network to 150/$FPS (dividing by $FPS because that parameter is measured in seconds), but then every time you wanted to rerun your simulation, you'd have to wait for all those frames to calculate.

A better way is to run your pre-roll out, then right mouse button (RMB) on the POP Network SOP and save the geometry (note: there are two POP Network nodes, and only the one used in the SOP context allows you to save geometry). Now put the path to that geometry in the Initial State field, set the Preroll Time back to zero, and you're all set – your simulation will start from that configuration, saving you a lot of waiting around.

Debugging Particle Systems

It's very common to set up a particle system where colors or other attributes are computed with expressions based on $LIFE or $AGE. It can be frustrating having to run the whole simulation in order to find out whether those expressions are doing the right thing. Even worse is having to render it out just to see if the colors are being set properly.

A quicker way to test these kinds of things is to RMB on the final POP and choose the Geometry Spreadsheet. Then scroll over to the Alpha or Color or other attribute that you are trying to manipulate.

Now when you single frame through the simulation, you can watch the values change. In this way, you can very quickly check to see if you are really generating the values you want.

And don't forget you can filter the columns that are displayed, so that you only see the attributes you are interested in.

Cling Ons

One interesting property that the Property POP allows you to add is Cling. But this can be hard to set up correctly, especially if you misunderstand what Cling actually does.

So the first thing to realize about Cling is that it acts counter to any forces that are in the simulation, so if there are no forces, it does nothing. That means that you'll need a Force POP in there to make it work.

The other thing to note is that it isn't really stickiness, or friction – Cling counters the desire of a particle to move away from the surface, along the surface normal, rather than countering the particle's attempt to slide along the surface.

To see Cling setup correctly, do this:

- Put down a Location POP, set the location to (0, 1, 0), The Constant Birth Rate to 2*$FPS, and the Velocity to (−0.1, −2, 0) with a Variance of (0.1, 0.1, 0.1).

- Connect a Force POP to the Location POP, and set the Force to (0, −10, 0).

- In a SOP network somewhere, put down a Sphere SOP. Set it to Polygons, set the Radius to (0.2, 0.2, 0.2) and the Frequency to 7.

- Connect a Collision POP to the Force POP. Set the SOP (collision geometry) to the sphere you just created. Set the Behavior to Slide on Collision.

- Add a Speed Limit POP, and set the Speed Limit values to (0, 0.2).

- Finally, add a Property POP and turn on the Cling property (Misc tab). Set the value to 9.

(*Continued*)

- Make sure the display flag is on the Property POP, and hit play. The particles should stream down, hit the ball and then follow its shape around to its underside. Now turn off the Cling property and see the difference. Also experiment with turning off the Speed Limit and/or Force POPs to see how they change the effect.

Creepy Stuff

The Creep POP requires some finesse to get right. The default setting contains the attributes \$POSUVU and \$POSUVV, which describe the particle's position in UV coordinate space. So you can, if you want, simply make sure that these attributes are created for each particle and have meaningful values before the particles get to the Creep POP.

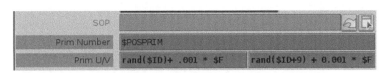

Or you can set the values in the Creep itself. In which case, you need to make sure that each value is a function of the particle's \$ID, and that the U and V values are different. Generally, that means a set of values defined something like this (see left).

The random numbers are added to make sure that the U and V values are different – otherwise, you'll get the particles marching along the surface in a line, which is probably not what you want.

The values also incorporate the \$FF value so that they get larger each frame, and are therefore driven across the surface that they are crept onto. Instead of \$ID, you can use something else, such as velocity. For instance (and this is taken from the helpcard example) see left.

Filling a Volume

To fill a shape's volume with particles (for example, to render a cloud in that shape), follow these steps:

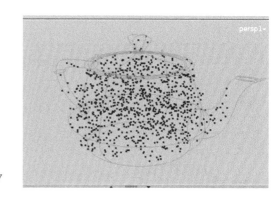

- Put down a Popnet SOP. Connect your geometry to the first input of the popnet. Then dive inside it.

- Put down a Source POP.

- In the Source tab, set the Emission Type to Volume, and set the Geometry Source to Use First Context Geometry.

- In the Birth tab, set the Impulse Activation to $FF == 1, and the Impulse Birth Rate to the number of points that you want in the cloud. Set the Constant Activation value to 0. Stand back and admire your particles.

In some cases, you may need to first pass the shape through the IsoOffset SOP, so that a proper closed volume is built. Also, the Activation has to be $FF, not $F, or else oversampling values other than 1 can break your simulation.

Filling Metaball Volumes

If you want to fill a metaball-based shape with particles, then use the ScatterMeta SOP. This is not part of the regular Houdini distribution, so you have to use proto_install to install it. For Linux users, just type

```
% proto_install
```

at the command line, then choose SOP_ScatterMeta from the menu. Windows users need to run *Programs* → *Side Effects Software* → *Houdini 9.0.xxx* → *Command Line Tools*, then in the window that opens, type the proto_install command as shown.

(Continued)

You can also scatter points inside a metaball surface using the standard Source POP – there is a menu entry for Metaballs – but this restricts the points to the metaball *surface* as displayed in the SOPs viewport. The ScatterMeta SOP, on the other hand, places points throughout the metaball density field, which extends beyond the visible metaball boundaries.

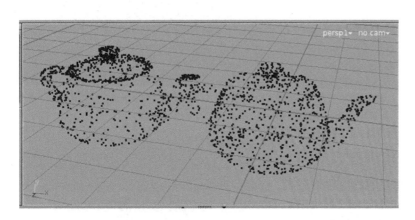

Particles and Surface Area

The Source POP also lets you birth particles from a surface, in either an ordered or random way. But if you have an irregular shape and you want to birth particles from its surface in a uniform way, then you should use the Measure SOP.

For an example, connect a Platonic Solids SOP (set Solid Type to Utah Teapot) to a Measure SOP (set Type to be Area), then use that as the input to a Source POP. Set the Emission Type to Surface (random) and note the distribution. Now change the Emission Type to Surface (attribute), and you should see a much better result. Note that the attribute that you use can be changed in the Distribution Attribute parameter field, but that it defaults to "area."

Getting More Blur

Let's say you have a particle simulation that you are happy with, but you think it needs to be rendered with more velocity blur (for example, creating water spray with point rendering). However, you don't want to change the speed of your particles, because that will change the simulation.

The solution is to go back to the SOP editor and add a Point SOP after the Popnet SOP. Choose Add Velocity from the Particle tab, and then multiply

(Continued)

the values by some constant. For example, $VX*10 in the X component, $VY*10 in the Y, etc. This won't change the speed of your particles, or the simulation in any way, but you will get more blur in your render.

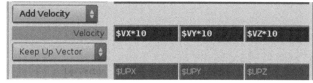

You can also make this parameter interactively adjustable. Create a Spare Channel, call it "velmult," and set the velocity components to $VX * ch("velmult"), $VY * ch("velmult"), etc. Then instead of typing new values to experiment, you just adjust the spare channel.

Oversampling vs Accurate Births

Many people wonder about the difference between oversampling the particle system, and asking for accurate births. Here's a quick review.

Accurate births is for moving or changing input geometry. It recooks the geometry for each frame, which means that turning it on will make a simulation run much more slowly.

Oversampling, on the other hand, will cook at sub-frame intervals, so if you are birthing from fast-moving geometry, where it is obvious that particles are appearing at discrete points in space (that correspond to frame 1, frame 2, frame 3, etc.), then set this to a higher number. This will cook in sub-frame intervals.

In some cases, you may have to do both things to get smoothly emitting particles. And also see tip called Accurate Sub-Frame Births, which deals with this in some detail.

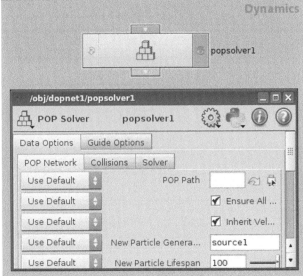

Caching Particles

There are four ways to cache particle simulations for interactive playback. The older, more obsolete way is to set the particle system up to cache into a viewer. You do this in the Particle network editor, where you will find the names of POP networks you have created. Each of these networks has an additional tab, the Viewer tab, which allows you to specify a number of frames to hold. If you set this to the size of your simulation, then go into the particle system and allow it to play, the results will be cached up for the viewer. This will allow you to scrub the simulation back and forth. Note this feature is not found in the POP Network SOP, only in the POP Network node that you put down at the Scene level, or in the/part location.

A second, and slightly better way, if you are using a Popnet SOP or a Particle SOP in the geometry editor, is to use the Cache SOP to collect the results of the particle system. You can optimize this a bit by choosing the Cache Points Only option. Once this SOP is cached up, you can also scrub the simulation back and forth, which is very useful.

The newest way to accomplish this is to embed the particle system in a Dynamic Operator (DOP) network. The DOP network does nothing except provide an environment for caching. To do this, create your particle system as normal. Then set up a DOP network, and into it put a POP Object and a POP Solver. Leave the POP Object set at its defaults, and point the POP Solver to your particle simulation. Now when you play the DOP simulation, the particles will be cached – and that will allow you to scrub the simulation back and forth, as well as playing it at top speed once it has played through the first time.

The best way, however, is to write the results of the particle simulation to disk. You do this with the Geometry Render Operator (ROP), which writes out one file per frame, and then read the results back in with a File SOP.

Orienting Geometry

Often, the final use of particles is as positions in space to copy other geometry to. When you are using them this way, you can set up attributes that control the orientation and size of the copied geometry.

Using the Property POP, create the "Uniform Scale" attribute, and set it to the appropriate value for each copied piece of geometry. Then using the Rotation POP, you can define an axis of rotation and a rotation amount for each particle.

Now when you bring these particles back into the SOP (geometry) context, and copy geometry to them using the Copy SOP with the "Rotate to Normals" flag turned on, you will get geometry scaled and rotated appropriately. Thus one SOP takes care of everything. The Rotation POP has a helpcard example that shows this in action.

A variation on this, which leads to a faster workflow, is to try to add these attributes in SOPs, using a Point SOP, for example, to add pscale after the particles are reloaded from disk. It is also possible to add rotation attributes afterwards, but that is more difficult, because they are in quaternions.

Access to Other Particles

All POPs have a Group field that allows you to specify that only a subset of the incoming particles – the ones in the group – are to be acted on by the operator. However, there is a loophole in this – POPs doesn't actually verify that the particles in the named group are part of the input stream. That means that you can grab particles from somewhere else in the simulation. This is definitely cheating, but it works.

As an example, say you want to start with a single particle, and then split it, and all its even-numbered descendants, every 10 frames. You can accomplish this by exploiting the loophole described above. First, set up this chain of three POPs as follows.

The first POP creates a single particle at frame 1, and puts it into the group named Birth.

The most important thing here is the toggling of Preserve Group. This means that on frame 2 and subsequent frames, when the Location POP would normally produce no particles (because the Activation is only true when $F == 1$), the contents of the Birth group are left alone. Otherwise, the group would be recreated each frame, and so on frames 2 through the end, the Birth group would be empty. And that would ruin what comes next.

In the Group POP, we choose the even-numbered particles (using the rule $PT\%2 == 0$) and put them into a group called EvenParts. Note that we are using as input two groups, the Birth group (which was our input here) and also the Splits group, which is created *after* this POP – in other words, this is a group we shouldn't be able to see. But we can, so we use it.

80

(*Continued*)

Finally, we have the Split POP, which splits the particles in the EvenParts group that we just created. The new particles are put into a group called Splits. Since Preserve Group is checked, this adds the new particles to the existing Splits group contents. And all of these are available to us in the Group POP, as we previously saw.

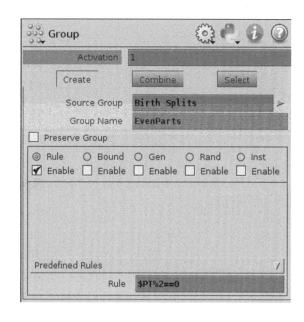

Births Based on Group Membership

If you want to create a particle (or several million) at a particular frame, then the simplest way, of course, is to put that into the Impulse Activation field of the Source POP, like this:

$F==45

In this case, the particle(s) will be created at frame 45.

But what if you want to create particles based on group membership? For example, you have a group SOP that creates a group called "myGroup." And this group is empty most of the time, but once in a while, the group has some geometry in it, and when it does, you want that geometry to create particles.

(Continued)

To do this, use the Source Group field in the Source POP. This will birth particles from whatever points (or primitives) are in the source group, and none when it is empty. One thing to note is that if your Group SOP is creating a point group, then you want your Emission Type to be Points (ordered or random). But if your Group SOP is creating a primitive group, then the Emission Type has to match.

Sprites Based on Particles

To set up sprites based on particles, use the Sprite POP. One slightly tricky thing is that you have to enable this POP after you connect it. Once you've done that, you can point to the shader you want to use for the sprite. Then you can use the various attributes created by this POP to control the size and orientation of the sprites.

One thing to note here is that it is the attributes that matter, not the Sprite POP. So if you want to work in SOPs, as long as you add the attribute "spriteshop" to the point geometry, you can render that geometry as sprites.

You can use the other attributes as well, such as "spritescale" (a vector) to adjust the size of each sprite, and "spriterot" to adjust the rotation. You can learn these names by dropping a Sprite POP, toggling on the various parameters, and then doing RMB on the node and choosing Geometry Spreadsheet. This will show you the names of the attributes that the POP would create, and that mantra would expect when rendering them.

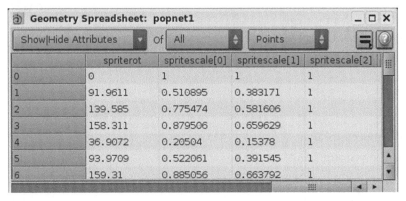

See the Rendering chapter for more details on Sprites.

Variable Birth Rates

The problem with the Constant birth type in the Location and Source POPs is that the birth rate is, well, constant. For example, if you have it set such that 100 particles will be born at each frame, then you will get exactly that number each time (assuming oversampling is set to 1).

But what if you want a variable number of births, especially one based on probability. Say that in this case the birth rate was still set to 100 particles per frame, but that you wanted the likelihood of a particle being born to be 0.5. Then on that frame, you'd only get 50 particles. This would be even more interesting if you wanted to animate the probability, so that over the course of the simulation, more and more particles (or fewer and fewer) were born.

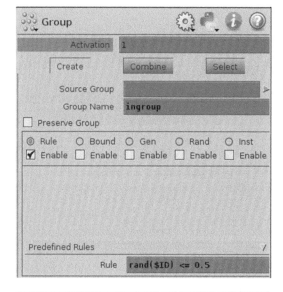

You can do this with a few POPs strung together. First you have your Source POP, with a constant birth rate. Then attach to that a Group POP, and set up the parameters as shown. Also, as shown, create another group called "outgroup" which is the inverse of the ingroup. That is, particles that are not in the ingroup, will be in the outgroup.

The Rule given here is that a random number based on the particle ID, should be less than 0.25. This means that there is a 25% chance that a particle will be in the ingroup, and a 75% chance it will be in the outgroup.

Then the next two POPs move the particles in the outgroup to a galaxy far, far away, and kill them. You have to move them as well as kill them, because you can't kill a particle on the first frame it is born. So if we didn't move them off, then they would be born on one frame, but not killed until the next, which would give us a lot of popping particles. Not good, usually.

Now, change the Rule to this

```
rand($ID) <= $F/$NFRAMES
```

This will animate the chance of a particle being kept, from close to 0 to 1. When you play the particle system now, you'll see more and more particles being born, which is what we asked for. Of course, you don't have to linearly increase the percentage of a particle staying alive – you could change this value every frame, based on some channel, or just on another random value.

Velocity Birth

Here's an interesting problem.

We want to birth particles only if the velocity of the source geometry is fast enough. Our first approach to this might be to go ahead and birth the particles, then kill the ones that are too slow. Unfortunately, this won't work, because the velocity isn't available in POPs until after the particle is birthed. So to use this method, we would also have to move those particles off into outer space, since they won't be killed until the next frame after they are born.

But here's another way. This relies on the Trail SOP to compute the velocity of the underlying geometry. The velocities of each point are averaged to create a single detail velocity value, that the Source POP can reference. Then if that value is greater than 0, the particles are born on that frame.

The SOP network is shown here.

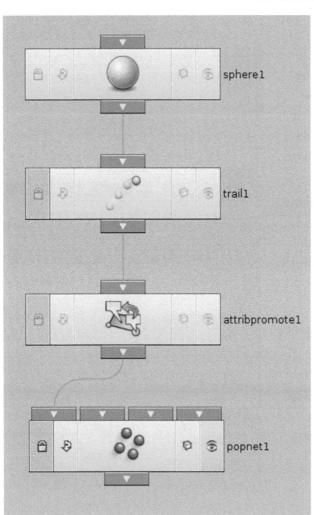

sphere1

trail1

attribpromote1

popnet1

(*Continued*)

The Trail SOP is set to calculate the velocity. The AttribPromote SOP has its parameters set like this:

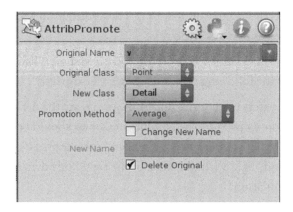

And then the Constant Activation of the Source POP looks like this:

Of course, you can use the detail velocity attribute in any more complex expression that you want.

Particles from Dynamic Simulations

You can extract the Impact data from a DOPs simulation to drive a particle system, say for creating smoke or dust that is procedurally linked to the dynamics sim. Here is one way to do this.

First, set up a Geo object that will hold the particle system. Then in its SOP network, connect the following nodes, as shown (see top left).

Now set the parameters up. For the Add SOP, just create the default point at (0, 0, 0). Then in the Copy SOP, the Number of Copies should be the following expression, noting that you may need to replace "/obj/dopnet1" with the path to your dopnet, and "ball" with the name of the rigid body dynamics (RBD) object in your simulation:

```
dopnumrecords("/obj/dopnet1", "ball", "Impacts", "Impacts")
```

In the Point SOP, set the XYZ Position fields to this expression, making the appropriate substitutions for "dopnet1" and "ball:"

```
dopfield("/obj/dopnet1", "ball", "Impacts", "Impacts", $PT,
"positionx")
dopfield("/obj/dopnet1", "ball", "Impacts", "Impacts", $PT,
"positiony")
```

```
dopfield("/obj/dopnet1", "ball", "Impacts", "Impacts", $PT,
"positionz")
```

Next, set up the Attribute Create SOP as shown here. This creates an attribute based on the impulse size that we can use to filter out unwanted impulses.

Which is what the Delete SOP is used for. Set the Entity to Points, enable the Number deletion, and set the Operation to Delete by Expression. Then put an expression in the Filter Expression field like:

```
$IMPULSE < 1000
```

The value will be completely arbitrary, and determined by your particular simulation requirements.

Then, optionally, you can use a second Point SOP to create velocity values before going into the POP Network. In the Particle tab, set the Velocity to Add Velocity, and set the Y value to something like:

```
$IMPULSE/500.
```

Finally, the POP Network. At its simplest, the POP Network contains a Source POP with the following settings, but of course you can add any particle operators you need. Good choices include Force to mimic gravity and Drag to give the whole thing a bit of friction.

Collecting Split Streams

The Collect POP can be tricky if you are splitting particles and then trying to collect them all back together again. If you are going to do this, you need to wire in the various inputs to the Collect POP properly, including in the proper order, to make the system work.

Basically, the Split POPs cannot work unless their input is first evaluated. You make sure that that happens by wiring that input into the Collect POP first. Then you make sure that all Split POPs come from the same input, and that they all go into the same Collect.

In other words, this is right:

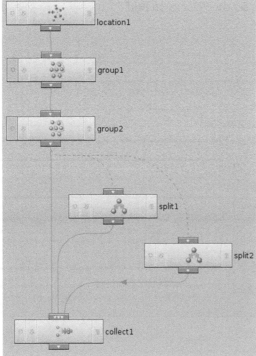

And this is wrong:

Getting Local Variables to SOPs

When you create attributes in POPs, they can be brought back out to SOPs and used there. But what you lose in this process is the local variable that goes with the attributes. So for example, say you create an attribute called "num" (using the Attribute POP), which maps to the variable $NUM. When you bring your particles back into SOPs, and try to use $NUM in a Point SOP, you'll get an error. The value of "num" will still be there, but what you have lost is the mapping from "num" to the local variable $NUM.

The way around this is to recreate the attribute in SOPs, as shown.

Also note that this applies to attributes *that you create* in POPs – the predefined particle attributes, such as ID and VX, VY, VZ, survive just fine in SOPs, and can be used directly without this little trick.

Using $LIFE for Control

One very common thing to do in particles is to use the $LIFE variable to look up into animation curves, as a way of controlling aspects of the simulation for each individual particle. For example, let's say that you are copying metaballs to each particle. But you don't want them to just pop on when the particle is born, and pop off when it dies. What you want is for it to scale up from 0 quickly after it's born, and scale back down to 0 just before it dies. Here's the procedure.

● In your POP Network SOP, add a Location POP, set Const. Birth Rate to 10, Life Expect to 2, and Life Variance to 0.5 so each particle lives (randomly) between 1.5 and 2.5 seconds.

● Back in SOPs, after the POP Network SOP append a Point SOP. In the Particle tab, change Keep Scale to Add Scale, and delete the $PSCALE expression.

● Click the little gear icon in the top area of the Point SOP, and choose Edit Spare Parameters. This will give you a dialog for adding and working with spare channels. Add a "float" type. This will give you a new parameter called "parm." In the Channels tab, change the Default value to 1. Hit Accept, and you'll have a new spare channel with the label "Label."

● Add a keyframe on "parm" by RMB (and holding) on the label or value area and selecting Add Keyframe. Now, scope this by using RMB and choosing Scope Channels. A channel editor window will open.

(Continued)

- In the Channel Editor, box select the first keyframe and change its frame number to 0 (type this in at the bottom of the Channel Editor). Alt-LMB on the dotted channel line and create a new key at frame 100. Create two more keyframes at frames 10 and 90.

Make sure the values of frame 0 and 100 are at 0 (zero) and frames 10 and 90 are at 1 (one).

Ok, so now we have a spare channel, called "parm," that animates from 0 at frame 1 to 1 at frame 10. Then it stays at 1 until frame 90, and then animates back to 0 at frame 100. Here's how we tie this all together.

- In the Scale field of the Point SOP, enter this expression:

```
chf("parm",$LIFE*100)
```

- Create a Sphere SOP, set the radius to 0.1.

- With the Copy SOP, copy the spheres onto the particles. When you play this back, you should see the spheres expand from birth, then shrink to 0 before they die.

How it works:

The chf() expression looks at a channel on a specific frame number. We created a channel from frame 0 to frame 100. Using $LIFE*100 in the chf() expression allows us to look at the channel based on the $LIFE variable. We multiply by 100 because $LIFE returns 0 to 1, which is hard to work with in the channel editor.

Particles from Images

You can quickly and easily birth particles based on an image. As an example, let's use the default butterfly, and use the alpha channel to control where the particles come from. We want particles to emerge only where the alpha of the butterfly is 1. Here's the drill:

- In the Image editor, put down a File Composite Operator (COP), and just leave it with its default image.

- Back in SOPs, put down a Grid SOP. Set the Rows and Columns to something reasonably high, such as 40 for each.

- Attach a Point SOP to the Grid, and change the Alpha menu to Add Alpha. RMB on the Alpha label, and choose Delete Channels. This will clear out the $CA that is there by default. In the parameter area, put this expression:

```
pic("/img/img1/default_pic", $BBX, $BBZ, D_CA)
```

- This references the butterfly image, using the bounding box in X and Z to map into the image and extract the alpha value.

- Append a Scatter SOP, and set the Number of Points to 1000. In the Alternate Attribute, put the word "Alpha" (no quotes) and set the Attribute Bias to 1.

- Connect the Scatter SOP to the first input of a Pop Network SOP. Select the Popnet SOP, and hit <enter> to go inside it.

- Put down a Source POP. In the Source tab, set the Geometry Source to Use First Context Geometry. This will give you particles coming out in the shape of the butterfly.

- Now use the Attribute tab to give the particles some velocity. In the Birth tab, you can modify the birth rate in particles per second. You're off and running!

Random Point Births

The POP Network node has largely replaced the Particle SOP for creating particle systems, but the old Particle SOP still has its uses. For setting up simple, quick simulations, it's hard to beat, since the whole simulation comes from a single node.

One common idiom that is used in this case is to add a Sort SOP to the input points, in order to randomize them. Otherwise, they will be birthed in their point order, which is rarely what you want.

Randomizing the Randomness

When you build a particle simulation with a Source POP, you get to randomize the point order right there – for example, when you choose an Emission Type of "Points (random)." However, the random point sequence this generates will not change – the particles will be emitted in the same random order over and over.

Therefore, the only way to get truly random particle emission is to randomize the points in the incoming geometry, before they go into the POP Network. To do this, place a Sort SOP before the POP Network SOP and choose Random – then set the Seed to something that changes every frame, such as $FF.

Faster Simulations

You can increase the speed of particle playback by going to *Edit* → *Preferences* → *Particles*, and checking the box for "Skip Particle Info Generation." This will give you an extra few percent performance (I've measured 10% before, but your mileage may vary), which can make a lot of difference in a large particle simulation.

ON THE SPOT

Secrets of the RBD Object

The Affector Matrix

Instant Simulations

Quick Access to Global Parameters

The Details View

Additive Noise

Avoid Recalculating SDFs

Avoid Recalculating Simulations

Explaining File Data Naming

Dividing Objects into Groups

More Convenient DOPs Merging

DATAPATH Revisited

Getting DOPs Positions to POPs

Ungluing Objects

Picking Up Where You Left Off

Using the Script Solver for Status

Calming Down a Simulation: Part 1

Calming Down a Simulation: Part 2

Offsetting Time

Animating RBD Objects

Speeding up Cloth Sims

Setting Up Hair Constraints

Door Hinges and See-Saws

Getting Particles into Sims

Setting up Soft Bodies

DOP Geometry Syntax

I've Been Hit!

Importing Motion

Getting DOPs Variables into SOPs

The dopfield() Function Explained

Getting Data out of DOPs

Adding Custom Geometry

Vector Syntax

4

DOPs Tips

Houdini's Dynamics Operators, or DOPs, are a powerful way to set up complex simulations with a remarkably small number of operators. Houdini 9 also adds capabilities for doing fluids and gases, to the original rigid body dynamics (RBD), cloth and wire simulations. Here we'll look at ways to get more out of these fantastic, fun tools.

Secrets of the RBD Object

The basic building block, if you will, of DOPs is the RBD Object node, which (as you might guess) sets up an RBD Object for simulation. But this node, which like many DOPs is really a Houdini Digital Asset (HDA), can do a lot of work in one small package.

For example, you can set up more than one RBD Object at the same time in a single operator. There are two ways to do this.

The first is to simply increase the Number of Objects parameter to whatever you want. Then you will create many copies of your input geometry. Then to keep them all from lying on top of each other, use a local variable like $OBJID to position each instance. For example, the image on the left shows how to create 9 RBD cubes and position them in 3 rows of 3:

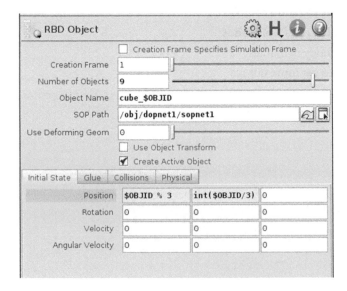

(Continued)

When you are creating more than one object at the same time, you can list more than one Surface Operator (SOP) geometry as well. For example, the image on the right on the previous page shows a setup that creates two RBD objects, one with geometry from the first SOP network, and the other from the second. Note the change in the Object Name string, so that the two objects are uniquely named. Now for extra fun, increase the Number of Objects to 4, and you'll get 2 of each SOP geometry, alternating. Increasing the Number of Objects will just go back and forth using one geometry than the other.

The Affector Matrix

The Affector Matrix is a little piece of user interface (UI) that you can find in the Details View of a DOPs network. The matrix is color coded to show how the objects affect each other. There are four possible colors, as you can see. Their meanings are:

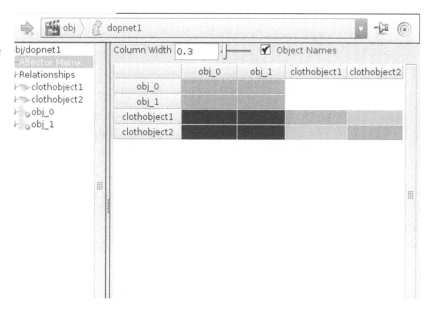

Grey	No relationship
Green	Mutual relationship (they affect each other)
Blue	One-way relationship. The object named in the column affects the object in the row, but not vice versa
Yellow	Warning. This warning comes when you have built a mutual relationship between two objects that do not share the same solver (in general, in order for objects to be mutual affectors, they must be solved by the same solver). The most common instance of this is when you build a mutual affector relationship between two different kinds of objects, such as an RBD Object and a Cloth Object. In a case like that DOPs will approximate the correct result by using feedback between the solvers during the substeps. It's a simulation of a simulation! In practice, this usually turns out to be what you expect, but it may not. The yellow warns you of this.

Instant Simulations

New for Nine!

The quickest way to set up a DOPs simulation in Houdini 9 is to go to the Rigid Body Dynamics tab of the tool shelf, and click on Ground Plane. This will create a DOPs network, and inside it create a Ground Plane object and add Gravity to boot. This saves lots of keystrokes.

Now all you have to do is to create any geometry from the shelf – say, a cube –position it up in the Y a little bit, and then select that geometry and click on Rigid Body Object. That adds the cube to your previous simulation network. Hit the play button, and your object falls onto the ground plane. In about 3 mouse clicks, you've got a simple simulation that you can start to experiment with. It doesn't get easier than that.

Quick Access to Global Parameters

If you put the cursor into the viewport, while you are in DOPs, and hit the "p" key, you'll pop up a floating parameter window for the DOPs simulation as a whole. On the Simulation tab, you can find useful things like "Recook Simulation" and time management parameters, such as Time Step and Scale Time.

This saves you navigating back up to the dopnet level to get access to these parameters.

The Details View

In the Details View for DOPs, you can change the tree view sort order to None and then move the data around, so that you can see various items next to each other. What's especially interesting, and useful, about this is that you can do it on a hierarchical basis. So you can set the display order of the data within a specific object to be one way, while leaving the display order for the rest of the tree view set another way.

To do these things, click the RMB on the name of any folder in the tree view. If you do this on the name of the dopnet, at the top, you will affect the entire tree. If you do it on an individual object or folder, you will be changing the setting just for the sub-objects of that folder.

Additive Noise

You can use the Noise DOP to *add* noise to forces as well as to scale the forces. For example, you might want a Uniform Force DOP that varies randomly from zero. To do this, simply set the Uniform Force values to 1, and then crank up the noise. This works with any kind of force node.

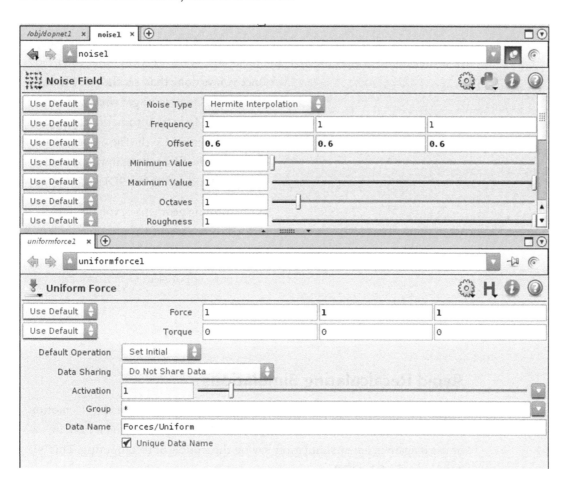

Avoid Recalculating SDFs

When an RBD Object's creation frame is reached, the first thing DOPs does is to compute a volume (SDF) representation. This representation is what is used to calculate collisions with other objects. Depending on the geometry and the accuracy required, this can be slow. Worse, if the geometry is deforming every frame, this calculation must be performed on every frame.

You can avoid all this extra work by caching the SDF data to disk. Of course, first you should display the SDF and make sure you are getting what you need.

Once you've done that, set the File Mode to Automatic. Once we've got what we want, set the File Mode to Automatic. The data will be written out to the file name given. Then once the file is there, it will be used instead of calculating the SDF.

For deforming geometries, you need to include some measure of time in the file name. For example:

`./Volume.$OBJNAME.$ST.simdata`

would do it.

Avoid Recalculating Simulations

Not only can you cache up SDF data, but you can also cache an object's motion (or a whole simulation's worth of objects) to disk, and then bring it back in, or use it again in a new simulation, saving the trouble of recomputing. This is done with the File DOP.

(Continued)

The simplest use of this is to tack it on the end of a DOP network, set the Operation Mode to Automatic, set the File location to something sensible (such as $TEMP/baked$SF4.sim) and play the simulation.

The first time through, it will write a file for each frame of the simulation. On subsequent runs, it will simply read the simulation data from disk and use that. You can also write the simulation cache to disk by using the Dynamics ROP (render operator) in the Output editor.

Note that if you bring objects created in one simulation, into another, those objects will not exist outside of the frame range they were originally created in. In other words, if you bring in something that simulates up to frame 50, and then want it to hang around and keep simulating on frame 51, it won't – unless you set the "Take Ownership of Loaded Objects" flag on this node. And if you do that, be aware that affector relationships are not preserved in .sim files, so you'll have to set them explicitly, using the Affector node.

The File DOP helpcard has some good examples of these different situations.

Explaining File Data Naming

The File Data DOP allows you to save to disk-specific object data, and bring it back into any simulation. This is very useful, and in fact the RBD Object digital asset uses this technique to save SDF data to disk. But if you put down one of these, you might wonder why the default file name is such a complex expression. Here it is:

```
./baked$SF4.$OBJID.`strreplace(chs("dataname"), "/", "_")`.
simdata
```

The reason is that you can save out any data, including gravity or other force data. But remember that the default location of gravity is Forces/Gravity, and so without the strreplace() function, the file name to write would become:

```
./baked0001.1.Forces/Gravity.simdata
```

(Continued)

which is a file name likely to cause problems, because of the extra "/" character. In fact, what is likely to happen is – nothing. No file, no warning, lots of confusion. So to avoid that problem, the strreplace() function turns the '/' character into a '_', and the result becomes:

```
./baked0001.1.Forces_Gravity.simdata
```

Dividing Objects into Groups

It's fairly common to use DOPs groups to divide objects into two sets, and then do something different to each group. For example, if you wanted to stop all motion on objects whose velocity had decreased below a minimum, you might have a Group DOP with a test in it like this:

```
abs(dopfield(".", $OBJNAME, "Position", "Options", 0,
"vely")) > .1
```

and then a second Group DOP with the opposite test:

```
abs(dopfield(".", $OBJNAME,
"Position", "Options", 0,
  "vely")) <= .1
```

But that's extra work, and worse, it's just asking for problems later, when you change one test and forget to change the other one. Then you'll end up with objects in both groups, or neither. A better way to make sure that every object ends up in one of two groups is to use the second Group node to reverse the sense of the first, with an expression like this:

```
1 - ch("/obj/dopnet1/static_
group/groupexpr0")
```

More Convenient DOPs Merging

When you merge objects in from a DOPs simulation (for example, into a SOP network that is part of a SOP Solver), you have to remember the magic syntax for extracting those objects. Since I know you've forgotten it, here it is:

```
`stamps("../OUT", "DATAPATH", "../..:*/Geometry")`
```

The trouble is, nobody can remember this. So don't try. Instead, put a SOP Network node into your DOPs Network, and then dive into the SOP Network, and put down an Object Merge. Then, in the Object 1 parameter line, enter the above expression. Now click on the gear icon and choose "Save Preset." Then just name this something useful, like "DOP Merge."

Now, whenever you drop an Object Merge into your SOP Solver network, just click on the Presets button, go to the end of the list and choose "DOP Merge." Easy peasy.

DATAPATH Revisited

In the previous tip, we used the "DATAPATH" constant in the stamps() function, to tell DOPs which aspect we wanted to merge in. Where did this magic string come from, and more important, are there others we should know about? Well, this comes from the SOP Solver, and in fact if you look at the helpcard for the SOP Solver, it explains that DATAPATH is one of several global parameters that are accessible in a SOP network with the stamp() or stamps() expression functions. The others are:

ST	Current simulation time
TIMESTEP	Length of timestep
OBJID	The object ID for the object being solved
DOPNET	The full path to the DOP Network that is being solved.

A good example is when you want to use an expression like dopfield() in the SOP Solver. In this case, you usually don't know the name or ID of the object you are processing. So how do you name it in the dopfield() expression? Like this:

```
dopfield("/obj/dopnet1", stamp("../OUT", "OBJID", 0),
  "Impacts", "Impacts", 0, "positionx")
```

The relevant part is the stamp() expression. Assuming that the last SOP in the chain you are processing is called "OUT," then this expression will deliver a new OBJID value for each object that is passed into the SOP Solver network.

The other arguments, such as "Impacts" and "positionx," are just for illustration – you should substitute in the names of whatever data it is that you are actually looking for.

Getting DOPs Positions to POPs

If you want to get RBD position data from DOPs to POPs, you use the dopoption() function in a Position POP (with y and z analogously):

```
dopoption("/obj/dopnet1", "rbdobj1", "Position", "tx")
```

Duplicate this for the Y and Z positions, using "ty" and "tz" as the last parameter, and then put the whole thing into a Position POP.

To get rotation information requires a bit more effort, however. The Rotation POP wants rotation specified as an axis and angle of rotation, but DOPs doesn't provide that format directly. Instead, DOPs provides rotation information either as quaternions (using "orientx/y/z/w" in place of tx in the above expression) or as Euler angles (using "rx/y/z"). Fortunately the conversion of a quaternion to an angle/axis value is pretty easy.

```
angle = acos(orientw) * 2
axis = normalize(orientx, orienty, orientz)
```

At least, the trigonometry is pretty easy. The syntax, on the other hand, takes a bit of typing. To use this information in the Rotation POP, you would put this expression into the Angle field:

```
acos(dopoption("/obj/dopnet1", $PT, "Position",
  "orientw"))*2
```

And this set of expressions into the Axis XYZ fields:

```
dopoption("/obj/dopnet1", $PT, "Position", "orientx")
dopoption("/obj/dopnet1", $PT, "Position", "orienty")
dopoption("/obj/dopnet1", $PT, "Position", "orientz")
```

Finally, you need to make sure that there is some kind of mapping from the DOPs objects to the particles. In the above example, we've assumed that there is one particle for each DOP object, so $PT in each expression will reference the appropriate DOPs object. Otherwise, you may want to name specific DOPs objects, for example, "rbdobject1."

Ungluing Objects

When using Glue Objects, it's important to understand that the glue bonds can only be broken by impacts caused from collisions. You can't get objects to come apart due to strong winds, or gravity, or stress from being twisted into different shapes. So what do you do when you want to get objects to unglue without collisions? Or, just as important, how do you control when objects come apart?

The answer is that you modify the Glue Strength yourself, based either on procedural considerations, or simply on keyframes that you set because that's what looks best. The easiest way to do this is to use the RBD State node to get access to the Glue Strength. Set the parameter menu to "Set Always," and then set keyframes on the Glue Strength. When you want the object to come unglued, change the value to 0. That's it!

Of course, you can base that value on something more complicated than keyframes – any expression can go in there, including one that looks to see if this object has collided with another, or passed a certain point in space, or whatever.

Picking Up Where You Left Off

You don't have to start a simulation at the beginning each time you run it. If you've been using the File DOP or the Dynamics ROP to write out .sim (simulation state) files, then you can use those to pick up again in the middle.

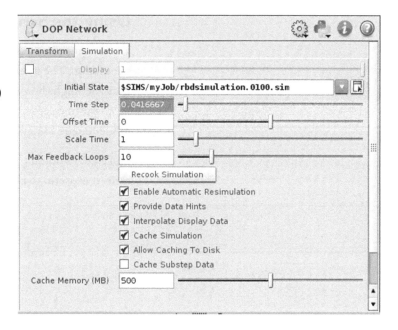

Firstly, if you want to continue a simulation from some frame, say 201, then you could use a File DOP to read in the .sim files, offset by 200 (which is the last successfully simulated frame). So the file name parameter would be something like:

```
myfile'$F+200'.sim
```

Alternatively, you may wish to use the end of one simulation as the starting point of another. You can easily do this in the Simulation tab of the DOP Network node itself. There is a parameter there called
Initial State. Just set this to the relevant .sim file, and everything will start from there. Of course, this only works if the object names and relationships are the same from one simulation to the other.

Using the Script Solver for Status

The Script Solver lets you run any hscript commands during a DOPs simulation. The intention is to be able to do any wild thing to the simulation that you might be able to think of. But one simple use of this is to provide a mechanism to get status about a running simulation, especially one that is on a render queue somewhere.

Since DOPs doesn't provide such status, and since simulations can take a long time, it is useful to be able to know what frame the simulation is on, how long the frames are taking and even if it is still a live process.

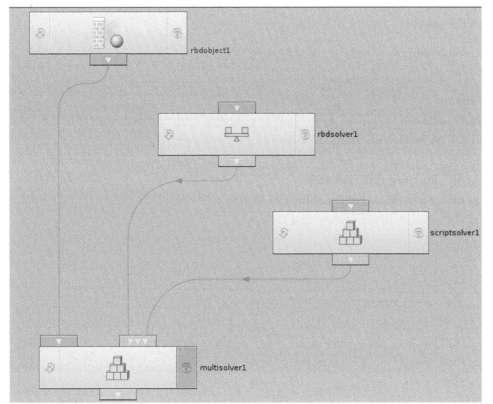

To do this, add a multisolver to some part of your network, and plug the solver you were using into it. Then plug a Script Solver in as well, making sure that the Script Solver is the last input. In both solvers, check the box marked Unique Data Name – by default, all solvers are simply named "Solver," and you don't want two solvers with the same name.

Then create two files – call them statusInit.cmd and status.cmd. Put the path to statusInit.cmd in the Initialization Script field of the Script Solver, and put the path to status.cmd in the Solve Script field. This is shown below.

(Continued)

Finally, here are the contents of these two extremely complex files:

status.cmd:

```
date >> /tmp/status
```

statusInit.cmd:

```
if $F == 1
echo "" > /tmp/status
end
```

The Init file needs the test for frame 1 because the Init file is actually run at every timestep, in case any new objects were created on that timestep. So we test to see if this is the start of the simulation, and if it is, clear out the contents of the status file. On every other timestep, we just write the result of the Houdini "date" command to the file. When we run the simulation, the contents of the file/tmp/status will be something like:

```
Frame 1: Tue Jan 24 20:36:43 PST 2006
Frame 2: Tue Jan 24 20:36:45 PST 2006
Frame 3: Tue Jan 24 20:36:45 PST 2006
Frame 4: Tue Jan 24 20:36:45 PST 2006
Frame 5: Tue Jan 24 20:36:45 PST 2006
Frame 6: Tue Jan 24 20:36:45 PST 2006
```

This tells us how long frames are taking, what frame we are currently on, etc.

For your own use, you'll want to adjust the name and location of the status file, and possibly the frame to initialize it on. And of course, the above is described for Linux, though if you are using cygwin on Windows, it will be very similar.

Calming Down a Simulation: Part 1

Put down an RBD State node. Now leave the mouse pointer over the Velocity label, and note that the popup says "Parameters: velx vely velz." This tells you the names of the velocity parameters.

One really useful thing to know about all such parameters is that you can use $name (for example, $velx) to refer to a parameter within a node. So if you put the expression:

```
$velx * 0.95
```

into the X velocity parameter, and do the same for Y and Z (using $vely and $velz, of course), and then set the Update Menu for the Velocity parameter to "Set Always," then the object(s) being modified by that node will slow down over time, as each frame the velocity will be set to 95% of what it was on the previous frame.

You can refer to any parameters in a given node in this way, even as you modify others. For example, you can use $tx (the X position) in the Y velocity field, if that has some meaning in your simulation.

Calming Down a Simulation: Part 2

Now that we know we can use variables like $velx to adjust the energy available to an object or set of objects, the next step is to create a spare channel on the RBD State node, and then animate that from 1 to 0 over whatever frame range, with whatever shape, might be best. Then use that like so:

```
$velx * ch("spare1")
```

Again, doing the same for Y and Z. And, most likely, for Angular Velocity as well, which, as you can see from the popup help, is called $angvelx, $angvely and $angvelz. This gives you even more control over the motion of a set of objects, since now you can keyframe the spare channel however you like.

If you want other nodes to also use this channel, then the reference there would be:

```
ch("../rbdstate1/spare1")
```

assuming that you used the default names for the node and the spare channel.

Offsetting Time

In the Simulation tab of the dopnet node, you can offset time. The first thing to know about this field is that it is measured in seconds, not frames. So if you want to offset your simulation by 10 frames, you need to put:

```
10/$FPS
```

into that parameter.

You can also use negative offsets; for example, −10/$FPS will start your simulation at frame −10. Also, keep in mind that these are offsets, not absolute start values. So if you offset your simulation by 10 frames, then objects that were created on frame 1, will be created on frame 11.

The other thing to know is that if your simulation is offset, that won't automatically change the creation times of your objects. So if your objects are all created on frame 1 (as they are by default), and you offset your simulation to frame 10, then you won't have any objects at all. That's because when DOPs begins the simulation, it will be frame 11. Only objects whose creation frame is 11 or greater will be created - the rest will have missed their chance.

So if you want to shift an entire simulation by some number of frames, you'll need to put an expression like:

```
1+ch("../timeoffset")*$FPS
```

into the creation frame parameter of every DOPs object. Alternatively, you can create a new variable, say $OFFSET, and put $OFFSET+1 into the creation frame field of every object, and $OFFSET/$FPS into the offset field of the dopfield node.

Animating RBD Objects

As you know, the RBD State node can be used to modify aspects of an RBD Object during the simulation. An important thing to be aware of, however, is that using the RBD State node to modify Position and Rotation values can cause problems, if you don't also take steps to update the Velocity (and/or Angular Velocity) values. That's because the RBD Solver won't be able to predict motion, and so collisions may turn out to be wrong.

The simple way to avoid problems is not to use the RBD State DOP for changing the positions of objects, and instead use the Motion DOP. This node has default expressions that automatically calculate the velocity values. Be sure and set those velocity values to "Set Always" as well, or it won't work properly.

Speeding up Cloth Sims

Cloth simulations can be slow to calculate. Here are several places to modify parameters and settings, in order to get quicker simulations. Of course, quicker almost always means less accurate, so consider these ways to speed up the process of getting close to what you want. After you get close, you can go back to slower, more accurate simulations for the last few tweaks.

Cloth Object, Collisions tab

Self-Collisions: These are expensive. Avoid computing them as long as you can.

Cloth Solver

Maximum Substeps: Set this to 16, or even less, to speed up the simulation

Maximum Strain Rate: Make this smaller to increase the speed. Try 0.025 and see what you get.

Cloth Geometry

The single biggest improvement you can make to increase the speed is to reduce the number of triangles in your cloth object(s). Try creating a low-res proxy version for early testing, and then switching to a higher resolution model as you get closer.

Setting Up Hair Constraints

There are two ways to constrain hair, but by far the simplest is this: In the SOP network that creates the hairs, simply group the points that are supposed to be constrained (that is, the root points). Name this group something, say "roots." Then in the DOP network, use a Wire Glue Group Constraint node, and set the Point Group field to "roots" (no quotes). Easy as that.

Door Hinges and See-Saws

People often want to create hinged doors or see-saws in DOPs. The trick to this is simple – it's two hard constraints at the edge of the door. For a door, they are on the same edge. For a see-saw, they are on opposite edges. Or, you can use the new RBD Hinge Constraint node.

Getting Particles into Sims

The POP Solver sends all the geometry that is attached to the object(s) that it solves, to a POP network. That geometry can come from a particle system, or it can come from an RBD Object or any other mechanism that gets Geometry data attached to an object. It is also possible to send no geometry at all to the POP network, and just return with the results of the particle simulation. In that case, you can just attach the POP Solver to an Empty Object, point the POP Solver to your POP network, and you're done. So all of the following are valid.

Not only is the geometry optional, but so is the POP Network. You can bring in geometry as a POP Object, and as long as you make sure there are velocities on the points, then you can use a POP Solver with no POP Network, and still have the geometry react to other objects in the simulation.

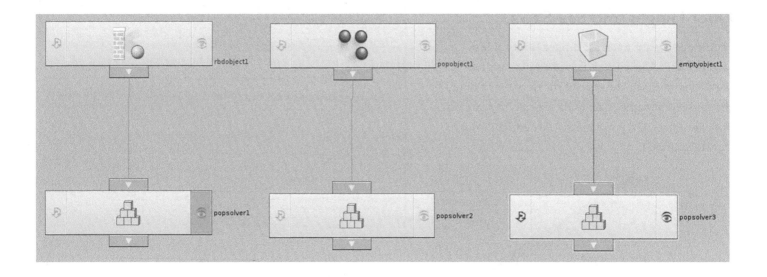

Setting up Soft Bodies

You can use the particles in DOPs to simulate softbody objects, like jello or balloons. The generic setup is pretty simple:

- Use a POP Object to bring in your geometry

- Attach that to the first input of a POP Shape Match DOP

- Connect that to a POP Solver

Then create the rest of your simulation, with forces and other objects. For example, attach Gravity to the POP Solver, and then merge that with a Ground Plane. Now by adjusting the three strength parameters in the POP Shape Match, you can change the squishiness factor.

DOP Geometry Syntax

The syntax for reaching into a DOP simulation and extracting geometry, works anyplace in Houdini that you are asked to provide a SOP path. So, for example, if you are in POPs and want to use the Source POP to bring in some geometry from a DOPs object called 'ball,' you can do that directly with this syntax:

```
/obj/dopnet1:ball/Geometry
```

You can even do this in the Geometry ROP, but be warned: in that context, the geometry you write out will be untransformed by the DOP simulation, which is unlikely to be what you want. If you want to write geometry from a DOP simulation to disk, you need to pass it through an Object Merge or DOP Transform SOP first, and then reference that SOP in your Geometry ROP.

I've Been Hit!

It's common to want to know when an object has been hit by another object, as a signal to do something in your simulation (or elsewhere in Houdini, for that matter). The test for this is the dopnumrecords() function. The usage would be:

```
dopnumrecords("/obj/dopnet1", "objectname", "Impacts",
  "Impacts")
```

where you would substitute the name of the object you are interested in for "objectname" and the name of the DOPs network for "/obj/dopnet1."

One confusing aspect of this is that impact data only exists on the frames where impacts occur. But users frequently want to know if an impact has ever occurred, and that information is not directly available.

The simple workaround to get this information is to use the Modify Data DOP to create a boolean variable and set its value to 1. Then set the Activation to be based on dopnumrecords() – when that has a value of 1 (or more), the variable will be created, and nothing will ever set it back to 0. So you can test it throughout the sim and get the right answer. You can also use a version of this technique to record the frame number (or time) when an impact occurred, which is another common request.

Once you know that there are impacts, you can use the dopfield() command to get the ID of the object that hit you (if you need it), or get the size of the impacts, or whatever you need to know.

Importing Motion

What if you have an object that has motion at the Object transform level, and you want to import that motion into DOPs? For example, you want to fly a plane around for a while, keyframing it as normal, until the moment when you release it into the DOPs simulation. To do this, you have several choices.

1 The Object Position operator. This will take the external motion of an object and import it into the channels of a DOPs object. In order to get this to work properly, you may need to follow it with an Active Value node, making sure that while the motion of the object is coming from the keyframes, the Active Value is zero. Then when you release the object into the simulation, set the Active Value to one, so that the RBD Solver can take over.

2 The Motion operator. This is a version of the RBD State operator, but it has some built-in expressions to make sure that the object's velocities are being

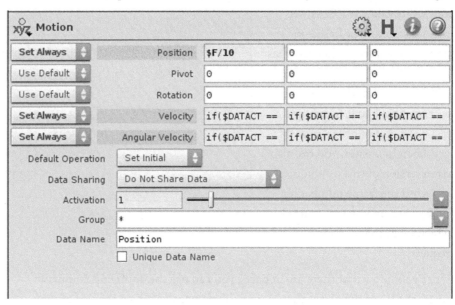

(Continued)

calculated properly. You can use this node, and set the Position and/or Rotation values to whatever other channel values you need. Just make sure to set the parameter modes on each of them to "Set Always."

❸ The RBD Keyframe Active node. This allows you to set the Active flag and the position values all in the same operator. When the Positions are being explicitly set (for example, they are coming from outside of DOPs), then the Object Active Value should be zero. You can keyframe the position and rotation values directly in the parameter fields of this node during this time. When the object is part of the simulation, then the value should be one.

Getting DOPs Variables into SOPs

What if you are building a SOP Solver network, and in there you find that it is necessary to use a DOPs variable like $SF. The problem is, these variables (and many others) are only defined in the DOPs context, so that when your SOP Solver network is executing, they are undefined. What to do?

Use the Modify Data DOP, and add the relevant value to your object, while it is in the DOP network. Then, in the SOP Solver network, extract it again with the doprecord() expression function.

For example, here is a DOP that shoves the value of $SF into a field that is part of the Position data record. And then in the SOP network, this information is retrieved with this expression:

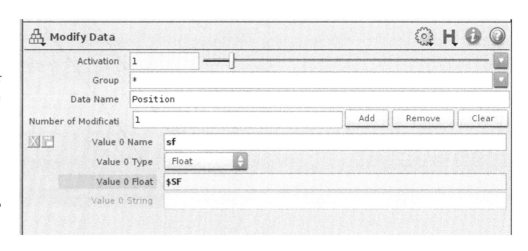

`dopoption("/obj/dopnet1", "label", "Position", "sf")`

The dopfield() Function Explained

It can be tricky to understand how to use the dopfield() and dopoption() functions to extract values from a DOPs simulation. Here's how it works.

First of all, let's remind ourselves what the dopfield() function looks like. The syntax given by exhelp is:

```
dopfield (dopnet, object,  subDataName, recordType,
  recordNum, fieldName)
```

The dopfield() Function Explained (Continued)

Where all the values are strings except the recordNum, which is (wait for it) a number.

If we compare this to the Details View of a simple simulation, with an object named "box," then we can see how these arguments line up with the simulation tree.

The tricky thing comes when you want data items that are further into the tree. For example, say you want to extract the Gravity value. The tree view looks like this:

Then the dopfield() command to get the value would be:

```
dopfield("/obj/dopnet1", "box", "Forces/Gravity", "Options",
   0, "forcey")
```

What about the recordNum? Well, mostly that is 0, because most data only has one record. The obvious exception to this is Impacts data, because when objects collide, there often are many subimpacts recorded. You can see that in the lower illustration:

The dopfield() Function Explained (Continued)

As another hint, you should use dopoption() and dopoptions() whenever you can. These expressions are identical to dopfield but they assume that the record name is "Options" and the record number is 0. This is almost always what you want. Thus the first example we gave would simplify to:

```
dopoption("/obj/dopnet1", "box", "Position", "ty")
```

which is less to type and easier to read.

Getting Data out of DOPs

There are lots of ways to get information out of DOPs:

- Object Merge can extract one or many Geometry data.

- DOP Transform SOP can extract transform and velocity information from DOPs and apply it to existing SOP geometry (see the helpcard example).

- The dopfield expression (in combination with the other dop expressions – do "help dop" to see them all) can extract basically any information available in the tree that shows up for DOPs in the Details View pane.

- Dynamics Channel Operator (CHOP) can extract pretty much any data available through dopfield expressions, but it can extract a whole bunch of fields at once using wildcards, and can extract the data through the whole simulation to create an animation curve from any data available through dopfield. See the helpcard example file for this CHOP.

- SOP expressions can reference DOP geometry data directly.

- The Geometry CHOP can reference DOP geometry directly.

- The Fetch Object can extract the transform from DOP Position data directly.

- POPs that take a SOP path can accept a path to DOP Geometry data.

- The Geometry ROP will accept a path to DOP Geometry data.

- The Dynamics ROP can save entire simulation states to disk. The File DOP and File Data DOP allow saving and loading of entire simulation states and individual pieces of simulation data, respectively.

So there are a bunch of ways to extract DOP data. Geometry and Position data have the most specialized Ops to help in that extraction, but then there is the dopfield expression and the Dynamics CHOP to let you get at everything else (though perhaps with a bit less elegance).

Adding Custom Geometry

DOPs works with data, and the geometry that describes your incoming object is just more data. One interesting feature of DOPs is that you can bring in objects with arbitrary amounts and kinds of data, and then create yet more data, and each operator will only work with the data it recognizes and needs. It will ignore the rest.

One particular aspect of this is that you can add extra geometry to your DOPs objects, and then just carry that geometry around, where it can be used afterwards. Or it can be processed by DOPs. There are a few simple steps:

- Put down an Apply Data DOP, and connect it to your object.

- Create a SOP Geometry DOP. Reference the geometry that you want. Then set Data Name to something unique (in that object) – by default, it's called Geometry, which means that it will be transformed by any solvers that act on this geometry. You probably don't want that, so call it something else.

- Attach the SOP Geometry node to the data (green) connector of the Apply Data.

The name of the geometry is important. By default, any data called "Geometry" is displayed and rendered. By default other geometry, that is called something else, is not displayed and not rendered. If you want to have your other geometry data show up in the viewport, you'll have to attach a Rendering Parameters data to that geometry, and set the values accordingly.

Vector Syntax

To get a vector value off of DOP simulation data, do:

```
vector(dopoptions("dopnet", "object", "Position", "t"))
```

Note that you have to use dopoptions not dopoption because you need to have it return a string in proper expression language vector format.

For example in a Modify Data, to extract a vector from one place and store it in another, you would name it "bla," say its type is 3Vector, and then use that expression in the value string.

To simply get a vector into that field, you would do this:

```
`vector("[1, 2, 3]")`
```

To extract a piece of a vector in order to create a new one, you would do this:

```
`{
float y = dopoption(".", $OBJID, "Position", "vely");
return "["+1+","+y+","+3+"]";
}`
```

Note the backticks.

ON THE SPOT

Giving Assets a Representative Type

Quicker Asset Handles

Self-Grouping Assets

Icons for Assets

Web References for Asset Help

Watch Out for Locked Ranges

Custom Help

Expanding Operator Type Library Files

Non-graphical Mode

Custom Names for Libraries

Dynamic Menus

Running Scripts on Startup

Pushing Buttons

Embedded Assets

What Assets Have I Got?

Versioning Assets

Custom Contents

Controlling Tab Selection

Invisible Preferences

What's Linked?

Disable When

Custom Expressions

Add Multiparms to an HDA

Where Did I Come From?

Hiding Extra Tabs

Embedding Presets

CHAPTER 5

Digital Assets

Houdini Digital Assets (HDAs) are an extremely powerful way of extending Houdini. With these, you can package up all kinds of custom tools and hand them off to other users, or to yourself, for later use. You can hide the grimy details, so that the user just deals with the problem as he would like to think of it. You can embed any arbitrary data, including scripts, images or a list of all your favorite pizza restaurants – they don't care. This chapter deals with getting more out of these amazing tools.

Giving Assets a Representative Type

When you create a digital asset that is meant to be a custom camera or light, you would like to see that object appear in menus where cameras (or lights) are expected. To get this to happen, use the "Representative Node" option in the first page of the Operator Type Properties dialog. Choose one of the cameras in your asset, and your object will appear in menus as if it were a camera, as well as behaving correctly in the bundle manager and any other situations where a camera is called for.

To give your new camera a professional finish, you need to hide the original camera that is inside your asset, so that only the asset itself appears in the camera menu. Select the camera node inside the asset, and then hit <shift>-d (or RMB (right mouse button) on the worksheet, and from the menu, choose "Hide Selected"). Now you are all set. (*Note*: if you hide the wrong thing, <shift>-e will reveal all the hidden nodes).

If you want your custom camera (or light) to have the same handles as a regular camera, you have to export the handles. You do this in the Handles tab of the Operator Type Properties window. Choose Camera from the Create Handle menu (or Light, as the case may be) and you'll get all the possible parameters. Now connect those parameters to the parameters of your asset, and the interactive handles will adjust the values accordingly.

However, see the next tip for a quicker way...

Quicker Asset Handles

When you build an asset that is based on an object (for example, a Geo Object or a Light), then you can get all the handles exported at once, by doing this:

- open the Operator Type Properties dialog (RMB on the node, bottom entry);

- go into the asset;

- select the representative type (for example, the camera node inside the asset);

- put the cursor into the viewport;

- hit <enter> to get the interactive handle(s);

- put the cursor on a handle, and RMB. From the menu, choose "Export Handle to Type Properties;"

- That's it – now all the handles will be exported *and connected up* in one step.

Self-Grouping Assets

You can use the "on created" event to execute a script that adds an asset to a bundle, using the "opbadd" and "opbop" commands. For example, you could have all your custom lights add themselves to the @all_lights bundle with this:

```
opbadd all_lights # create the bundle
opbop all_lights set /obj/my_light_* # set it to the lights
```

assuming that all your custom lights began with the string "my_light._"

Icons for Assets

A custom asset isn't complete until it has its own icon. To add an icon, click on the icon labeled Icon in the Basic tab of the Operator Type Properties dialog. Then, you have some options:

- You can just borrow existing icons from Houdini. For example, the light icon for your custom light. You can find the Houdini icons at $HH/config/Icons and more at $HH/config/Icons/Sample

- You can use any image format that Houdini supports as an icon. It should be fairly small (100 × 100), square and in 8-bit RGB format (but these are just guidelines for reasonable display performance – any image will work). PNG is a good format here.

- You can use any program that creates Scalable Vector Graphics (SVG) files (such as Inkscape) and create them that way. These vector-based icons will obviously scale better than the bit map images of method 1 above. The Houdini icons are SVG files which are based on the Tango style, found at tango.freedesktop.org. You can also find lots of sample icons there.

- If you really want to go old-school, you can convert geometry to .icon format and use that. You use the gicon utility for that .gicon ships with Houdini, and it takes a .bgeo file and turns it into a .icon file. Type "gicon" on the command line to get more information.

Web References for Asset Help

You can have the help page of your digital asset simply refer to another URL. You might do this if, for example, your facility had a wiki, and you wanted to keep all the helpcards for your custom assets available on the wiki. Then you would just point each node's help page to the appropriate internal page, and be done. To do this, simply check the "Use this URL" box at the bottom of the Help tab in the Operator Type Properties dialog, and then put in the appropriate location. See the illustration.

Watch Out for Locked Ranges

Not so much a tip, as a warning – if you build an asset with a parameter whose range is locked, you can still get into trouble. Say for example you lock a value to be in the range 1–10.

This means that the slider associated with that value will not permit the user to go past 1 in the smaller direction, and 10 in the higher direction. So far, so good. However, if the user types a value in the parameter box that is outside the range, you can get into trouble. That's because two things happen, one of them invisible: the first thing that happens is that the value is clipped to the closest allowed value – so if the user types 15, then the value is actually displayed as 10, which is the closest allowed value.

But the value of 15 is still stored in the parameter. That means that if, at some future date, you change the allowable range to include 15, this parameter will "magically" jump to 15, because that is now a legal value. This hidden surprise could change the behavior of a hip file in ways that will be very hard to track down, since the file will seem to suddenly behave differently, even though you haven't changed any values.

Custom Help

New for Nine!

The mechanism for creating helpcard text has completely changed in Houdini 9 – it has moved to a wiki approach. That means that you can create your own helpcards with some very simple syntax, and this is the same syntax that the shipped helpcards use.

The best way to figure out how to create your own helpcard is to start from one that is close, and modify it. You'll find the helpcard text files in $HFS/mozilla/documents/nodes/ and then look in the appropriate directory for the type of node, such as POP or SOP. Here's a quick overview of some common syntax:

Metadata: each card starts with several lines of metadata. Each metadata property starts with a number sign (#) and is separated from the value with a colon (:)

```
#type: node
#context: sop
```

Headings and tabs are done with the equal sign (=), like so:

```
= Asset Name =
== Tab name ==
=== Sub-tab name ===
```

The short description of the node is set in italics with the triple double-quote (")

```
""" text """
```

This text is also extracted to be used as the tooltip if the node is place on the shelf, so keep that short.

(Continued)

Section names begin with the at sign (@), such as:

```
@parameters
@locals
```

Other helpcards are referenced with this syntax:

```
[Linking text | Node:dop/volumecollider]
```

You can create a tip with the keyword TIP, like this:

TIP:

This is the tip text

The illustration shows some of these features being used. This is the text that created the helpcard shown here:

```
= Node Name =
"""Short Description"""

Some text describing your asset.

@parameters

This is the parameters section.

== Tab Name ==
* Bullet point
* Another bullet point
=== Subtab Name ===
  Description of parameters
# Numbered list
# of items

TIP:

You can put a tip into a box like this.

@locals

TX, TY, TZ:

Some local variables
```

Expanding Operator Type Library Files

Many people know that you can expand the contents of a Houdini hip file by using the "hexpand" command. However, what you may not know is that there is an equivalent for Operator Type Libraries (OTLs), called "hotl."

However, when you use "hotl," you'll notice that the contents of the .otl file are sometimes gzipped before they are saved. The contents section is really just a CPIO packet, like it is in a hip file, and can be expanded with hexpand as usual. But if it is gzipped you have to do a little more work.

The first thing you can do, is not gzip your contents (that's controlled from the "Compress Contents" toggle on the Basic folder in the Type Properties dialog). The second thing you can do is manually unzip your Contents.gz file with the gunzip command. However what you get out of that is not yet ready for hexpand. Houdini uses a 4-byte header in the Contents file to store the size of the section. To strip those bytes you can use a handy utility available on most Linux systems:

```
dd bs=4 skip=1 of=contents.hip if=Contents
```

This will take your unzipped Contents section and produce a contents.hip file which you can then hexpand. Sure it's obscure, but someday, you'll thank me!

Non-graphical Mode

It is often useful to use different functions depending on whether or not your script is running in a Houdini graphical session or an hbatch (non-graphical) session. You can switch the function on the fly without having to code the logic throughout your script. Try this:

```
if (`arg(run("version"), 0)` == "Houdini")
  set notifier = "message [houdini]"
else
  set notifier = "echo [hbatch]"
endif
```

Now in your script if you want to issue a message just use

```
$notifier "hello"
```

When running from Houdini it will pop up a message box, but if the same script runs in non-graphical Houdini (hbatch), it will echo the message to the terminal.

Custom Names for Libraries

You can give a descriptive name to the location of a set of OTLs , and then use that name to refer to that set. For example, a default location for OTL files is $HOME/houdini9.0/otls. You can name that location "My Libraries" with the otrenamesource command in a Houdini textport, like this:

```
otrenamesource $HOME/houdini9.0/otls "My Libraries"
```

If you look in $HOME/houdini9.0/otls after you issue the command, you'll see a file called OPlibraries. Inside it will be the name "My Libraries." In this way you can name several locations that you might want to store OTL files. Then when using any of otload, otunload or otrefresh, you just specify your more meaningful string. You can also see this being used when you install an OTL through the dialog, and in the Operator Type Manager dialog.

Dynamic Menus

You can create menus whose contents are determined on the fly with a little bit of scripting. In the Menu tab of the parameter, check the "Use Menu" box and also the "Menu Script" radio button. This lets you put some hscript in there to create the menu.

The menu itself is created by echoing pairs of values representing the menu value and the menu text. For example, say you wanted to create a menu that let the user choose one of the current object nodes. Then you could use these lines to do it.

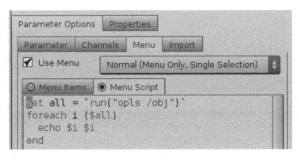

```
# set a variable that holds a list of all the menu
entries
set all = `run("opls /obj")`
# run a loop that echoes back each entry twice since
the menu
# needs a token and a label for each menu item.
foreach i ($all)
  echo $i $i
end
```

This script creates a menu entry for each node in /obj. Of course, you can create more complex filtering mechanisms, such as just listing the Mantra ROPs, etc.

The tricky bit is that you have to have a pair of each entry, one for the "token" that actually gets used by the menu, and another for the Label part of the menu. That's what the foreach loop is doing. And labels with spaces in them are tricky to create, so avoid those.

Running Scripts on Startup

Now that Houdini 9 allows you to execute a python script whenever Houdini starts up, this tip is less necessary, but it's still an interesting way to do some things. If you want to run a script every time Houdini loads, another way to do that is to create an empty digital asset, and put something into the OnLoad script area. For example, you could pop up a new Custom Panels pane, or force your networks to auto-layout (which might be a fun practical joke to play on someone else – I sure wouldn't want my nodes moved around every time I opened up Houdini!).

And yet another way to accomplish this is to use the 456.cmd script file (see the chapter on Configuration tips).

Pushing Buttons

Frequently, people want to create scripts that perform an action that is the equivalent of the user pushing a button. For example, say you have a complex asset that includes a Geometry ROP, and you want to give the user the ability to execute that ROP from the interface.

Just have your script "push the button" by specifying the "-C" option, like this:

```
opparm -C geo_out execute ( 1 )
```

Of course, you can also do this in hscripts that are not part of a digital asset.

Embedded Assets

When you are first creating an asset, the dialog asks you the name of the library to save it to. This is normally an .otl file, but there is another option. You can type the word "Embedded" on that line, without the quotes, and that will embed the asset in that particular hip file only.

This is useful for testing ideas without putting them on disk, or for making sure that a .hip file has access to an asset, perhaps because you are going to send the file to someone. Of course, the disadvantage is that you cannot use the asset in another .hip file.

What Assets Have I Got?

In the textport, type:

```
> otls
```

to get a list of currently installed assets, and the libraries they live in. You can also specify an .otl file to see the contents of it. For example:

```
> otls OBJ_ONLOAD_RUNSCRIPT.otl
Loaded from: Current HIP File
Object/pjb_ONLOAD
```

Assets create operators, and the operators are stored in tables, one table for each type. So the above listing tells us that the table is Object and the operator is pjb_ONLOAD.

```
> otls $HFS/houdini/otls/OPlibPop.otl
Loaded from: Standard Libraries ($HFS/houdini)
  Pop/sprinkler
  Pop/fireworks
```

Versioning Assets

You can give any asset a version number of your own devising, to use in whatever versioning scheme you've got. You use the "otversion" command for this. The use is:

```
> otversion <table>/<op>
```

which prints the current version

```
> otversion -d <table>/<op>
```

this clears the version

```
> otversion <table>/<op> <version>
```

and this sets the current version to be <version>

The <table> is one of

Object	Object level operators
SOP	Geometry operators
Particle	Particle network operators
POP	Particle operators (POPs)
ChopNet	Channel network operators
CHOP	Channel operators
Driver	Output operators (ROPs)
SHOP	Shader operators
COP2	Composite operators
CopNet	Composite network operators
VOP	VEX operators
VopNet	VEX network operators

The <op> is the name of your operator. One place to find that is in the Operator Type Properties dialog of the asset, on the Basic tab – the very first parameter is the name. Another way to find the name is to use the otls

(Continued)

command (see the previous tip) – this will give you the information you need. With a combination of otls and otversion, you could write a simple hscript that looked in all your assets and reported back on the versions, for further use in your own asset management system.

Custom Contents

Digital Assets can contain whatever custom information you want, such as images and scripts. To get them into the asset, use the Extra Files tab of the Operator Type Properties dialog. Just go point to the file, and then click on Add File.

To refer to this information elsewhere in Houdini, you would put an expression like this into the relevant parameter:

```
opdef:/Sop/mynode?mypicture.jpg
```

This assumes, of course, that you've loaded an image into your HDA, and stored it as "mypicture.jpg." It assumes that you've named your asset "mynode." And it also assumes that you are creating a Surface Operator (SOP) type asset (that's why the path begins "/Sop") – for other types of assets, you'll use a different context. You can find out what the path should be by looking at your HDA in the Operator Type Manager dialog – the context is shown next to the name.

Controlling Tab Selection

All nodes have a parameter called stdswitcher, which is used to save the state of the parameter dialog for the node. In particular, it tells Houdini which tab you were on when you saved the hip file. You can use this to control which tab your asset dialog opens up on when it is selected (or created).

To see this, open a textport, and then type:

```
> opscript <node>
```

where <node> is the path to your node. You should get something like this:

```
...
opparm geo1 stdswitcher (2 2 2) keeppos ( off ) pre_xform
( clean ) ...
...
```

The number of digits in the stdswitcher option corresponds to the number of tabs in the dialog, and the digit shown is the index to the tab that was selected when you ran the command (numbering from zero). In the above example, there are 3 digits in the parentheses, so the node has 3 tabs. The digit itself is 2, so the node is currently set to look at tab 2. Tabs are numbered from zero.

So if you want your asset to open on tab 3 when it is selected by the user, you would put this command into your select script:

```
opparm stdswitcher (3 3 3 3)
```

Invisible Preferences

By default, invisible parameters will also revert to their default values when the user does "Revert to Defaults" on your custom node. But you may not want that to happen. For example, if you were using an invisible integer value to act as a trigger for something, then you would want to retain control over that parameter's value. To prevent the value of invisible parameters changing, you can unset the appropriate toggle in the *Edit → Preferences → Miscellaneous* preference dialog.

What's Linked?

To see a full list of what's linked to a particular channel, look in the Channels sub-tab of the Parameters tab, in the Operator Type Properties dialog. Click on the downward-pointing arrow button next to each channel. That will bring up a menu that includes (among other things) every channel in the link field.

Disable When

New for Nine!

The Disable When syntax has been greatly enhanced in Houdini 9. Now all of the following are supported:

==	Equal
!=	Not equal
<=	Less than or equal
>=	Greater than or equal
<	Less than
>	Greater than

The operations involving "<" and ">" always convert the parameter value to a float to do the comparison. You can still put no explicit operator and get "==" behavior. The "^" operator is no longer supported.

Custom Expressions

New For Nine!

In Houdini 8.1, you could define custom expressions inside your Digital Asset, but you had to do it on the sly, by putting the definition into the Events tab, and using Before First Create. But in Houdini 9, the Type Properties Dialog has a Scripts tab, and you can define your custom expressions in there.

And here's a handy hint: you can rename Houdini expressions with long names, just by calling them from your own, shorter-named expression. For example:

```
string opip( string name, float index )
{
  return opinputpath(name, index);
}
```

Add Multiparms to an HDA

New for Nine!

Houdini 9 lets you create and link multiparm parameters in a digital asset. Multiparms are parameters with no fixed number of instances. One example is in the Add SOP, which lets you add any number of new points – the widget that lets you add (or remove) another point is a multiparm. You can now mimic this behavior in your digital assets.

Here's an example of what this means and how to do it.

- Put down an Add SOP. <shift>-C on it, so that it becomes a subnet.

- RMB on the subnet, and choose "Create Digital Asset." Give it a sensible name, and hit Accept.

- You'll get the Type Properties dialog. Go to the "Parameters" tab.

- Go into the subnet you made, and drag the "Number of Points" parameter from the Points tab of the Add SOP, over to the Parameter tab of the Type Properties dialog. Drop it there. You'll see a bunch of parameters get installed and set up.

- Hit Accept, and then go back up to the digital asset. It will now have a "Number of Points" parameter in its parameter pane. Change the value from 0 to 3. Yippee!

One place this instantly becomes useful is in adding Deep Raster support to all your ROP digital assets.

Where Did I Come From?

New for Nine!

You can display in each digital asset the source of that particular asset. This is handy if you have multiple versions of an asset; making sure you are using the right one is important. It also helps to be able to see if the asset is Embedded or not.

To turn this on, go to *Windows → Operator Type Manager...*, and in the Configuration tab, at the bottom, set the Operator Type Bar menu to Display Menu of All Definitions. Now put down a Rigid Body Dynamics (RBD) Object node in a Dynamic Operators (DOPs) network, and notice that in the parameter pane, it tells you that this asset is coming from $HH/otls/OPlibDop.otl.

Hiding Extra Tabs

There is an option in the Basic tab of the Operator Type Properties dialog, "Hide Default Parameters." This option isn't used enough in digital assets.

When it is selected, instead of getting the default Transform and Subnet tabs in the User Interface (UI) for your asset, you'll only get the parameters that you define from the Parameters tab.

This makes assets much cleaner, and it makes them look like every other Houdini node. Note that this option only applies for assets that create Objects, CHOPs and ROPs – for assets of other types, it is disabled.

Embedding Presets

You can embed presets into your HDA. To do this, first create a presets file for your asset, just the way you would create presets for any other Houdini node (namely, by using the drop-down menu under the gear icon in the parameter pane of your asset).

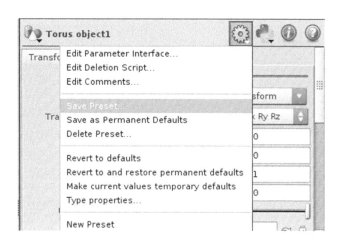

That will create an ".idx" file in $HOME/houdini9.0/presets. Reopen the Type Properties dialog on your asset, and go to the Extra Files tab. Create a new section called Presets, and navigate to the .idx file as the contents of that section. Then click on Add File. Finally, hit Accept.

The embedded presets should be picked up automatically when the asset is loaded, even if the original .idx file is not in the houdini9.0/presets directory (which would be the case if you handed this asset off to another Houdini user).

ON THE SPOT

Rendering

This chapter includes hints on using Mantra (Houdini's own renderer), as well as RenderMan and Mental Ray. There are also nifty tips related to creating and using shaders. Houdini 9 has new rendering support for Physically Based Rendering (PBR), as well as volume rendering and improved motion blur. In addition, it has become very easy to add custom support for new renderers and lighting models. All in all, it's an exciting leap forward.

Quick Access to Shader Parameters

If you <ctrl>-LMB (left mouse button) on any jump icon that refers to some other operator, then the parameter pane for that operator will open up in a popup dialog. For example, go to the Material Properties parameter of a geometry object, and <ctrl>-LMB on the icon – you'll get a floating window of the standard properties operator defined for that object.

A Smaller Render Menu

As you add Render Operators (ROPs), you increase the length of the render menu in the viewport. But you may have lots of ROPs that are intended as layers, or sub-renders, that you don't want to see cluttering up that menu. The way to get rid of them is to simply hide them in the ROP Network, by selecting them and doing <shift>-d. You can bring them back again with <shift>-e.

Using Mental Ray Shaders

Part of the Houdini distribution is a utility program called "mids" which converts a Mental Image .mi file into a Houdini dialog script. Even better, it can just keep going and create a digital asset, and store that asset in an .otl file. To do this, simply do this on the command line:

```
% mids -l OPmi_library.otl myshader.mi
```

where of course OPmi_library.otl is whatever file name you want, and myshader.mi is one or more .mi shader files. Wildcards also work, so you could do:

```
% mids -l MI_Chrome.otl *chrome.mi
```

Then you put the .otl file in your path, or install it manually into your Houdini session, using the File menu entry "Install Digital Asset Library ..."

Assigning Shaders Quickly

To assign a shader to an object, just create the shader in the SHOP network, then drag it to the viewport and drop it on the object you want to assign it to. Choose the first option from the menu that comes up, and you're done!

Smarter Rendering

If you have a lot of geometry to render, then you can usually speed this up with a couple of tricks. First, render the geometry from a file, rather than from Houdini. This uses less memory and is more efficient. Second, use the bounding box feature, so that mantra can decide in advance whether or not it even needs to load a certain object – and whether it can unload it in mid-render.

In Houdini 9, you do both of these things at the same time. First, go to a Shader Network, such as /shop, and put down a Mantra Delayed Load SHOP. In the Main tab, specify the name of the file you want to render. Then in the IFD Bounds tab, you can specify a bounding box. The default is Explicit Bounds, in which case you have to specify a bounding box in the Min Bounds/Max Bounds parameter areas.

A better choice, however, is Specified By SOP's Bounding Box. This allows you to use a Box SOP to define a bounding box for your geometry, set the render flag on that SOP, and then point to the file you want. Then the whole thing will be handled automatically. If you display the Box SOP as well, then you can interactively position the geometry it represents very quickly.

Properties

New For Nine!

An important new concept for Houdini 9 is that of Properties. Properties are collections of rendering and viewing parameters – but because they come from operators, you can have multiple objects (or cameras or lights) refer to the same operator, and therefore share the same set of properties. Some properties are common to all renderers, and some are specific to individual renderers. This simplifies a lot of things, though it also adds a layer of indirection that is important to understand.

If you go to /out, put down a default Mantra ROP, and go to its parameters, you'll see that the Properties tab has a parameter at the top called Default Properties. This can point to a Properties node that will define the render properties for this instance of Mantra. The Properties node will be defined in a /shop network. To see how this works, do this:

- Go to /shop, and put down a Properties node. Note that it has no parameters at all. In its parameters, go to the gear icon, and choose Edit Parameter Interface…

- Look in the Optional Rendering Parameters tab. There is a list of renderers that the properties support. My, there certainly are a lot of them.

- Now expand the mantra9.0 folder, and look inside. My goodness, look at all the various parameters and attributes that mantra can understand, and that you can add to a Properties SHOP.

- Open the Shading folder. RMB on the Refraction Mask property. Choose Install Parameter, and then hit Accept. Notice that in the Shading folder of the parameter pane, you now have access to a new parameter, called Refraction Mask.

(Continued)

- Similarly, you can see all the attributes for other renderers, such as RenderMan.

Once you've created a set of shading parameters that you want, you can reference this Property node from any and all Mantra nodes anywhere in your hip file, so that you only have to create this custom set one time.

Custom Deep Raster Info

You can write other object attributes to deep raster planes, even if that information is not in the Variable Name menu list of the Mantra ROP. To do it, you need to do three things:

❶ The value you export must be a parameter to the shader (which means that you will have to create your own shader).

❷ You need to use the "export" tag when declaring the shader parameter.

❸ The class of the variable has to be set properly in the ROP Output Driver.

So to be able to write out an arbitrary vector parameter, called vparm, here is how you would declare this in your shader:

```
#pragma hint vparm hidden
surface
myshader( export vector vparm = {0, 0, 0} )
{
}
```

The #pragma above the shader declaration is added to hide the parameter from the interface. This is optional, but generally exported parameters are not ones that users are manipulating.

You can also easily do this if your shader is being built in VEX operators (VOPs), with the Export Parameter checkbox in the Parameter VOP.

Finally, the ROP needs to set this up as a vector, as shown.

Note that the name that is exported (Variable Name) must match the name given in the ROP – it must be "vparm" in both cases.

Rendering on Fields

To render on fields, you need to add the appropriate property:

- Go to the /out editor, and put down a Mantra ROP.
- Pull down the gear icon menu, and choose the first entry: Edit Parameter Interface.
- On the right side of the dialog, click on the Optional Rendering Parameters tab, and open the mantra9.0 folder.

(Continued)

- Inside the mantra9.0 folder, open the Output folder. Find the entry called Video Field (near the bottom of the list).

- RMB on this entry, and select Install Parameter to Output Folder. Hit Accept.

- In the Mantra ROP's parameters, in the Properties tab, the Output sub-tab should now show you a new control, for setting video field rendering. This will be near the bottom of the parameters.

This workflow is reasonably straightforward, but you can avoid it by creating your own custom mantra ROP that includes field rendering (or anything else you want) by default. Also note that in the Edit Parameter Interface dialog, you can grab the new Video Field parameter (or any other one) on the left side of the interface, and move it up or down to anyplace in the parameter pane layout. So you can make parameters more or less obvious for yourself or other users.

i3D Format Change

New For Nine!

The image3D file format has been updated in Houdini 9. To be able to use i3D files generated by a previous version of Houdini, you'll need to run a conversion, like this:

```
% i3dconvert -u oldfile newfile
```

to update each file.

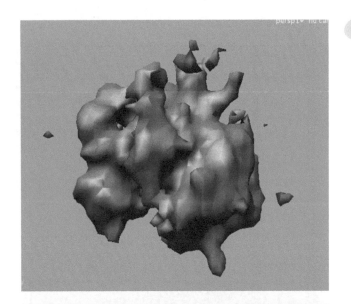

Visualizing the i3D File

If you create an i3D volumetric file, you might like to see what is inside it. This is simple to do – just put down an IsoSurface SOP, and in the 3D Texture tab, read in the i3D file where is asks for 3D Texture File. Use the Divisions parameters to increase the accuracy of the representation.

For extra fun, toggle on the Build Volume checkbox at the bottom of the parameter pane – you get a soft wispy version of your file.

Combing Velocity

With the Comb SOP, you can specify an arbitrary attribute to comb. One interesting one to try is V, for velocity. You can get some interesting motion blur effects this way.

One problem with this is that you can't see what you are doing with the velocity until you render an image. But in Houdini 9, you can fix this problem by adding custom attributes to visualize in the viewport. There is a tip describing how to do this in the UI chapter.

Alternatively, you can comb the point normals, which you can visualize, and then use the Attribute SOP to rename N to V (that is, take the normals you just painted and rename them to be velocity).

i3D Workflow

In Houdini 9, the i3D file format and workflow may well be replaced by "real" volumetric rendering from Dynamics Operators (DOPs). But the techniques remain, and the workflow is convoluted, so let's understand how to use this tool too. Here's a quick example:

- Go to /shop, and put down a VEX Fluffy Clouds shader. Leave everything at the defaults. Also put down a VEX 3D Texture Fog SHOP. In that shader, for the 3D Texture, put "fluffy.i3D" without the quotes.

- Go to /out, and put down a 3D Texture Generator ROP.

- In the Texture Generator parameters, specify an Output Image of fluffy.i3D. Set the Resolution to [64 64 64]. Go to the SHOP parameter, and select the Fluffy Clouds shader you created in the first step.

- Hit Render on this ROP, and make sure that you've created a file called fluffy.i3D.

- Go to the /obj editor, and use the tab menu to create an Atmosphere object. Set the Translate value to −2 in Z. In the Render tab, set the Fog Shader to point to the 3D Texture Fog shader you put down earlier.

- Render looking through the default camera, using Mantra, and you should see some fog.

So the general workflow is: use a special ROP and a special shader to create an i3D file, then use a special object, referencing another shader that uses the i3D file, to create the fog. Simple!

Ok, not so simple. But we'll come back to this, and with luck make it less inscrutable.

Light Wrangling

With Houdini 9, Side Effects have introduced the concept of
Light Wrangling. To understand what this is, and what it can do, first
look at $HH/soho/wranglers in your Houdini distribution. You'll see
HoudiniLightIFD.py and HoudiniLightRIB.py. These are python
scripts that are invoked when the IFD or RIB is generated – the
python script maps the parameters in the light to parameters that
renderer can deal with.

Now in the /obj editor, put down a Light object – it should come
in labeled "hlight." Now RMB on the node, and choose Type
Properties. In the dialog that comes up, go to the Parameters tab,
and scroll to the bottom of the long list of parameters. Notice the
last one, Light Wrangler, which is invisible to the user. Select it,
and on the right side of the dialog, look in the Channels tab. Note
that the default value for Light Wrangler is "HoudiniLight" – this
string matches the names of the python scripts we just saw. This is
not a coincidence.

The idea is that you can create custom lights as Houdini Digital
Assets (HDAs) which have whatever custom parameters you
want. Then you provide a light_wrangler name, which tells
Houdini what python script to look for and run, in order to
create the parameters that Mantra or RenderMan or whatever
are looking for. So you'd give the light_wrangler a value of,
say, MyGroovyShader, and then create a python script called
MyGroovyShaderIFD.py, and it would get executed between
Houdini and Mantra, in order to create the appropriate
parameters for Mantra.

Deep Raster Object ID

You could also add the object ID or the primitive ID as output channels (which is done for you automatically in IPR renders). To do this, add a new export variable in the Mantra ROP, and set the following:

- Image Plane 1: Op_Id (or Prim_Id)

- VEX Variable: Op_Id (or Prim_Id)

- VEX Type: Float Type

- Quantize: 8 bit integer

- Sample Filter: Closest Surface

- Pixel Filter: You'll have to type the phrase "minmax idcover" (no quotes) which is a special filtering mode for ID channels.

The values will take on the integer primitive or operator id values +1 (so that a value of 0 means no surface under that pixel).

Fluffy Clouds

The Vex Fluffy Cloud SHOP is intended to generate a single fluffy cloud inside a unit box. This means it doesn't require any geometry. To set this up, in the 3D Texture Generator ROP, set the "Render As" field to "No Geometry Needed."

The defaults specify a unit cube, and if you use values less than 1, then you trim the size of the cloud, as you'd expect. But if you use values greater than 1, you don't get a bigger cloud. Instead, you get the cloud stretched more over the unit cube. If you want a larger cloud, scale the Atmosphere object that you use to render the resulting i3d file.

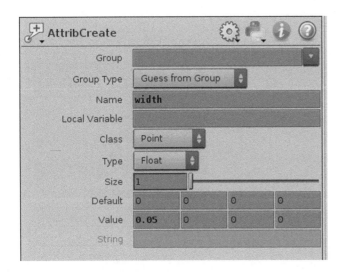

Curves in Mantra

As with RenderMan, Mantra builds curves as procedurals prior to the shader calls. There are two attributes that Mantra uses to control the curves. The first is "width," which controls the width along the curve. The other is "orient," which is a vector that is used to determine which way the curve is facing. The procedural will construct the geometry before any displacement or surface shaders are called. So all you have to do is to make sure that these attributes exist and are set to reasonable values.

You can still use displacement shaders to push the curve around like any other nicely ruled surface. The s and t values are nicely defined along the length of the curve.

And finally, an important note – curves are rendered as flat ribbons, not as cylinders. That means they can only displace in one direction. So if you want to render cylinders to simulate something like hair, you have to pass the curves in twice and deform the forward cylinder separately from the backward cylinder.

See the Photon Cache

If you are doing global illumination, you can use the standalone program "i3dconvert" to turn the photon maps and the irradiance caches into geometry, which you can then bring into Houdini (or gplay) and look at. This is a neat way to visualize the photon maps you are creating.

Irradiance caches and photon maps are by Mantra, but you will have to add the properties to create them – they are found in the PBR folder. The irradiance cache has a .cache suffix, while

(Continued)

the photon maps have a .pmap suffix. Once these are created, you can do something like this:

```
% i3dconvert test.pmap test.bgeo
```

and then read test.bgeo into Houdini with a File SOP.

Or, if that is too much work, you can just put a line like this into a Unix SOP:

```
i3dconvert ./test.pmap stdout.bgeo
```

In either case, don't forget to turn the viewport display to "points" or you won't see anything, because the contents of the file is all points.

Panoramas

If you are trying to generate panoramic images from Mantra, and the edges of the images don't line up properly, you need to turn off MicroPolygon rendering. In the Mantra output driver, in the Properties tab, Render sub-tab, change the Rendering Engine to Ray Tracing.

Phantom Objects

One very useful trick is to be able to render shadows as a separate pass from the objects that cast them. This allows you to defer choosing the final density of the shadows until the composite, as well as softening or even tinting them at composite time. To do this, you must make the objects Phantom Objects when they are rendered. Phantoms will cast shadows and generate reflections, but will not appear themselves. An object is rendered as a Phantom Object by toggling the checkbox in the Render tab of its Properties.

Using Ramps as Images

One of the applications that ships with Houdini is redit, the Ramp Editor. This is a standalone version of the Ramp Editor you can find in Houdini itself, with one exception – it allows you to save the ramp as a file.

And why would you want to do this? Because ramp files can be used anywhere in Houdini that image files are. So you can create ramps that will be used as reflection maps, for example. The only slight catch is that the file browser for images doesn't recognize the .ramp suffix, so you'll have to type in the name yourself.

Setting Up Deep Rasters

Deep rasters are very useful for all kinds of compositing tricks, including delaying lighting decisions until after elements are rendered, as well as making depth comparisons on 2D images. The simplest way to create deep raster information is to use mantra and the Side Effects .pic file format. This format can contain multiple planes in the same file, and SESI tools like mplay can show them to you directly.

As a simple example, go to the Mantra ROP, and in the Properties tab, the Output sub-tab, and at the bottom, where it says Extra Image Planes, click on Add. You will get a new dialog for creating a deep raster layer. From the VEX Variable menu, choose Pz from the Variable Name menu. Then render your scene to a file, say test.pic. Finally, run mplay and load in test.pic. You'll see in the planes menu that there is now a new entry, Pz, and if you choose it, you will see the depth represented.

In fact, you can skip that step, and just render directly to the ip device. If you do that, and you enable the Main Bar in the mplay window that pops up (*Options−>Main Bar*), you can see the plane menu and view the depth directly.

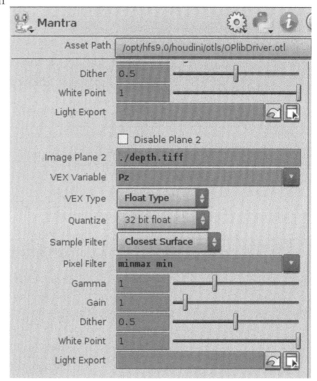

To make this slightly more complicated, you can render different information to different files (and file formats). If your beauty pass render is to a tiff file, for example, you could store the depth information for each pixel in a separate tiff file, as shown at right.

Here's the tricky thing: mantra decides that the information in the File/Plane parameter is a File, *only* if the main output format is something that cannot hold deep raster information. For example, if you render your main image to ./beauty.pic, then if you try to write the depth to a file called ./depth.pic, it **won't work**. Instead,

you will end up creating a layer in ./beauty.pic, and that layer will be called "__depth_pic" (because the _ character is substituted for the dots and slashes).

So you want to make sure that your main render is to something like ./beauty.jpg or ./beauty.tiff, since these formats don't support extra planes.

IPR Feedback Scripts

If you <ctrl>-LMB on the IPR image, it launches a feedback script. The default script will tell you about the image and the object under the cursor, like so:

But you can modify this default script, and create image queries of your own. The script is located at $HH/scripts/ipr/pickpixel.cmd. You should copy that into the equivalent location in your home directory, namely $HOME/houdini9.0/scripts/ipr, and then edit it to do what you like. The file is commented, and it makes extensive use of the iprquery() and iprquerys() functions, which you can get help with by opening a textport and typing:

```
exhelp iprquery
```

iprquery() returns numerical information about the object under the cursor, and iprquerys() returns string values associated with that object.

Compiling RenderMan Shaders

Instead of compiling the RenderMan shader, and then playing around with the .ds file to get the user parameters available in Houdini, just do this:

```
% shader myshader.sl
% rmands -l myshader.otl myshader.slo
```

This will create a digital asset with the compiled shader in it. Then you install that through the file menu, and you're done – it will be on the shader menu, with all the correct parameters exposed.

(Continued)

Even better, you can do this:

```
% rmands -l rmanshaders.otl *.slo
```

and this will put all your shaders into one asset. Then you can put this into a directory such as:

```
$SHOW/houdini/otls
```

and set up Houdini with an environment variable, thus:

```
HOUDINI_OTL_PATH = $SHOW/houdini/otls
```

Then whenever anyone runs Houdini, it will automatically load up all the shaders (and dialogs and stuff) with minimal work for you. Sadly, any custom UI hints are lost when you do this. So if your RenderMan shader was made in VOPs, and you want to keep the tabs, labels, etc. your only choice is to manually click RMB on the VOP and do "Create New Shop Type from VOPNET."

Improved Texture Mapping

Houdini has a file format, the .rat file, that allows for mipmaps ("rat" stands for "random access texture"). Any texture you use with Mantra should be a .rat file, except for quick tests. Also, as a useful side effect, this also usually means that you can use render settings that speed up the render, without sacrificing quality.

To convert to .rat format, just use the icp utility, for example:

```
% icp mytexture.tiff mytexture.rat
```

There is an environment variable, HOUDINI_RAT_USAGE, associated with .rat files. This variable specifies the maximum amount of memory used by .rat textures in Houdini and in renders. The default value is 32 megabytes, which is too low for most modern situations. You'll probably want to increase that.

Optimizing Mantra Renders

If you know that you have a lot of transparency that never reaches an opacity of 1, you should adjust Mantra's Opacity Limit down a bit. That could help speed transparent object rendering up a little. Opacity Limit is in the Render tab of either an object, or of Mantra's properties. The default value is 0.995.

Also, if you add the Dicing tab to Mantra's properties, then you'll get the Ray Shading Quality and the Shading Quality parameters. The Ray Shading Quality relates to ray tracing, as you might imagine. By default, this is 1, but if you lower it to .5, you can usually get much faster renders with no visible image change.

Shading Quality, on the other hand, is for scanline renders. Set this higher for better image quality and longer renders. So for test renders, try values around 0.5, while for final renders a value of 1 or even 2 may be required.

Rendering RIB Archives

It's simple to bind RIB archive references into your RenderMan files. In a SHOP Network, put down a RenderMan Delayed Read Archive, and name the appropriate RIB file. You can also specify a bounding box here, if you want.

Then back in the object's Geometry tab, set the Procedural Shader parameter to point to the shader you just created. The result will be a delayedreadarchive line in your RIB file that references the RIB archive file.

(Continued)

You don't need to use a procedural here, unless you are doing something more complex, like a Level of Detail delayed read, in which case you would specify, using the Renderman Dynamic Load SHOP, an appropriate render procedural to do the on-the-fly archive reading. This is how Massive is hooked into Houdini – they provide a RenderMan procedural that creates the geometry on the fly for each frame.

How to Render Sprites

Setting up sprites takes a few steps. They are:

- Go to a SHOP Network, and put down a Mantra: Sprite Procedural node. Name it "sprites" (no quotes). While you're there, create a VEX Decal shader, and set the image to "default.pic" (no quotes) so that you now have the required shaders ready to point to.

- Assuming you want your sprites to be driven by a particle system, then in the POP Network, add a Sprite POP. Click on the Enable Sprite SHOP toggle, and then point it to your VEX Decal shader that you just created.

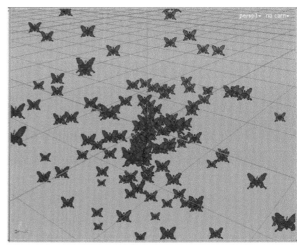

- Then go to the object that contains the particles, and in the Render tab, in the Geometry sub-tab, set the Procedural Shader to the full path to the Sprite Procedural shader you put down in the first step.

- Finally, put the cursor in the viewport and hit the 'd' hotkey. In the Particles tab, choose Display Particles as Sprites.

Sprites and other Procedurals

New For Nine!

Specification of procedurals for mantra/RIB are now done through Geometry SHOPs. There are now several new Shading Operators (SHOPs) to represent the procedural and its arguments:

Mantra: HScript Procedural	RMan: Delayed Read Archive
Mantra: Image3D Procedural	RMan: Dynamic Load
Mantra: Metaball Procedural	RMan: Run Program
Mantra: Program Procedural	
Mantra: Sprite Procedural	

These SHOPs have special parameters to specify the bounding box for the procedurals. They can be found in the Mantra or RIB parameter folders. Several of these new procedurals are described in this chapter.

Refreshing Textures and Views

It can be the case that if you change a texture map in a shader, the GL render in the viewport doesn't change to reflect this. The reason is that the texture is in cache memory, for efficiency, and so you have to force the cache to update. To do this, use the command:

```
texcache -c
```

in the textport. You can also force a refresh of the 3D viewer, with the command:

```
viewupdate -u now
```

If you really want a scorched earth policy, you can bind the following to a hotkey:

```
texcache -c ; viewdisplay -N all m on *.*.* ; viewdisplay -N
all off *.*.*
```

This forces the GL to refresh by turning on and then off the display of points.

And if you want to just manually clear out caches, use the <alt>-M hotkey anywhere in the interface. That will give you a dialog for managing the various caches.

Motion Blur for Clouds

You can do volume renders with motion blur, using Mantra. To do this, you need to render out a per-frame i3d file on your reference metaball object that has a velocity attribute attached. A good way of getting this is to use the Trail SOP. Notice that the motion that you are blurring has to come from the SOP level, for example, from a Transform SOP or from the velocity attributes of a particle system.

(Continued)

When you render the i3D file, the image3D ROP has a toggle for Motion Blur – turn that on. Then adjust the shutter time to control the amount of blur – larger numbers hold the shutter open longer, and increase the blur.

Then render the i3D file in an Atmosphere object, using a mantra ROP, as normal. The mantra ROP does not have to have motion blur turned on – the blur is built into the i3D file. The bad news about this is that it means you have to re-render the i3D file if you want to change or remove the motion blur.

Render Dependencies

The ROPs in the /out section of Houdini can be plugged together like any other tiles anywhere else in Houdini. When you do this with ROPs, however, what you are doing is defining a dependency between those two operators. If the output of OpA is plugged into the input of OpB, then what this means is that OpB depends on OpA being rendered first.

You can plug many outputs into one input, and you can plug the same output into many inputs. The result can be a complex tree that means that certain geometry archives must be created, then various render passes run, and finally a composite pass runs to put the whole thing together. You can render these either frame by frame, where each node in the tree is executed, in order, for a given frame, or in batch mode, where a given node does all of its rendering before moving on to the next one.

(Continued)

The hscript command:

```
render -p /out/output_node
```

will give a list of passes, with dependencies, that can be passed to a render queue manager, which in turn will schedule the various passes.

Faster Motion Blur

The newly exposed parameter Motion Factor can speed up the rendering of images with motion blur or depth of field. You'll find it in the Sampling tab of an object's Properties. This will decrease the shading rate adaptively for primitives that exhibit large blurring – in simple tests, I have seen increases in speed of 2 to 5 times. Values greater than 1 will cause even less detail to be used in the blurred regions, while decreasing will add more detail.

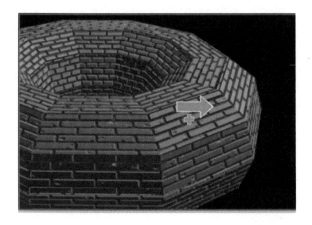

Assigning Shaders in IPR

Once you've set up an IPR render, you can drag a shader from SHOPs and drop it onto an object in the rendered image. That will assign the shader to that object, and then render the result. In fact, what really happens is that, when you drag and drop an object over an IPR image, a script is automatically run. That script is located at $HH/scripts/ipr/dragdrop.cmd. There is another tip that goes into more detail on this.

Note: This may be disabled in early versions of Houdini 9.

Multi-processor Optimizing

Another way to optimize mantra renders when you have a multi-processor machine, is to maximize the bucket size. When rendering with multiple processors on the same image, each processor tends to duplicate some work near the boundaries of tiles. By having larger tiles, you get less duplication of effort across processors. The default bucket size is 16 × 16 – increase this to 32 × 32 or even 64 × 64. You can do this in the Properties tab, in the Render sub-tab, with the Tile Size parameter.

Knowing the Type of Render

You may find a situation where it would be useful for each ROP to set a value that specifies something about the render it is about to create. For example, you may want to know that renderers like RenderMan, 3Delight, and Air all work with RIB files. To do this, in the Pre-Frame Script put:

```
setenv RENDERTYPE = "RIB"; varchange
```

The varchange command will refresh any expressions that depend on the values of defined variables, so you need it here to force anything that contains $RENDERTYPE to update.

Rendering Point Instances

If you want to bind a RIB archive to the points of a piece of geometry, first set up the RIB archive as described earlier, in the tip called Rendering RIB Archives. Then follow these simple steps:

- Go to the gear icon in the parameters pane for the object, and choose Edit Parameter Interface...

- In the dialog that appears, go to the Optional Rendering Parameters tab. Open the prman12.5 folder, and RMB on the Instance folder. Choose Install Parameters to Instance Folder. Then hit Accept.

- Go back to your object's properties, and in the newly created Instance tab check on the Point Instancing box. Put the name of the object that has the points you want to instance onto, and now your output RIB will put a ReadArchive at each point of that object.

You can control the scale and orientation of the copies by binding pscale, Normal, Velocity or UpVector attributes to the points.

Rendering with Object Tags
New For Nine!

In Houdini 9, a new mechanism has been added to simplify collections of objects for light masks. The idea is that you can now tag objects with keyword categories, and then specify objects based on the keywords.

Keywords are added to objects by creating a "categories" property. Keywords can be added to lights with the "lightcategories" property. Lights can also have the "reflectcategories" and "refractcategories" properties to specify reflection and

(*Continued*)

refraction masks. Any list of keywords may be specified. The list is comma or space separated.

You can match keywords using the following operators:

- "*" = Match all objects

- "-*" = Match no objects

- "+" = Match all objects which have keywords specified

- "-" = Match all objects which have no keywords specified

- "name" = Match all objects which have keyword "name"

- "-name" = Match all objects which do not have the keyword "name"

Simple expressions may be joined using "&" (AND) and "|" (OR), but parentheses are not supported.

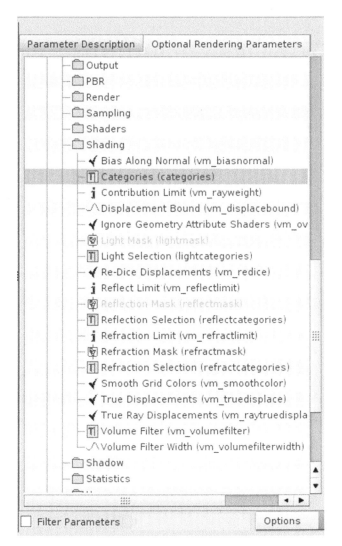

ON THE SPOT

CHOPs Tricks

Channel Operators, or CHOPs, are the unsung heroes of Houdini. With these tools, you can modify the timing of animation without changing the shape or having to reanimate. You can distort geometry. You can combine curves to make new curves, and then turn those curves into positions in space, or rotation values, or anything you like. Not to mention the uses involving midi input and/ or output, real-time gesture capture, and other more esoteric results.

A little time spent understanding CHOPs will be paid back many times with quick solutions to what would otherwise be difficult, time-consuming, or impossible problems. You should definitely spend some more time looking through the help examples of this very powerful editor. In the mean time, here's a taster of useful tricks to know.

Which Viewer?

If you just start Houdini, jump to the "ch" network (CHOPs), and put down a Wave CHOP, you won't see anything. To get your curve to show up, you might think that it would be enough to tab over to the viewer tab that says Channel Editor, but you'd be wrong. You need to change one of the panes, or add a new one, and set it to Motion View. Then choose that tab as your viewer, and you can see your channels.

Accumulating Values

Say you fetch a channel using the Fetch CHOP. Then you want to sum up, or accumulate, the values of this channel over time – so the value at frame 10 is the sum of the values at frames 1 through 10. How would you accomplish this?

With the Area CHOP. This will give you the integral of a section of a channel. To get the sum of the values, choose the Order to be First.

Measure the Speed

How do you measure the speed of an animation channel, or of some deforming geometry? With the Slope CHOP. This will give you the rate of change (speed). You can also calculate the second derivative of the incoming channel, which will give you acceleration. And you can ask for the rate of change of the acceleration, which is the third derivative.

Fanning Out New Channels

The Fan CHOP can be used to take a set of channels as input, and iteratively pass them on one at a time as output. One good use for this is to provide a sequence of templates to use for the Copy CHOP, especially for Copy/Stamping. As an example, say you've got a Dynamics CHOP and it is bringing in 3 channels from a Dynamic Operators (DOPs) object, such as t[xyz].

Then you could connect that up to a simple network like this:

The Copy gets each dynamics t? channel in turn, and uses it as a template for the Copy. The parameters look as shown:

- Fan CHOP: Channel Names set to chan[1–3]
 Outside Range set to Loop Index

- Wave CHOP: Period set to stamp ("../copy1," "period," 3)

 Decay Rate set to 0.45

- Copy CHOP: Turn on "Cook Each Copy"
 Param 1 set to "name," value $C
 Param 2 set to "period," value
 rand($C/3.14159)*2.

The resulting channels are shown at right.

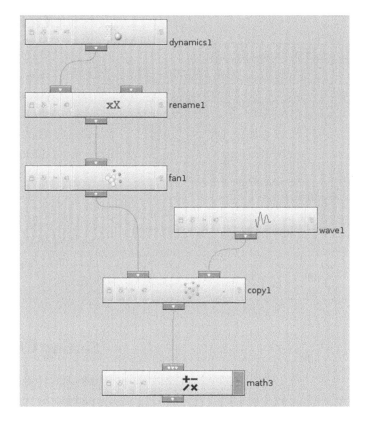

Default Range in Dynamics

One tricky thing about the Dynamics CHOP is that it is set to a default range of 10 seconds. This may force you to cook way more frames than you actually need to extract. The way around this is, before you click on the Update button, go to the Common tab and set the Units to Frames. Then go to the Channel tab and set the Start value to $RFSTART and the End value to $RFEND. This will make sure that the Start and End values are set to correspond to the values you have set in the playbar range. Thus you'll never cook more frames than you are looking at.

And it would be a good idea to only have to do this once. You can make sure of that by going to the tool menu (the gear icon) and choosing Save as Permanent Defaults. Then all subsequent Dynamics CHOPs will have these more relevant settings.

Setting CHOPs Units

Instead of having to worry about CHOPs defaulting to seconds, units that don't match other parts of Houdini such as the animation channels and Dynamics, you can configure Houdini to use frames. You do this with the environment variable

```
HOUDINI_CHOP_UNITS
```

For example,

```
setenv HOUDINI_CHOP_UNITS frames
```

Aside from frames, you can also specify samples and seconds.

Exporting Dynamics to Maya

If you are grabbing channels in CHOPs using the Dynamics CHOP, as a way to export the simulation motion to Maya (or some other package), then you will almost certainly need to retrieve the p? channels as well as the t? and r? channels. The p? channels represent the pivot, which in dynamics is the computed center of mass for an object, and this is unlikely to be the default of (0, 0, 0). And don't forget that on the Maya end, when you read in the channels you need to read in and correctly handle these pivot values.

Faster Expressions

If you have an expression that relies on a relatively complex constant, a good trick for

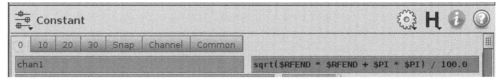

speeding that up is to pre-compute the value in a Constant CHOP. Then use the chop() expression to retrieve this value. If you have a slow expression used in multiple places, this can make a useful difference in speed.

Dots in CHOPs

Put down a Wave CHOP, put the cursor into the Motion Viewer, and hit the "d" key – dots! This is very useful for seeing the specific samples or values that you have, as well as the overall curve.

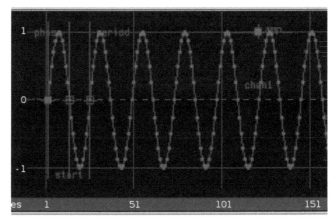

You can also access this functionality in the Options menu at the top of the viewport, but really, why bother? Hotkeys are much cooler.

Automatic Range Adjustment

A common way to use the icmin() and icmax() expression functions is to have them automatically rescale the range of a channel. For example:

- Append a Math CHOP to some other CHOP, such as a Wave.

- In the From Range tab, set the input range to icmin(0, $C) and the output range to icmax(0, $C), as shown.

- Set your output range to the desired range, for example 0 to 1.

- Now go back to the Wave CHOP and adjust either the Offset and/or the Amplitude, so that the min and/or max values of the channel change. The Math CHOP detects the new range and scales the output back to the range you want.

Jump to Export CHOP

If you use the Export CHOP to override the value of a parameter elsewhere in Houdini, then if you click right mouse button (RMB) on that parameter, you'll find a menu entry "Jump to Export CHOP." Choose this, and you'll zoom over to the CHOP network, and the CHOP, that is defining this channel, so that you can inspect/edit it.

Slopes and Initial Positions

You can use the Slope CHOP and the Area CHOP to modify animation curves, among other things. But one problem with these operators is that, once they calculate the total change, they've lost the original starting position of the curve. For example, put down a Wave CHOP, set the Type to Gaussian and the Offset to 1. Then connect an Area CHOP. Note that the value at frame 1 is now 0, not 1. If you have just one curve like this, you can use the "First Constant" parameter of the Area CHOP to correct the result by adding back the 1. But it would be better to have an automatic way to solve this problem.

Luckily, there is. Put down an Expression CHOP, and set the expression for the relevant channels to:

```
ic(0, $C, 0)
```

which is the incoming value of the first channel at time 0. Then put down a Math CHOP, and connect the Area and Expression operators to it. Set the "Combine CHOPs" parameter to Add and you're done.

Note that the Expression CHOP lets you assign the same expression to any number of incoming channels, with the "Channels per Expr" parameter.

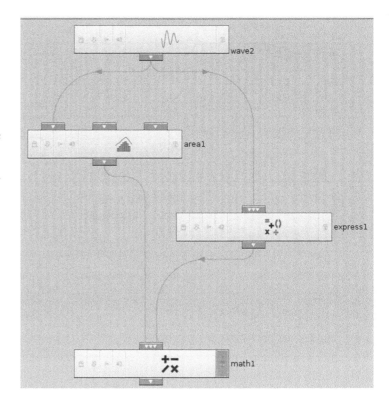

Multiple Copies of Channels

It's possible to create multiple copies of the same channel by simply using the channel specification grammar in the Channel tab. For example, put down a Wave CHOP, and then in the Channel tab, for Channel Name, change the string to:

```
chan[1-9]
```

(Continued)

This will give you 9 identical copies of the Wave, which you may then use as inputs to Shuffle or Fan CHOPs.

And if you don't know in advance how many copies you'll want, you can use an expression to determine that. Just put the expression in backticks, like so:

```
chan[1-`$FPS`]
```

You can even reference channels this way, as in:

```
chan[1-`ch("/obj/model/
spare1")`]
```

Geometry

You can get geometry values into, and out of, CHOPs very easily. To bring geometry in, use the Geometry CHOP. Nobody could have predicted that!

This is set up to grab the xyz values of the geometry you point to, but you can ask for any attribute. Typically you'll manipulate the values in some way, and then export them back to Surface Operators (SOPs).

To do that, use the Channel SOP to grab the channel values into the geometry.

Be careful that you don't set up a feedback loop, where the geometry is going to CHOPs and then back to the same SOP network. A good way to avoid

(*Continued*)

this is to make sure you specify a particular SOP in the Geometry CHOP parameter line, rather than just naming a geometry object and depending on the Display flag to choose which SOP to export to CHOPs.

And don't forget you can drag and drop the SOP tile into the Geometry CHOP parameter area.

Clamping Values

You can use a quick expression to clamp the values of a curve. Put down an Expression CHOP, and in the Expr tab, type something like this for Expression 1:

```
if ($V <= 0, 0, $V)
```

Then put down a Wave CHOP, and connect the output of the Wave to the Expression CHOP. The expression is saying that when the value of the curve goes below zero, set it to zero. If you want to add a second expression to clamp the values on the other end, you need a second Expression CHOP. Try putting this into the Expression 1 field of a second Expression CHOP:

```
if ($V >= 0.5, 0.5, $V)
```

You need a second operator because the 6 expressions in the Expression CHOP refer to 6 channels of input, not to 6 operations you can perform on the same channel.

ON THE SPOT

VEX and VOPs

VEX is the Houdini shading language (it stands for Vector EXpressions) though it can create much more than shaders. And VEX operators (VOPs) is the interactive editor that allows you to create Houdini operators. You can make your own geometry operators (SOPs), composite nodes (COPs), particle operators (POPs), channel operators (CHOPs), and shaders (displacement, light, surface, etc., for Mantra and RenderMan), using the same procedural operator paradigm as you use for modeling, animation, particles, and the rest of Houdini's features.

In this chapter we explore a few useful hints to help ease your way into these tools.

Checkerboards

A quick way to create a checkerboard pattern is to use the Boxes VOP. If you set the number of layers to 2, you get an anti-aliased checkerboard with very little effort. Here are the steps:

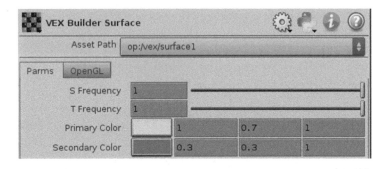

- In VOPs, create a VEX Surface Shader. Dive inside.

- Put down a Boxes VOP. Middle mouse button (MMB) on the sfreq input, and make it a parameter. Do the same with tfreq.

- Put down a Colormix VOP. Connect the "amount" output of the Boxes to the "bias" parameter of the Colormix.

- MMB on the "primary" input of the Colormix, and make it a parameter. Do the same with the "secondary" parameter.

- Connect the "clr" output of the Colormix node to the Cf input of the output node.

Go back up to the VOP level and click right mouse button (RMB) on the Surface Shader node. Choose "Create New Shop from Vop Network." Then go to SHOPs and use your new shader.

The key is to use the Color Mix VOP to choose between two colors. In this example, we've made the colors user adjustable, and added a parameter to control the frequency of the boxes.

Color Attributes are not Vectors

Colors in VEX are defined as a vector data type, not as a float[3]. You must be careful to not let this affect your thinking when it comes to adding extra geometry attributes using the AttribCreate SOP. You may be tempted to add an attribute to represent color using the vector data type in the SOP which can cause major havoc later because you may do some transforms on that geometry (using a Transform SOP, for instance).

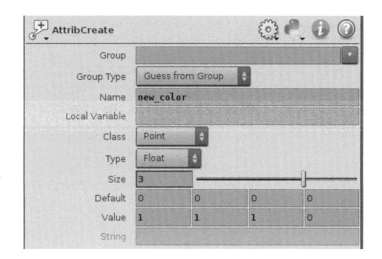

Any transformations *will transform vector atttributes too* and so corrupt your color information, which is obviously not meant to be modified during a transform. Transforms will rotate vector types to ensure true vector information like velocity vectors and normals remain correct. So take care to create float[3] data types for color information in the AttribCreate SOP and spare yourself some unnecessary psychedelia.

Using Less Memory

For better interactive performance, you can use "texcache -r" to scale down the resolution of the textures being displayed the 3D viewport. Just open a textport and type the command.

Named Parameters

It's common to want to create a shader that takes a named parameter, which may be present in the incoming geometry. For example, your shader might need a normal to work, and you'd like to allow the parameter page to specify a normal, which will be overridden if there is a normal on the geometry.

VOPs will automatically use existing attributes like Normal to override whatever settings you may have in your shader parameters. But what if your shader has a custom parameter, and you want to allow the shader to use that attribute directly, if it exists?

For example, consider the checkerboard shader we created in the first tip – it has two color parameters, "primary" and "secondary." We'd like it to recognize the existence of those attributes on the incoming geometry, and if they exist, use those values instead.

This is pretty easy. Just go back to the VOP network that created the shader, and in the Parameter VOP for both Primary and Secondary, check the box labeled "Use Input Value If Parameter Not Bound." That's it.

Now convince yourself this works by creating some geometry in Surface Operators (SOPs), appending an AttribCreate SOP, and naming the attribute "secondary." Change the Type to Vector, and then set a RGB value in the Value fields. If you assign your shader to this geometry, and render it with mantra, you should see your new color override the one in the shader's parameter settings.

Optimize Ray Tracing

If you are creating a shader that uses ray tracing, you can optimize it by checking the rcolor parameter (the reflected color). If the color is close to black, then the reflections won't contribute any color, and can be skipped. As a basic setup, this means:

- Connect the color to a Length VOP. If you don't already have the color as a vector, you'll first have to convert it to one by using the FloatToVector VOP.

- Create a Constant VOP, and set it to be a Float whose value is 0.01. We use this small number, rather than absolute zero, because we want to catch things that are close to zero too. You may want to adjust this value later.

- Put down a Compare VOP. Connect the Length to input1, and the Constant to input2. Set the Test to Less Than or Equal.

- Put down an If VOP. Connect the output of the Compare to the "condition" input. Set the Condition to False. Connect the rcolor vector to the "next" input connector of the If.

Now you would put your RayTrace VOP and other related operators inside the If VOP. These would be executed if the If statement were true (that is, if the rcolor was large enough to be worth the trouble of tracing the reflected rays). If not, then the rcolor would be passed right on through the If. So either way, the output of the If VOP would be the component you would add for your reflections.

Maximum Distance for Mantra Rays

If you want to create a mantra shader that doesn't bother to illuminate surfaces which are too far away, you can use the "maxdist" parameter. All ray tracing functions in VEX take an optional parameter "maxdist" that can be used to set the maximum ray tracing distance. For example:

```
rayhittest(P, N, 0.01, "maxdist", 100);
```

Specifying Categories

New for Nine!

In Houdini 9, all illumination and tracing functions now take an optional keyword argument "categories", which takes a keyword expression as an argument. For example:

```
diffuse(nn, "categories", "-global");
```

will compute the diffuse contribution from all lights which do not have the keyword "global" specified.

```
gather(p, d, "categories", "background");
```

will compute gather from all objects with the "background" tag.

Pragma Hints

A couple of useful **#pragma hint** lines that you can use with your VEX code.

First, you can use the undocumented **#pragma hint** nolabel to create a parameter with no label. You can combine this with the `#pragma hint joinnext`, which will join two parameters onto one line. You can also use **#pragma choice** to create menu items. Create a file with the following code, call it foo.vfl.

```
#pragma hint a joinnext
#pragma hint b nolabel
#pragma label a "This is A"
#pragma label b "and B"
// The next two lines make 'b' a menu with two choices
#pragma choice b 0 "optionb0"
#pragma choice b 1 "optionb1"
sop foo(float a=1; float b=0;)
{
}
```

Then compile and run it with

```
% vcc -l foo.otl foo.vfl
% houdini foo.otl
```

In the SOP editor, you should find "foo" in the tab menu, and when you place down a foo SOP, you'll get this (see figure right).

Known Bug: There is a problem if you try to join two parameters, when the first parameter is a menu parameter. In this case, the **#pragma hint a joinnext** does not survive, and each parameter ends up on a

(Continued)

separate line. You could, if you wanted, go into the DialogScript, and re-add the joinnext, but that's a tedious solution.

```
#pragma hint a joinnext
#pragma hint b nolabel
#pragma label a "This is A"
#pragma label b "and B"
#pragma choice a 0 "optional" //
make 'a' a menu parameter
#pragma choice a 1 "optiona2"
#pragma choice b 0 "optionb0"
#pragma choice b 1 "optionb1"
sop bar(float a=1; float b=0;)
{
}
```

Compiling the above and dropping down the node it creates gives you this (see figure left top).

Converting VEX to RenderMan

It would be great to be able to write shaders just once, and then compile them with either VEX or RenderMan compilers. Unfortunately, you can't really do that, at least not in the general case.

But you could write a stub VEX function, using ifdefs, and run vcc to generate the dialog script (.ds) file, or the Operator Type Library (OTL) file. This would hide the VEX #pragma instructions from the prman compiler, which doesn't understand them. Then once you are able to compile the shader for both

(Continued)

languages, you can use the rendermask pragma to specify that the shader will run for both renderers. For example:

```
#include "prman.h"
#pragma rendermask "VMantra,RIB"
#pragma label diff "Diffuse"
surface
shader( color diff = 1;)
{
  normal nn = normalize(faceforward(N, I));
  Ci = diffuse(nn) * diff;
}
```

This shader should compile with both prman and VEX. You can create the OTL for the Shader Operator (SHOP) using vcc, but use the SHOP for either prman or VEX.

As an alternative approach, if you just work in Prman VOPs to create your shaders, then the resulting .sl file will contain ifdefs around the #pragma stuff, so the RenderMan compiler will ignore it. And then if you rename the saved .sl source to .vfl, the vcc compiler will accept it too.

Either way, you should test your shaders thoroughly for compatibility, as I can't guarantee there will be no differences or incompatibilities.

Summing a Loop

How do you loop through some values and accumulate a total? You use the "accum" value to pass the accumulated sum back and forth. As a simple example:

● In a VOP network, put down a VEX Geometry Operator node. We are going to create a SOP that takes a set of points as input, and computes the average location (the centroid) of all of them. The result will be all the points in the input geometry, moved to the centroid of all those points.

(Continued)

- In the new VOP, put down a For Loop node, a Global Variables node, and a Constant node.

- Set the Constant node type to Vector, and change the Constant Name to "accum" (no quotes).

- Connect the "Npt" connector on the Global Variables node, to the "end" connector on the For operator.

- Connect the Constant operator to the "next" input For operator.

- Select the For operator and hit <enter> to go inside it.

- Put down a Subnet Input node, an Add node, and an Import Attribute node.

- Connect the "accum" output of the Subnet Input node to the "input1" connector of the Add node. Connect the "sum" output of the Add node to the "accum" input of the Subnet Output node.

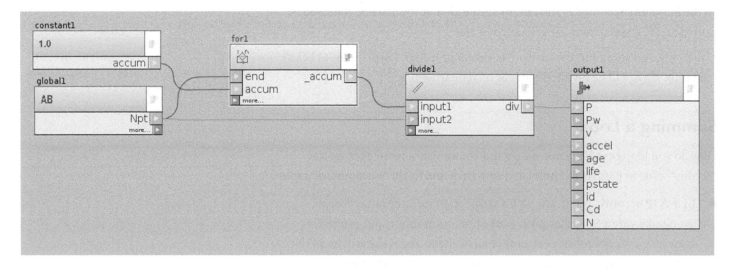

(Continued)

- Set the Attribute in the Import Attribute op to "P" (no quotes).

- Connect the "i" output of the Subnet Input node to the "ptnum" input of the Import Attribute. Connect the "adata" output of the Import Attribute to the "input2" connector of the Add op. Go back up one level (use the "u" hotkey).

- Put down a Divide VOP, and connect "input1" to the output of the ForLoop op. Connect "input2" to the "Npt" connector of the Global Variables. Connect the "div" output to the "P" input of the Output operator.

That's it. The important point is the use of the "accum" value to hold the accumulating result, which is passed into and back out of the For loop.

Strategies for Colored Shadows

Let's say you have an opaque object that you want to cast a green shadow, instead of a black one. Here are three rendering solutions using mantra:

1. Create two light sources, parented to each other. Have one light cast shadows and the other have no shadows. Change the colors of the lights so that when combined they produce the correct color. For example, to get a green shadow, set the shadowing light to be (1, 0, 1) and the non-shadowed light to be (0, 1, 0). In this case, the green light will pass through any objects, resulting in green shadows.

The advantage of this approach is that you don't have to create a new shader. The disadvantage is that it may be hard to get a specific color in the shadow, since you have to do color arithmetic.

(Continued)

❷ Create a custom shadow shader. You can query the color of the light *before* shadows are cast, compute the shadows, and then blend between the original color and the shadowed color. For example,

```
shadow
colorShadow(vector shadow_clr={0,1,0})
{
  vector Cl_org;
  Cl_org = Cl;
  // Compute normal shadow color, for example:
  Cl *= lerp(fastshadow(Ps, L, bias), 1, fill_amount);
  // Then blend to desired color
  Cl=(Cl_org - Cl) * shadow_clr + Cl;
}
```

❸ Modify the surface shader so that the object becomes transparent *only* for shadows. This is different than the other two approaches since each surface that the light passes through can have a different colored shadow.

```
surface
colorShadow(vector shadow_clr={0,1,0})
{
  // If this object is being tested to see if it
  // casts a shadow, return a transparent colored
  // shadow value
if ( isshadowray())
   Of = {1, 1, 1} - shadow_clr;
  else
  {
  // Compute normal surface color
  }
}
```

Note that for this third scheme to work, the light casting the shadow must have a shader attached to it that handles transparent objects.

Controlling Compiler Options

New for Nine!

There is now a spare property which can be added to vopnets to control the compiler and options to the compiler. To see this, go to /vex and create a VEX Surface Shader, which by default will be called surface1. Then open a textport (hotkey: <alt>-T) and in it type the following:

```
opproperty /vex/surface1 vopnet vcc_compiler
```

A new Compiler tab will appear in the parameter pane of your surface1 node. Look in that tab, and you'll see a Compiler command defined.

There are 4 local variables, which are set when evaluating the vop_compiler property:

VOP_INCLUDEPATH	A list of include files with the -I prefix (that is "-I/tmp -Ic:/temp")
VOP_SOURCEFILE	The name of the temporary source file written out by the VOP editor
VOP_OBJECTFILE	The desired target object file
VOP_ERRORFILE	The temporary log file where the compiler should output any errors

There are spare properties defined for vopnets which can be added using the opproperty command:

```
opproperty /vex/path/to/vopnet vopnet vcc_compiler
opproperty /vex/path/to/vopnet vopnet prman_compiler
```

And you should be able to do this interactively, by RMB on the VOP net node, and choosing "Edit Parameter Interface." Then go to the Optional Rendering Parameters tab, and open the vopnet folder. Then RMB on the Compiler entry inside, and install the parameters.

```
Basic   Parameters   Help   Handles   VEX Code   Scripts   Tools   Selectors   Input/Output   Extra F

#pragma opname          g_brick
#pragma oplabel         "VEX Gallery Brick"

#pragma label    g_ambient      "Brick Ambient"
#pragma label    g_diffuse      "Brick Diffuse"
#pragma label    g_specular     "Brick Specular"
#pragma label    g_reflect      "Brick Reflect"
#pragma label    g_srough       "Brick Roughness"
#pragma label    g_lmodel       "Brick Light Model"
#pragma hint     g_ambient      color
#pragma hint     g_diffuse      color
#pragma label    cchange "Color Variance"
#pragma hint     g_specular     color
#pragma hint     g_reflect      color
#pragma choice   g_lmodel     specular    "VEX Specular"
#pragma choice   g_lmodel     blinn       "Blinn Specular"
#pragma choice   g_lmodel     phong       "Phong Specular"
#pragma choice   g_lmodel     lambert     "No Specular"
#pragma choice   g_lmodel     constant    "Constant Shading"
```

Seeing VEX Example Code

All of the Mantra shaders that come with Houdini have the VEX code accessible, which is very useful for seeing how things were done. To see the VEX code for any VEX shader, go to SHOPs and put down an instance of the shader. Then RMB on the shader's icon, and choose "Operator Type Properties."

When that dialog opens, go to the tab marked VEX Code, and there you are.

Creating Vector Parameters

In a situation where you want a custom parameter that is a non-standard size, such as a float variable of size 2, you'll have to declare the variable to be something that is standard, that encompasses it. For example, to get a vector of size 2, you have to create a standard vector of size 3. Then you can access the values as $value.0 and $value.1 – you'll just ignore $value.2.

Otherwise, even though your hover help may say that you have $value1 and $value2 declared for that parameter, you won't be able to reference the values that way, and in fact you'll get an error telling you that $value1 is an undefined symbol.

Custom Headers

You can put your VEX code into any directory in $HOUDINI_VEX_PATH. To see the defaults for that, type

```
% hconfig -ap
```

For adding your own header files, rather than put them in /houdini9.0/vex/include, a better location is $HOME/vex/include. You'll have to create this directory, but if it exists, the vex compiler will search it for headers to include.

If Then Else

There is no "else" condition in VOPs, so if you want to create an "if – then – else" construct, you have a couple of choices.

The first is to copy and paste the "If" VOP and reverse the inputs, followed by a Switch VOP with the same test condition.

The second is to use an Inline Code VOP to code the test in VEX. You may find that if you are creating an operator with lots of conditionals, it's just easier to write the whole thing in VEX and create a VOP from that.

BRDF Shaders

New for Nine!

Mantra 9 supports BRDF shading calculations. You can get an example of what that looks like in a VEX shader by going to SHOPs, putting down a VEX Metal shader, RMB on the node, and choose Type Properties. In the dialog that opens, look at the VEX Code tab. This has the source, and you can see that the BRDF calculations are used by assigning the result to the F component of the shader.

You can see this implemented in VOPs, by putting down a Surface Shader VOP, and then going inside. The Output block that you have there now contains an F, which you would use to assign the result of the calculations shown in the shader source.

Adding Outputs to Subnets

Let's say you are creating a shader subnet. You'd like to add one or more outputs to this subnet. You might be tempted to use the Parameter VOP to create these, but that's not the way to do it.

Instead, just make a new connection to the Subnet Output VOP (connect something to the "next" input). Then to change the name of the output, look at the parameter dialog for the Subnet Output VOP. You'll see a little table where you can edit the names (and descriptive labels for the popup help) of the outputs.

A good example of this is the Marble VOP.

Hiding Unused Shader Types

If you put

```
shopvisible -MI -RIB
```

into your 123.cmd file, you won't have to look at all the shaders for renderers you don't have. Alternatively,

```
shopvisible -VEX -RIB
```

will mean that only your Mental Images shaders will be visible.

Use the + to make them visible again, for example,

```
shopvisible +RIB
```

Of course, you can also just type these commands into a Houdini textport. And you can use the command by itself, with no arguments, to see what your current settings are.

In-Line VOP Networks

New for Nine!

In Houdini 8, you could create a VOP network inside a SOP network, or in a composite network, but once you had done that, you still had to RMB on the network node and choose to create a SOP or COP from your VOP network.

But in Houdini 9, this extra step goes away – the VOP nodes take inputs, and so can directly be used as a processing node. If you know you only want to create a simple set of operations, to be used one time, you can do that and just keep going.

And yet if you change your mind later, and want to turn this VOP network into a new SOP node type, you can still RMB on the node and choose Convert...

SHOP Time

To create a shader (or other operator) that uses the current time, or frame number, as an input, just create a Parameter VOP, and set its Type to Float. Set the Parameter Name to "time" and the Parameter Label to "Time."

Then once you have created the shader, just put $T or $FF in that parameter field.

Customize the VOPs Preview Render

It's possible to have VOPs use any RenderMan compliant renderer, such as Air, to preview your shader in VOPs.

There are two steps to getting this to work. The first one is easy: Houdini renders the shader ball using the "render" command (Linux) or "prman" command (Windows). So you can simply create an alias for the render command so that it really runs Air (or whatever renderer you want). That would be something like

```
alias render air
```

The second step is a bit more programmer-ish, so depending on your background, you may want to ask a favor of your local developer friends, rather than tough this one out yourself. When VOPs is asked to compile an RSL shader, it runs a program called hrmanshader. The source for this is found in $HH/public/ hrmanshader. You'll need to modify this to reflect the program of your choice, then compile it and use that instead of the default version (which is installed in $HFS/bin). There are explanatory comments in the code, which is short.

The Second Input

If you are creating a SOP using the VEX Geometry Operator, then you can set it to have more than one input. But inside your VOP network, you'll find that the Global Variables VOP only accesses values from the first SOP input. So in order to get values from the second input, you need to use the Import Attribute VOP.

Also, if you wanted to get the number of points from the second input, you would do it by:

- Create a Parameter VOP

- Set it to be Invisible

- Set the Integer Default value to the expression:

```
npoints("../" + opinput(".", 1))
```

which in this case would give you the number of points in the second input (they are numbered from 0).

Inline Code

If you want to access a VEX function that might not have a VOP built for it, or perhaps a custom VEX function written in the HDK, you can use the Inline Code VOP. It has good help, but here's a quick summary using the VEX function "computenormals:"

- Put down an InLine Code VOP. Set Output 1 Type to Vector, and name it "out" (no quotes).

- Wire in whatever input you want. For computenormals, we want to feed in P so do that from the Global Variables VOP. Connect the P output to the "next" input of the Inline.

(Continued)

● In the Inline VEX Code text input field, enter this line:

```
$out = computenormals($P);
```

Note that there is a semi-colon at the end of the statement. Whatever goes in here must be a valid VEX line (or lines) of code. That includes ending lines with semi-colons.

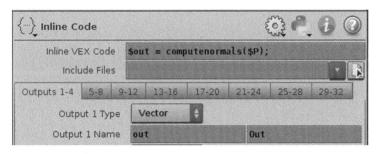

Important notes: If you change the input, you will have to change the code that says $P to whatever the new input name is. You can partially work around this by plugging a Null VOP into the Inline Code VOP, then giving the Null VOP output a name like myP. Use $myP in the Inline VOP. That way, if you change the input to the Null VOP things will still work.

However, this is only a partial solution, because there is a problem with the Null VOP – if you don't have an input wired in, the output disappears too.

Managing Parameters

When you use VOPs to create custom operators, you will probably end up creating lots of parameters that your operator presents to the user. You'd like to manage these – put them into a sensible order, for example, and group them into tabs. You can do all this interactively.

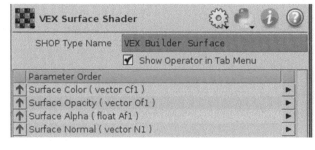

As a test case, put down a VEX Surface Shader VOP, and then dive inside. MMB on the first 3 or 4 output entries, and make them into parameters. That should give you a set of parameters to work with. Now go back up to the VOPs level, and look at the parameter pane for that VOP. You should have the left image.

(Continued)

Now you can reorder the parameters by clicking on the up arrow next to the name. Or, better, you can drag and drop a parameter name someplace else in the list.

The next thing to do is to organize them into folders. To do this, select the first two parameters (select the top one, then <shift>-LMB on the second one). Click on the little triangle on the right edge of the selected parameters, and you'll see them get grouped into a tab, shown by the curly brackets. You can click on the default name for the tab ("New Group") and change it to something meaningful.

Finally, you can delete the tab group by clicking on the red X at the right end of the line with the curly bracket. The left image shows the newly organized parameters. And the right image shows the resulting parameter pane.

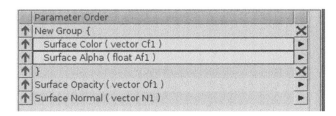

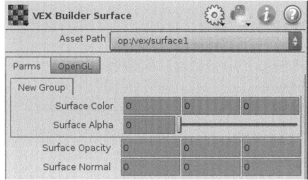

ON THE SPOT

COPs Hacks

COPs stands for Composite Operators, and this is the section of Houdini that allows you to read in, manipulate and write out images. This is a full-blown compositor, and while you might not use it for the most difficult live action composites, it's excellent for creating and manipulating elements to be used in many situations. COPs is also the place where you bring in images to use in doing modeling, texture and bump mapping, and other non-compositing activities.

Follow that Node!

By default, COPs will display the node that has the display flag set – not too surprising. However, that can be annoying – you might not like choosing another node, then having to follow that up with a click on the display flag in order to see the output of that node.

Help is on its way, however. Using the button in the Main bar, you can choose to have COPs display the currently selected node instead. Just click the little green box, and then whenever you move to another node, the viewport display will change with it. Note this doesn't move the display flag; in fact, it ignores it.

Limiting Color Ranges

If you bring floating point or other high-dynamic range (HDR) images into COPs, then all color correction operators work on the full HDR range; there is no automatic clamping. That means that it's possible to get odd results if you're not careful when working with these kinds of images.

It's easier to get into trouble than you might think. For example, merely increasing the contrast with a Contrast COP can cause dark colors to become negative. A Limit COP with the "Lower Limit" enabled and set to 0, and the "Upper Limit" disabled will, you know, limit these problems.

Keying in 3D

It's often useful to be able to cut out mattes based on the underlying geometry of the surface instead of the color. The Geokey COP lets you do this. It depends on having images that contain point (P) and/or normal (N) information. Mantra will render these images very easily, using the Deep Raster tab on the Mantra ROP (Render Operator).

Once you have an input image with extra planes, it's a simple matter to connect one to the GeoKey node, and then you can create a matte based on each point's distance from a point in space, from a clipping plane, or based on the angle of the normal. There is a helpcard example for this operator that explores all of these possibilities.

Using Memory Effectively

It's important to understand the trade-offs that COPs makes between memory use and processing speed, in order to get the best performance from the software.

The settings to note are in the *Edit → Preferences → Compositing → Cache* tab.

You want the Tile Size to be as large as possible – the more pixels that are available at once, the more efficient the operations. The default of 200×200 has been determined to be optimal, so you would only reduce it if you were working on very small resolution images (smaller than TV, for example). If you had more than 1 GB of RAM available, as more and more people do, then you might consider increasing the Tile Size.

(*Continued*)

The Cache Size should also be as large as possible. Remember, there are two caches – the one in this Preference tab is for cooking images. There is another one for the display – put the cursor into the COPs viewport, and hit the "d" key to get to that one.

Finally, when "Reduce Cache Size when Inactive" is enabled, after a certain period of time (~5 min), the Max Cache Size is slowly reduced from the set Cache Size to the second size (505 to 31 MB in the image shown). This causes more cooking to be performed if you aren't constantly working in COPs, but it frees up more memory for the rest of Houdini.

So if you are working consistently in COPs, increase the Max Cache Size to whatever you can spare, and turn off "Reduce Cache Size when Inactive." This should give you better overall interactivity.

Also, if you are running a dual-core machine, as many people are, then make sure that threading is turned on in the Cooking tab. COPs is able to take advantage of this nicely.

Built-In Optimizations

COPs has a very smart optimizer that tries to do the least work possible. If you understand what it is doing, you can sometime rearrange nodes to be more efficient.

The colors in this table show a coding that COPs use, and it also indicates what kinds of optimizations are being performed. For example, the beige nodes deal with frame timings, and so do not modify or cache image data; this means that computationally, they are close to "free." The blue nodes affect color, and COPs will collapse color operations that occur in series, into a single color operation – that means that whenever you can, you should try to get blue nodes lined up in a series.

COPs also never cooks or even loads frames that aren't referenced (the same is true of image planes that are not referenced) – so don't spend time worrying about trying to deal with those. Similarly, calculations are done tile by tile, so if an area of your image isn't referenced downstream, it won't be cooked.

Visualize a Character Set

You can use the Font COP to load new character sets, as well as use the built-in ones. To see what special characters are available in a font, type the following lines into a file, naming the file font.cmd.

```
opcf /img/img1
opadd font font1
opadd mosaic mosaic1
opparm font1 text ('\\\\\'$I-1'=\\'$I-1'' ) textsize
  ( 50 ) overridesize ( on )
opparm font1 size ( 200 50 ) overriderange ( on ) start
  ( 1 ) length ( 256 )
opparm mosaic1 numperline ( 8 ) imagelimit ( 256 )
opwire font1 -0 mosaic1
opset -d on -r on mosaic1
opset -d off font1
```

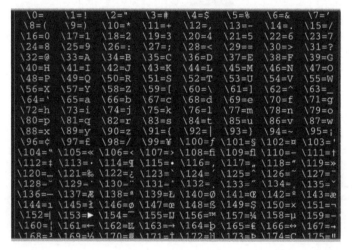

Then open Houdini, go to /img and put down an Image Network node. Open a textport, and type:

```
source font.cmd
```

The result will be something like this:

TV Safe Areas

Unlike the geometry viewer, the COPs viewer doesn't have built-in overlays for useful things like TV safe title or field charts. However, you can create these yourself, with some restrictions.

To do this, create a text file that contains the following lines:

```
# This defines TV Safe Title for NTSC
# Based on digital image size of 640 X 486
color 0.8 0.2 0.2 1
box 66 51 508 384
# Action Safe
color 0.2 0.2 0.8 1
box 32 27 576 432
```

Say you call this file NTSC_safe.txt. Then in Houdini, put the cursor in the COPs viewer and hit the "d" hotkey (just the letter d). In the dialog that pops up, go to the Viewport tab. At the bottom is a parameter called "Image Guide" – load NTSC_safe.txt in there, and hit Accept.

One drawback to this technique is that the numbers you give are absolute pixel positions, so you can't, for example, specify a working grid for lowres proxies and then just have it work when you scale up your images. Instead, you'll have to have separate files for each resolution.

Here is the description of the commands you can put into these files. All coordinates are expressed in pixels:

color R G B A	Sets the drawing color
box X Y Width Height	Draws a box at (X, Y) with the specified Width and Height
rect X1 Y1 X2 Y2	Draws a box with one corner at (X1, Y1) and the opposite corner at (X2, Y2)
line X1 Y1 X2 Y2	Draws a line from (X1, Y1) to (X2, Y2)
lines N dx dy X1 Y1 X2 Y2	Draw N lines from (X1, Y1) to (X2, Y2), offsetting both coordinate pairs by (dx, dy) each time. Use this to draw grids.

UnPin

UnPin is the opposite of Corner Pin – it allows you to define a new quadrilateral that the corners of the original image should map to. To get the handles, type the "e" key – this shows you the four corners of the image, which you can then drag around. What you are doing here is modifying the input image. Then you hit "e" again, to see the modified output, the result of what you just did.

What's cool is that once you hit "e" a second time, you'll not only see the result of the initial corner changes, but you'll also get an interactive version of this tool – as you drag the corners around, the image will update. This makes it much easier to get what you expect.

Using Vector EXpression Operators to Distort Images in COPs

The Vector EXpression Operators (VOP) COP Filter Definition is a very slick tool. It allows you to create VOP networks that act on 2D images, including using noise to perturb and distort images. As a quick introduction, go into COPs and put down a File COP to get an image. Then put down a VOP COP2 Filter Definition, and dive inside it. You can do lots of fun image manipulation with a basic structure like this:

- Put down a Global Variable VOP.

- Put down a Float to Vector VOP, and connect the X output of the Global VOP to the fval1 input of the FloatToVec. Connect Y to fval2.

- Put down a Voronoi Noise VOP. Change its signature to 3D Vector Noise, and set the 3D Vector Frequency to [5 5 5]. Connect the FloatToVec node to the "pos" input of the Voronoi Noise. *(Continued)*

- Put down a COP Input VOP. Connect u and v to the dist1 output of the Voronoi Noise. Change the COP Input's Signature to "Vector from UV," and set the number of Components to 3. Set Pixel Filtering to "Full Filtering."

- Connect the output of the COP Input node to the input of a new Vector To Float VOP.

- Finally, connect the fval1, fval2 and fval3 outputs of the Vectofloat node to the R, G, B inputs of the Output node that was already sitting there.

To use this VOP setup in a COP network, go back out to the COPs level, and RMB (right mouse button) on the VOP COP2 Filter Definition you placed down – choose "Create COP2 Type From VOP Network ..." Name it something like noisy, and then this will place a new COP, called noisy, in the tab menu. Put down one

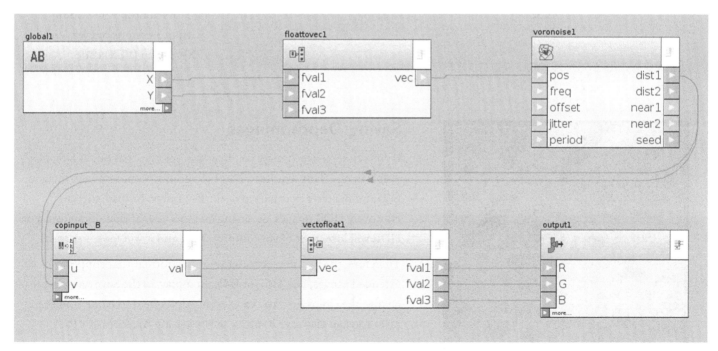

(*Continued*)

of those, connect it to your input image, and away you go.

The way to start experimenting with this is to first play with the parameters of the Voronoi Noise COP, and then start substituting other types of distortion for this operator. The basic idea is to manipulate the u and v parameters as lookups into the input image. The Voronoi Noise is one way to do it, but there are lots of others, including with expressions or even Vector EXpression (VEX) code.

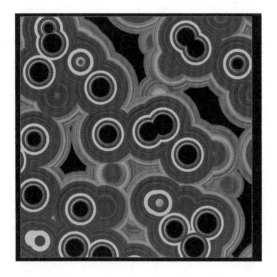

Saving Depth Images

If you render a depth map, you may want to save that out as a regular visible image. This requires a bit of cleverness, because Z map images in Houdini aren't normalized to the 0–1 range. Instead, they are effectively HDR images. So saving one to a format that doesn't support HDR will lose most of your information, and it will look incorrect.

Therefore, the best choice is to save it to a format that supports extended ranges, like TIFF or EXR. In mplay, in the Save As ... dialog, change the Color field to "Pz," set the Alpha field to None, and then save. You can also save it into a .pic by setting the scope to "Pz."

222

(Continued)

If you want to save the image to a format that doesn't support extended range, such as jpg, then you'll have to compress the range first. To do this, display the depth plane, click "Adapt to Full Pixel Range" (hotkey Shift+R) and then select *Save->Preview*. This will normalize the depth to 0–1. Then save the result.

Image Format Settings

It is possible to change the defaults that Houdini uses when you save jpeg and tiff files. The relevant file is $HH/FBoptions. You can change the default tiff depth to 16 bits, as well as many other options. The file is well documented. You can modify the contents of the distribution itself, which will change the settings for every user of Houdini.

Or you can copy this file into your $HOME/houdini9.0/directory, in which case the values will only apply to files created by you. These settings are not portable with the hip files that you create.

You can also get a list of supported file formats, and the options applicable to each, by running the standalone command:

```
% iconvert -
```

You can also use this command to check to see what settings you currently have. For example, copy the FBoptions file from $HH to $HOME/houdini9.0. Then edit the file and add the line:

```
PNG     artist     agamemnon
```

to the end of the file. Now run the iconvert command, and note that the "artist" value for that format is now "agamemnon." Of course, if your login name actually is agamemnon, then you would have seen that setting already.

Built-In Images

When you put down a File COP, you'll notice that it already has a pretty picture of a butterfly all ready for you, which is handy. You may have wondered how it is that this image – called default.pic – gets found by Houdini.

The answer is that there is a directory in the Houdini installation, which is the first place that Houdini looks for images that are not referenced with an absolute path. The directory is at:

```
$HFS/houdini/pic
```

If you look in there, you'll find almost 40 image files, all of which can be referenced just by their simple name, with no path. Some of the more useful ones of these are:

```
Mandril.pic
Wedge.pic
butterfly1.pic through butterfly7.pic
FieldGuide.pic
```

You can use these anywhere an image is required in Houdini, so one very good use of these is as a stand-in for a texture when you are just setting up a shader. Rather than wait until you have the texture you really want, just toss in the Mandril as a way of seeing if you are setting your UV coordinates correctly.

Even cooler, if you create a pic directory in $HOME/ houdini9.0/, then you can put images in there and they, too, will be found without any qualifying path. For example, do this:

```
% mkdir $HOME/houdini9.0/pic
% cp $HFS/houdini/pic/Mandril.pic $HOME/
  houdini9.0/pic/monkey.pic
```

(Continued)

Then launch Houdini, go to the compositor, put down a File COP and replace the default.pic image name with monkey.pic. You should see the Mandril image that you copied into your home directory.

Don't forget that this can also be dangerous – if you start referencing a lot of images that only you have, then other people will have trouble opening and using the .hip files you give them.

Creating a Lookup Table in COPs

Lookup tables (LUTs) are efficient ways of doing color manipulations on images you are viewing. Typically, you would create these to compensate for your monitor characteristics, and/or to match the color characteristics of some other output device that your images are intended for. Mplay lets you load up LUTs and view your images through them.

You can create an LUT using COPs. As a simple example, put down a Ramp COP, and change its size (Image tab) to 256 in X, 100 in Y (in fact, the size in Y doesn't matter). Then append to this any color correction nodes you like, such as Gamma or Color Curves. Manipulate the ramp in whatever which way makes you happy, and then RMB on the last node in the chain. Near the top, you'll see "Save LUT ..." – choose that, and save the image as, say, something.lut. Then you can load that file anyplace that Houdini wants a LUT, for example into mplay.

This example creates a 1D LUT for 8-bit images, but you can extend this to deeper images and to 3D LUTs.

Histograms

The Compositing image viewer also lets you view your image as a histogram (or, if you prefer to think of it this way, to view a histogram of your image). There are two ways to get access to this. The first is through the icon menu of any composite operator – that is a pull-down menu accessed through the icon at the left edge of the image viewer parameter bar, shown at left. At the bottom of that menu are three choices: Image, Timeline and Histogram.

The second method is through the histogram button which is always on the viewer settings bar, shown at lower left.

Either way, you'll get a histogram like the one shown below.

Loading Sequences

If you know you want to set up a composite that has many different clips as input, and you don't want to be dropping a File COP for each sequence, or if you just want to browse for clips graphically, then put the cursor into the network view, and hit the backtick key (`), often found next to the "1" key.

This will bring up a browser that lets you see images and sequences – select one or more (<ctrl>-LMB will do multiple selections), and then hit Accept. A new File COP will be dropped for each image or sequence; these will be appropriately named as well.

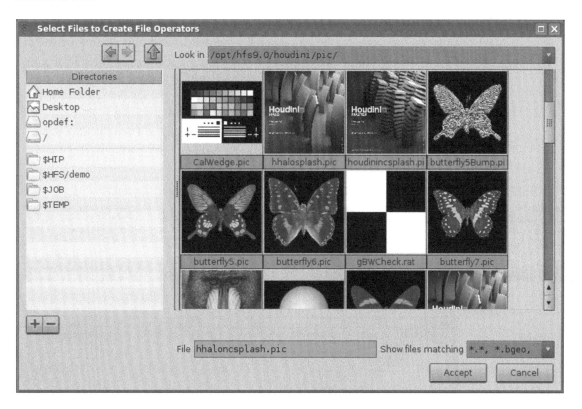

Comparing Images

The compositor gives you several useful tools for comparing images. The controls for these are found in the difference bar, which is stowed by default. It's the horizontal bar, on top of the image viewer, nearest the image.

Click on this to expand it. You can also get these controls exposed by RMB on the image, and choosing "Diff."

Next, you need two images to compare. The easiest way to choose these is to click on the display flag of one COP, and then click on the template flag of the operator you want to compare to. Alternatively, you can use the menu in the difference bar to choose an operator, but if you have lots of them in your network, the menu can be a bit hairy. On the other hand, this also allows you to choose the current Render operator or the Current operator as one side of your comparison, so you might need to use the menu just to set one of those.

Then you have to choose a difference type. The menu gives you several ways to compare images, including vertical and horizontal wipes. Then the little scroll nubbin lets you slide from one image to the other.

Reference Images

Sometimes you want to set up a new image to be "just like" an existing one, in all aspects except the actual image. That is, you want it to be the same size, the same bit depth, frame range, etc. One way to do this is to use the Reference COP, which will grab all of these details, but not copy the image itself. Then you plug the Reference COP in as, well, reference, to the node you are creating or changing. This also lets you pass around useful information about the comp you are creating, without passing the image planes themselves.

For example, put down a File node, and notice that the default image (the butterfly) has a resolution of 512×512. Now put down a Color node – the default size is 100×100. But if you connect a Reference node to the output of the File node, and then connect the output of the Reference node to the input of the Color node, the Color node output will change to 512×512.

One other thing to note is that you can do this directly – you can just plug the File node directly into the Color node, and that will also set the color and bit depths. But the Reference node is more efficient, since it doesn't carry any image planes to the Color node. In large networks, this can be important.

Sadly, you cannot set reference sizes or bit depths for the File COP.

Viewing Multiple Images

The default viewer configuration is to display up to 4 images, in a 2×2 array. You can see this by dropping in a File COP, copying it and pasting it 3 more times, and then box selecting all 4 nodes and turning on the display flag so that all are displayed at once.

Two things to notice about this:

First, you can choose to have 1 to 4 rows and 1 to 4 columns as your display. Two by two is just the default.

Second, notice that the layout of the images didn't appear until you actually had set some images to display. That is, by default Houdini displays the simplest layout it can, given the number of images you have selected for display.

But both of these things are configurable. In the Main bar of the COPs viewer, there is a menu that says "2×2" on it.

If you open this menu, you'll see that you can set the number of rows and columns to display, from 1 to 4 in each direction. More interestingly, turn off the toggle that says "Hide Blank Viewports." Now set the rows and columns to 4 each. Ah, so that's what that button does!

Background Images

The image viewer allows background images just as the geometry viewer does, and you install them in the same way. Hit the "d" hotkey, and in the dialog box choose the Background tab to choose the image that you want.

One interesting thing about this viewer though, is that there is an extra toggle that relates to the background image. If you expand the right-hand menu bar, there is a little obscure icon whose popup help says "Toggle Transparency." What that will do is to turn on (or off) the use of alpha with respect to the

(Continued)

background image. So if your elements have alpha, and this toggle is set, you will see the images blended properly with the background.

Bringing in Geometry

As well as images, you can also drag in geometry from other parts of Houdini. Just put down a Geometry COP, and point it to a Surface Operators (SOP) somewhere in your hip file. This will give you a flat shaded render of that geometry. You can transform the geometry by using the controls in the Transform tab, or, if you are a little more ambitious, you can link the transform values back to your object's transform.

Either way, this is a very quick, cheap way to get mattes or silhouettes from existing geometry.

Free the Composites!

You can reduce the amount of memory that composites use by clearing out the cache after every frame. Simply add the command:

```
compfree
```

to the Post-Frame Script parameter in the Composite ROP.

Of course, you lose the advantage of keeping partial calculations in memory, but presumably the reason you would want to do this is because holding those partial frames actually slows down your render, by forcing the machine to swap.

ON THE SPOT

Houdini Startup

The 456.cmd File

Python Startup

Change the UI Colors

Automatic Autosave

Houdini Environment Variables

Adding Additional File Formats

Using External Tools

Paths

Setting Gamma

Customize the Jump Menu

Custom Operator Menu Scripts

Middle Mouse Pan

Proto_Install: Extra Goodies

Quick Version Check

Hotkeys

New Fonts

Smarter File Numbering

Changing the Temp Directory

Configuration Files

Preference Files

Locked Preference Files

Hiding Operators

Custom Color Palettes

Default Animation Curves

Configuration Details

This chapter deals with ways to configure and customize Houdini. There are many, many ways to do this, from the way it looks to hotkeys to the default environment you are presented with when you start it up. And customization doesn't just apply to the individual user, either – you can set up different environments for different shots, or sequences or whatever.

Houdini Startup

When Houdini starts up, it reads a file called 123.cmd, which contains hscript commands, and executes the contents. The default location for this file is $HFS/houdini/scripts, but you can put your own custom version in your home directory. Houdini will use the version in your home directory, if there is one there.

So first copy the existing file, which is here:

$HFS/houdini/scripts/123.cmd

to your home directory, here:

$HOME/houdini9.0/scripts/123.cmd

Then modify your local copy of 123. cmd to set up Houdini however you like. For example, I have Houdini start with a Renderman ROP, because I will probably want one at some point, and that saves me a step later. Similarly, my default environment has an object with some actual geometry, because I often want to start that way. You can add, or subtract, anything you want to the startup Houdini environment.

One good way to start your custom 123.cmd file is to set up a hip file with the operators you like, then use the opscript command to write that setup to a 123.cmd file.

The 456.cmd File

You can also create a file called 456.cmd. By default, there is no such file, even in the standard Houdini distribution, but if you create one in your $HOME/houdini9.0/scripts directory, then this file will be executed whenever a fresh Houdini starts, and whenever you do a *File→New*. This is true even from the command line.

As you'll see if you try it, doing *File→New* means that you end up with a completely empty Houdini session. That's because there is no 456.cmd file by default. So the simplest use of the 456.cmd file is to copy the contents of 123.cmd to it, so that if you do a *File→New*, you'll get your standard startup environment.

Python Startup

New for Nine!

With python embedded in Houdini, you can use that to execute scripts at startup instead of the hscript commands in 123.cmd and 456.cmd. If you have a file called 123.py in your scripts directory, that will be run *instead* of the 123.cmd. Ditto for the 456.py file.

If you want to run your 123.cmd commands *as well* as the python script, then you can call the one from the other by putting the line:

```
hou.hscript("source -q 123.cmd")
```

into your 123.py script (and of course similarly for the 456.py script file).

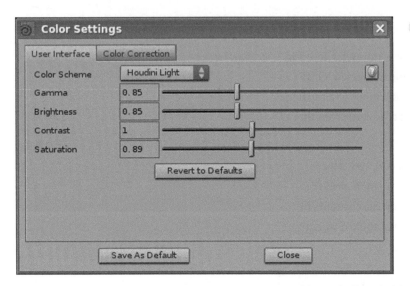

Change the UI Colors

The UI color schemes are defined in a set of files in the $HH/config directory. By default, you've got UILight.hcs and UIDark.hcs. If you want to, you can edit these and change the color scheme.

But a much better, safer way to do this is to create your own hcs files in your home directory. Start by copying whichever file is closest to what you want, say $HH/config/UILight.hcs, into $HOME/houdini9.0/config. Name it something else, like MyScheme.hcs. Make it writable, and edit the first line to change the label that shows up in the menu.

This file, and all such files, will be picked up by Houdini and presented to you in the configuration menu. You get to this menu by choosing *Edit → Color Settings*, and the menu is called Color Scheme.

Why would you want to do this? Well, you can amuse yourself during renders, or play fun tricks on other Houdini users by covering their screens in garish colors. But one actually useful purpose for this would be to choose visibly different colors for items that have been badly chosen. For example, the color for a node that is a Digital Asset is light blue, and the color for a node that has a comment is dark blue. These are hard to distinguish when it is just a small label.

If you change the comment color line in UILight.hcs to something else, say:

```
OpNameCommentsColor: 0.9 0.9 0.0
```

(Continued)

then you get something easier to distinguish from light blue:

And the other fertile area for color manipulation is in the DOPs Detail View – you can change the color of Data, or Objects, to be something you like better. These are the lines you'll want to play with:

```
DopInOutObjectColor: 0.65 0.65 0.65
DopInOutDataColor: 0.50 0.80 0.50
DopInOutRelDataColor: 0.20 0.60 0.20
DopInOutAnyColor: 0.9 0.9 0.9
```

As well as the lines that define the colors for DOP objects, data and records (SIMObjectColor, SIMDataColor and SIMRecordColor, respectively), and so make it more obvious which is which.

Automatic Autosave

The autosave feature is not something that can be set to be on, um, automatically. Instead, you have to enable it each time you launch Houdini. This was done on purpose, as hip files can be quite large, and it was felt that users wouldn't want all that data being written without being aware of it.

But you may disagree. You may want this feature enabled all the time, without having to think about it each time you start Houdini. To accomplish this, there is the "autosave" command. You could add a line to the 123.cmd that says:

```
autosave on
```

and the feature will be enabled each time you load (or reload) Houdini.

One problem with this approach, though, is that when you first start an empty Houdini session, you'll get "untitled.hip" being autosaved until you save it with a name. So a better way to do this is to put this little script in your 456.cmd file:

```
# Ask about turning on Autosave
# but only if running interactive Houdini session!
set fullver = `run("version -n")`
set app = `arg($fullver,0)`
if(`strcmp($app, "hbatch")` <0)
    set turnOn = `run("message -b Yes,No -d 0 Turn on
        Autosave?")`
    if ($turnOn == 0)
      autosave on
    endif
endif
```

Houdini Environment Variables

There are a lot of environment variables that you can set to modify the way that Houdini works, or to tell it where to look for things, or many other things. You can get a list of them by typing:

```
hconfig -a
```

and you can get help on any given one by typing:

```
hconfig -h <VARIABLE>
```

for example:

```
hconfig -h MANTRA_BIAS_NORMAL
```

returns

```
MANTRA_BIAS_NORMAL
    Specifies that biasing for ray tracing operations in
    mantra should operate along the normal vector rather
    than along the outgoing ray.
```

Probably the most commonly used of these is HOUDINI_UISCALE, which controls the size of the text and icons in the UI. The default value is 100; numbers less than 100 will make the text smaller, and so give you more layout area to work with, while values greater than 100 will help your eyesight. Many people prefer this setting:

```
setenv HOUDINI_UISCALE 80
```

in order to maximize screen space. You've also got HOUDINI_OVERRIDE_ XRES and YRES, which allow you to set specific XY resolutions. That can be useful if you are trying to set up the display to work with a projector.

On Windows, you set these up by doing right mouse button (RMB) on the My Computer icon, then choosing Properties. In that dialog, choose the Advanced tab, and click on the button labeled Environment Variables. You can create these variables just for yourself, or for the entire system.

Adding Additional File Formats

If you've got custom file formats you want Houdini to be able to handle, then you can add them to the FBio table. This is found in the $HH directory, and like most customization files, contains comments and examples that are fairly self-explanatory.

Essentially, for a given file extension, you define a procedure to read the custom file format and write a Houdini file format to stdout. And you define a similar procedure to read a Houdini format from stdin and create a custom file. Generically, this looks like:

```
<format> <read_command> <write_command>
```

The simplest examples involve using a custom program that does the conversion directly, such as the "fromaccom" and "toaccom" commands that come as part of the standard Houdini installation. These commands go directly back and forth from the Accom image format to the SESI .pic format, so the lines describing them in the FBio file are very simple:

```
.acc "$HFS/houdini/sbin/fromaccom %s" "$HFS/houdini/sbin/
toaccom %s"
.accom "$HFS/houdini/sbin/fromaccom %s" "$HFS/houdini/sbin/
toaccom %s"
```

More complex examples involve creating intermediate files, and then removing them when the process is finished. For example, handling the RenderMan .tex file format looks like this:

```
.tex "sho -dspy tiff -dspyfile /tmp/$$.tif %s 2>/dev/null ;
icp /tmp/$$.tif stdout ; exec rm -f /tmp/$$.tif" "icp stdin
/tmp/$$.tif ; txmake -mode clamp /tmp/$$.tif %s ; exec rm -f
/tmp/$$.tif"
```

(Continued)

This uses .tif files as an intermediate bridging format. It also uses the construction $$ to create a uniquely named file each time the command is run.

You can do the same thing with geometry file formats, using the GEOio file. For example, if you add the line:

```
.bz2 "bzcat %s" "bzip2 > %s"
```

to the file $HOME/houdini9.0/GEOio, you will be able to directly reference geometry files of the form "name.bgeo.bz2," which will automatically be compressed/uncompressed as the situation requires.

Using External Tools

You can use external tools directly in a Surface Operator (SOP) chain in Houdini, by using the Unix SOP. This operator does not actually require Unix – it will work just as well on Windows. The general usage is:

```
command infile outfile
```

The infile and the outfile can be anything, but if you want to process incoming Houdini geometry, then the infile will be stdin.geo (ASCII) or stdin.bgeo (binary). In this case, your external program will need to be able to read Houdini's geometry format. Similarly, if you want the result to be usable by the next SOP, the outfile has to be either stdout.bgeo or stdout.geo. The default Unix SOP shows an example of this.

Paths

For dealing with directories, there are two types of environment variables – paths and locations.

Paths variables, such as HOUDINI_SCRIPT_PATH, can define more than one path, and these paths are searched, in the order they appear, to find files of a certain type.

Location variables, like $HSITE or $HIP, specify the location of a particular directory. $HIP, for example, is set to the directory that the current .hip file was opened in. Often these locations are used within the path variables. However, you can't have multiple directories in a location variable – instead, they define a unique location on disk. Their purpose is to avoid having hardcoded file paths. For example:

```
$HIP/geo/model.bgeo
```

instead of:

```
/mnt/fileserver/show/act1/scene1/geo/model.bgeo
```

This makes the hip file much more portable, and allows different people to work on it on different machines (or even operating systems) without working about locations or pathname conventions. So, you can set $HSITE to some common root directory, such as your main file server.

The other way that you could specify the path to "model.bgeo" in a parameter is to modify the HOUDINI_GEOMETRY_PATH, which by default is:

```
./
$HOUDINI_PATH/geo/
```

(Continued)

You could change the path so that it looks like:

```
./
```

```
$HIP/geo/
$HOUDINI_PATH/geo/
```

and then simply enter "model.bgeo" in the file parameter. If no path is specified as part of the filename, then $HOUDINI_GEOMETRY_PATH is searched for that file. In this case, it will find it in $HIP/geo/model.bgeo.

Other important Houdini paths:

Path	Use
HOUDINI_PATH	Base path for searches
HOUDINI_CLIP_PATH	Channel file locations
HOUDINI_DSO_PATH	Custom plug-ins
HOUDINI_GEOMETRY_PATH	Geometry files
HOUDINI_MACRO_PATH	Toolbar macro files
HOUDINI_OPLIBRARIES_PATH	Loading OTLs at startup
HOUDINI_OUTLINEFONT_PATH	Fonts for Font SOP/Font COP
HOUDINI_SCRIPT_PATH	Scripts including 123.cmd
HOUDINI_SOHO_PATH	Scripted outputs
HOUDINI_TEXTURE_PATH	Loading images
HOUDINI_TOOLBAR_PATH	Network pane toolbars
HOUDINI_VEX_PATH	VEX code locations

There are a few other paths also defined and used by Houdini that are not listed here. For information on all the paths, including how to set them up, run:

```
hconfig -ap
```

```
                Directories
  Home Folder
  Desktop
  opdef:
  /

  $HIP
  $HFS/demo
  $JOB
  /usr/tmp
  $TEMP

  $HOME/Images/
  $JOB/Scenes/Geometry/
  /opt/my_favorites/comm
```

Setting Gamma

In Houdini, the easiest way to set the default Gamma and LUT is through the *Edit → Color Settings* dialog, then look in the Color Correction tab. This is an interface to the colorsettings command, which can be put in a 123.cmd file. These settings are for viewing images in the viewport. In that same dialog, in the User Interface tab, are settings for changing the way the UI looks, so that you can darken it.

For Mplay, go to *Options → Display Options → Correction* and choose "Save As Default."

Customize the Jump Menu

When you open the file browser for reading or writing files, there is a jump menu that lets you jump to certain pre-defined locations. This menu is the bottom of the Directories section of the file browser.

You can add to this set by creating a file called:

$HOME/houdini9.0/jump.pref

Each line in that file will be added to the jump menu. There is no context information – all file browsers in all contexts will have the same entries.

Custom Operator Menu Scripts

You can create custom entries for the RMB menu by doing this:

First, create the file

```
$HOME/houdini9.0/OPmenu
```

put this line in it

```
Object/subnet saveOut "Save this subnet" saveExample.cmd
```

Second, create a file called saveExample.cmd and put it into:

```
$HOME/houdini9.0/scripts
```

Then this appears on the right mouse menu on a node of that type. You don't even need to restart Houdini – just issue the command "menurefresh" from the textport. There is more documentation inside the Opmenu file contained in the Houdini distribution – you'll find that at $HH/OPmenu.

Middle Mouse Pan

Long-time Houdini users may find the switch of mouse keys in Houdini 9 to be just too much to cope with. You can switch them back by setting the environment variable HOUDINI_MMB_PAN, as in:

```
% setenv HOUDINI_MMB_PAN 0
```

The the middle mouse will zoom and the RMB will pan, as they did in Houdini 8.

Proto_Install: Extra Goodies

Houdini ships with a number of operators that are not part of the standard package, but which do useful things. The distinction is that these items are provided on an "as is" basis, and you can't ask for support if one of them goes haywire. Well, you can ask...

To get access to these extras, Linux users just type:

```
% proto_install
```

at the command line. Windows users need to run *Programs→Side Effects Software→Houdini 9.0.xxx→Command Line Tools*, then in the window that opens, type the proto_install command as shown.

You'll be presented with a list of available items. Some of the SOPs are very useful, such as the ScatterMeta SOP. And the number one most common installation to make from this menu is RManDisplay, which will allow your Renderman renders to go into a standard mplay window. If you are using Renderman, you definitely want to install this tool.

Quick Version Check

Sometimes you want to know the version of Houdini that was used to create a given .hip file. This information is actually stored in every .hip file, and the quickest way to get at it is to issue this command on Linux or in a cygwin shell:

```
% grep -a VERSION thing.hip
```

The -a is important, because .hip files are not pure ASCII files, and so without the -a flag, grep will get confused.

Hotkeys

Users sometimes ask if they can print out a list of hotkeys. The answer, so far, is no. But what you can do is print out a list of the custom hotkeys that you have created, as well as the hotkeys you have overridden with your own changes.

When you modify hotkeys, a file in your home directory is updated. That file can be found at:

`$HOME/houdini9.0/HotkeyOverrides`

Pretty easy to remember. Just print that out, and you're all set.

New Fonts

Houdini will use any Type 1 and Truetype fonts. To install new ones, find a (copyright free) font someplace online, or of course you can buy them. Create a directory where you will keep these fonts, unzip the font and put it in there. There is an environment variable that points to the font directory – the best way to proceed is to update it to point to your new directory, for example:

`setenv HOUDINI_OUTLINEFONT_PATH $HOME/myFonts`

(Continued)

Next, copy all the existing Houdini fonts into your new directory. This is because Houdini seems to only be happy with one single font directory. So, in Linux, you would do this:

```
cp $HH/fonts/* $HOME/myFonts
rm $HOME/myFonts/font.index
```

The second line removes the font index file, which describes what is in the directory. You need to do that because the original one does not have write permissions and so won't let you update it. If you're feeling techy, you can just give that file write permissions instead of removing it.

Now start Houdini, and in the Font SOP or the Font COP, launch the Font Manager (or alternatively, use the standalone application gfont – launch that with the command gfont -i). Then choose *File→Load Specific Font*, navigate to the new directory and select the new font. Do *File→Rescan Directory*, and then *File→ Save* – this updates the font.index file for future reference.

Now you're all set, and to add additional fonts, all you have to do is dump them into the new directory, and rescan to find them. After that, they will always be available.

Smarter File Numbering

If you have the file save option that automatically increments the file number each time you save your work (*Edit→Preferences→Save Options*) then if you start with number 1 (which seems completely reasonable), you will get files numbered 1, 2, 3, etc., with no leading zero. This may be easier to read, but for both Linux and Windows, it means that the files will appear in a strange order, namely:

```
untitled1.hip
untitled10.hip
```

(Continued)

```
untitled100.hip
untitled11.hip
...
untitled2.hip
untitled21.hip
```

etc.

To fix this, name your first file with leading zeros, for example, myFile001.hip.

More interesting, if you have the numbered backup feature enabled, then by default your backups will be called "myFile_auto1.hip," "myFile_auto2.hip," etc. (assuming your original file is "myFile.hip"). This will lead to the same name sorting problem as before. To get around this, you can use the Houdini environment variable:

```
HOUDINI_BACKUP_FILENAME
```

By default, this is set to $BASENAME_auto$N, where $BASENAME will evaluate to your filename, and $N to the numbered backup. But if you set it to this:

```
% setenv HOUDINI_BACKUP_FILENAME '$BASENAME_auto$N3'
```

then you will get 3 digits in the file number, which will be zero padded – in other words, "myFile_auto001.hip," etc. For more information, type:

```
% hconfig -h HOUDINI_BACKUP_FILENAME
```

This technique also applies to the autosave files; see:

```
% hconfig -h HOUDINI_AUTOSAVE_FILENAME
```

Changing the Temp Directory

Of course, Houdini never crashes, but if it did, it would try to save the current session to a hip file in a temp directory. By default, it uses /tmp (on Linux) unless the environment variable HOUDINI_TEMP_DIR is set. So you can change the location of these temporary files by doing:

```
setenv HOUDINI_TEMP_DIR /some/large/directory
```

which will save those files in some large directory.

It's worth noting that it isn't just crashes that get saved in the temp directory – DOPs also puts all its cache files there, and Houdini also uses it for buffer space for copy/paste operations. So you'd like to set it to a directory that is sufficiently large. Especially since, if it fills up, Houdini will stop working without telling you!

Configuration Files

Houdini has a lot of configuration files, so that you can customize its little pants off. You'll find them in the installation under "houdini," that is, /opt/hfs9.0/houdini (or, for Linux users, just $HH). Most of them have enough comments inside them to explain how they should be used and modified.

The best thing to do is to copy the file to your own home directory, and modify that. For example, copy the file $HH/FBres to $HOME/houdini9.0/FBres, and then edit the copy to add this line at the top of the list of formats:

```
720 1920 1.0 "Portrait Format"
```

Save the file, run Houdini, and look in the Composite ROP where you specify the output resolution. There will be your new portrait format entry.

Preference Files

Houdini also has a lot of preference files. These are easy to spot –they are in your home directory, under $HOME/houdini9.0, and they end in .pref. These are not as well documented a s the configuration files – in fact, they have no comments at all – but you can sometimes puzzle out what they are doing from their contents.

What is more interesting is that there are several .pref files that are not in the directory by default, but which Houdini will recognize and use if they exist. The most well known (and useful) of these is the jump.pref file discussed elsewhere. Here is a list of all the preference files that I know of at the time of this writing, with the hidden ones noted. This information is subject to change, so your mileage may vary.

colors.pref	hchannel.pref	hnetwork.pref *	mplay.pref
compdisplay.pref	hcommon.pref *	hopmanager.pref *	.sesi_licenses.pref
desktops.pref *	hcomposite.pref *	houdini.pref *	stoolbars.pref
display.pref *	hhalo.pref	hworksheet.pref	toolbars.pref *
gplay.pref *	hkey.pref *	ipaint.pref *	tool.pref *
hchanneleditor.pref	hlister.pref	jump.pref	

*These are included in default installation.

Locked Preference Files

Really useful tip: If you put .nosave on the end of a .pref file, then it can't be changed by a user in Houdini! This is especially useful for the hopmanager.pref file, so that a facility can set up how Houdini Digital Assets (HDAs) should behave, then lock it down with (in Linux):

```
% chmod a-w hopmanager.pref.nosave
```

to prevent people from doing bad things like saving their HDAs to the .hip file.

Hiding Operators

You can hide operators, either for all Houdini sessions or for the current session. You might want to do this if you are creating new operators, or custom versions of existing ones. Say you created a new version of the File SOP, and you wanted to make sure that users used that one instead of the regular Houdini version.

You hide operators by copying the file:

```
$HFS/OPcustomize
```

into your $HOME directory, and then modifying the local copy. The format of the file is described in the file itself, but in essence, what you do is use the ophide command.

You can use the ophide command directly, to hide an operator within a single Houdini session. As an example, if you open a textport and type:

```
-> ophide Sop sphere
```

then the sphere operator will no longer be visible in the tab menu of the SOP editor. This does not persist for subsequent runs of Houdini, and it doesn't even get saved with the current session – so if you really want to hide an operator consistently, use the OPcustomize file or put the ophide command into your 123.cmd file.

There is also opexclude, which will remove the operator type, so that it can't be created in any way (for example, by scripting). However, this only works for operator types that are not already present in the current hip file, so you can't exclude geometry objects if there are already geometry objects in the current file. That's why if you try the example in the help, you get error messages:

```
-> opexclude Object geo light
opexclude: invalid operator geo
opexclude: invalid operator light
```

Custom Color Palettes

Houdini supports customized palettes that you can access from the Color List button in the color picker gadget. To add your own palettes, add files in the following directory:

```
$HOME/houdini9.0/config/ColorPalettes
```

The files are text files with the following format:

```
r g b ColorName
```

Where r, g and b are RGB values from 0 to 255, and ColorName is a name for the color. Each color is defined on a new line.

The ColorPalettes directory is searched for under the /config directory in the HOUDINI_PATH and HOUDINI_UI_PATH directories.

Default Animation Curves

The default animation curve type between keyframes is the cubic() function. But many animators prefer to use bezier() curves as the default. You can change this by going to *"Edit → Main Preferences → Animation."* There you'll find a preference for translation and most other channel types, as well as a separate preference for rotation channels – set them to whatever functions you like.

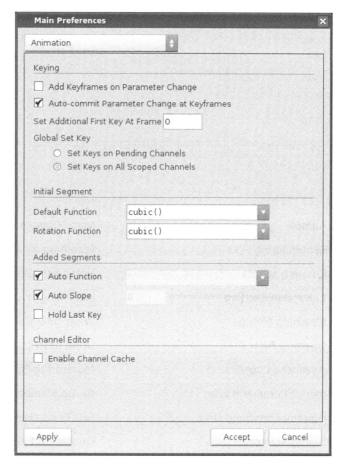

ON THE SPOT

Aliases	Name Completion	Debugging Paths
Renumbering Files	Searching for Help	Script Select
Creation Scripts	Getting the Message	Magic Path Expansion
Expression Caching	Launching Houdini	Using Timecode
Matching Groups	What Operators Do I Have?	Getting Property Parameter Values
Opening Ports	Using opscript to Discover Parameters	Understanding Ranges
Advanced Copy/Stamp	Monitoring Performance	Referring to Myself
hscript Command Echo	Group Members	HDK User Reference
Houdini Command Line	Less Popup Help	Embedded Functions
Saving Memory	Quotes for Efficiency	Expression Parameters
Quieter hbatch	Variable Modification	

Miscellaneous Tips

This chapter is mostly about scripting in Houdini, but it also contains little nuggets of wisdom to do with file formats, searching for help, and just using the software more efficiently and effectively. It's the Lucky Dip of tips and tricks.

Aliases

When you start Houdini, and then open a textport, you can navigate through the network levels using common unix commands like "cd" and "ls." But these commands are not part of hscript – instead, these commands are created for you as aliases, courtesy of the 123.cmd file.

You can use this fact to create other custom aliases for yourself, to make whatever scripting or navigation work that you are doing, simpler. Just type "alias" in the textport to see how these are set up. And feel free to put common alias definitions into the 123.cmd file – that's what it's there for.

Or you can create aliases that are associated with just a given hip file. You can create them in the textport, by using the alias command. Or if you want a graphical interface for this, go to *Edit → Aliases and Variables*. Or just use the <alt>-A hotkey.

Renumbering Files

Sometimes you need to read in a sequence of files, but offset from their original numbering. For example, you have a sequence of .bgeo files that are numbered from 1 to 100, but you want to ignore the first 9 of them, so that frame 10 on disk becomes frame 1 in the hip file, etc.

The answer is to put an expression, based on $F, in the File SOP input field, such as:

`$GEO/myfiles.`$F-9`.bgeo`

(Continued)

If the file numbers are zero padded (for example, myfiles.0001.bgeo) use the padzero() function in an expression like:

```
$GEO/myfiles.`padzero(4,$F-9)`.bgeo
```

You can also use clamp() to make sure that you don't generate frame numbers that don't exist. For example:

```
$GEO/myfiles.`padzero(4,clamp($F-9,1,100))`.bgeo
```

will make sure that you don't ask for frame numbers less than 1 or more than 100.

Creation Scripts

Houdini has the ability to run a specific script whenever a node of a given type is created. Houdini will search the regular script paths for a directory with the type name (for example, SOP, obj, etc.) followed by the name of the node with the ".cmd" extension. The name of the operator is passed into the script as "$arg1."

So for example the following script:

```
$HOME/houdini9.0/scripts/sop/polyextrude.cmd
```

will run everytime a PolyExtrude SOP is created.

To test this, put the line:

```
message "my name is $arg1"
```

into the polyextrude.cmd file, and then launch Houdini and put down a PolyExtrude SOP.

Expression Caching

In *Edit → Preferences → Animation*, there is a preference at the bottom labeled Enable Channel Cache. This will cache up the results of expressions that are referenced in the channel editor. This is most useful when using expressions that reference Surface Operators (SOPs) which require the SOP to cook during expression evaluation. By turning this on, you will improve interactive speed for complex setups, especially ones involving animation rigs.

Matching Groups

It often happens that you want to select a set of points, say, based on their attribute values. But if these values don't form a pattern, then you may be left with a very long expression in your Group SOP expression field that looks like this:

```
$ATT == 1 || $ATT == 4 || $ATT == 5 || $ATT == 12 etc
```

Instead of this growing string, however, you can take advantage of a quirk in the strmatch() function, that allows it to take comma-separated strings as a set of patterns. Thus the above could be shortened to this:

```
strmatch("1,4,5,12", $ATT)
```

Easier to type and easier to read.

Opening Ports

How do you connect a running instance of Houdini with another, separate process feeding it commands? With the openport command and the hcommand application. In the textport in Houdini, use openport:

```
/ -> openport -a

Opened 13221
```

Then in a shell, you can use hcommand to connect to Houdini and run commands, for example:

```
hcommand 13221 message "hello world"
```

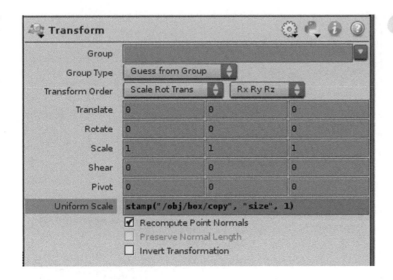

Advanced Copy/Stamp

Remember that the syntax for the stamp() function, used with copy/stamping, is this:

```
stamp("../a_node", "a_value", default)
```

Why, you may ask, does it need the "../a_node" argument? The answer is that this gives Houdini context when cooking, so that it knows which set of nodes to recook and which to ignore. And what, you may ask, does that do for me, a humble Houdini user?

The answer is that it means that stamping can work across networks, to get at anything that the input to the copy depends on. So you can copy/stamp through, for example, Object Merge SOPs and Shader SOPs. To understand this, try this example:

- At the object level, create a Torus. Name this object torus, just for kicks. Now go into the torus object, and append to the Torus SOP a Transform SOP. Set the display flag on this SOP. Set the script type for the Transform to hscript (use the big H menu in the parameter pane) and then, in the Uniform Scale parameter, enter this expression:

  ```
  stamp("/obj/box/copy", "size", 1)
  ```

- Go back up to the object level, and put down a Box object. Name it "box" (no quotes). Go inside the SOP Network for box. Make the box size (3, 3, 3).

- Put down an Object Merge SOP. At the bottom of the parameters, set the Object 1 string to /obj/torus.

- Put down a Copy SOP. Connect the Object Merge to the first input, and connect the Box SOP to the second input. Set the display flag on the Copy SOP.

(Continued)

- In the Copy SOP, go to the Stamp tab. Turn on Stamp Inputs. Set the scripting language to hscript. For Variable 1, enter "size" (no quotes) and for Value 1, enter:

 rand($PT)

You should see this image.

What is happening is that the Transform SOP in the other network knows that it needs to cook because the Copy SOP in this network requires input. So it does, using the variable "size" that the Copy SOP makes available to it. This same idea can work across arbitrary Houdini Networks to do all kinds of useful things.

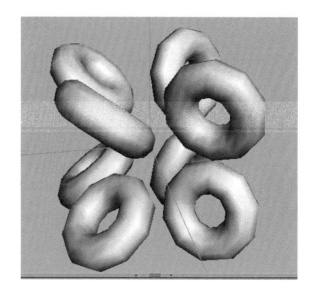

hscript Command Echo

Sometimes people ask for the Houdini version of the Maya feature where you can have every action echoed, as a command, to the textport. There is no direct equivalent to this in Houdini, because the underlying way that Houdini works is different. However, you can open a textport in Houdini and type:

 > commandecho on

This will tell you which hscript commands are being executed, which can be helpful when debugging some things, such as callback scripts from the creation of a Houdini Digital Asset (HDA) or a button push.

Houdini Command Line

If you are using Linux, (or cygwin under Windows), then it's worth knowing that you can launch Houdini (and hbatch) with many options. You can put any number of .hip, .cmd and/or .otl files on the command line. If you specify multiple .hip files, they are merged together into one session.

If you specify .cmd files, then the hscript in those files is executed on startup. And if you name .otl files, then those are installed into the current session of Houdini. So:

```
% houdini mynodes.otl yournodes.otl
```

will launch Houdini with all the digital assets in the mynodes.otl file and the yournodes.otl file installed and ready to use.

Saving Memory

If you have a very heavy SOP Network, you can optimize it a bit by going into the SOP Network editor, and changing the display to list mode (hotkey "t"). Then select all (hotkey "a") and toggle off all the yellow flags for Highlight, by clicking any yellow flag in the "H" column.

It may seem small but it will speed things up a little bit. When you get into 1500+ nodes for a rig inside a character HDA, every bit of information you can let go off will help save memory.

Quieter hbatch

When hbatch starts up, it prints out version information, like this:

```
% hbatch
hbatch Version 9.0.530 (Compiled on 03/09/07)
```

In some scripting situations, especially when hbatch is embedded in a shell script or other external program, this output information can get in the way. The -q option suppresses this message.

```
% hbatch -q
```

Name Completion

If you have the popup help enabled in the textport and/or the parameter fields (*Edit → Preferences → General User Interface*), then as you type you'll get a list of commands that would complete the word you're typing. For example, in the textport, if you type "ops" you'll get a popup of the commands that begin with those three letters.

Once you've typed enough letters to narrow it down to a single possibility, you can hit <tab> and it will finish typing the command name for you, and you can continue to type the command string.

Searching for Help

There are several additional ways to find the help you are looking for. First, in the location field of the hbrowser:

- Type cmd *name* to go directly to the help for a command.

- Type exp *name* for expressions.

- Type vex *name* for vex functions.

- Type op *net name* for operators.

Second, parameter names are indexed in a field named "parm." So, to find all operators with a parameter with a name containing "range," search for:

Third, you can use AND and OR in the search field in hbrowser. The default for multiple search terms is OR.

Finally, in the textport:

```
help -k <string>
```

searches the help text for any matches to *string*. For example:

```
help -k find
```

returns

```
dopsolveadddata              opfind
otcontentls  otls
opchange     opglob
otcontentsave                otunload
opdepend     otconfig         otcopy
```

which are all commands that have the word "find" in the help text.

Getting the Message

We use the "message" command as an example all through this book – now lets find out how to use it properly.

The "message" command allows you to ask for a response, and if you're doing that, you'd probably like to know what that response is. Try this simple example in a Houdini textport:

```
set pill = `run("message -b Red,Blue -d 0 Which pill?")`
echo $pill
```

The result put into "pill" is a value, starting at 0, that corresponds to the user's choice. So in this example, Red is 0 and Blue is 1. The -d argument specifies the default choice, again numbered from zero, that the user will get if she just hits <return>. If there is an error, the returned result is -1. If you want the returned result to be the label string, not a number like 1, then use the -p option.

Also, the choices (in this case, Red and Blue) need to be enclosed in quotes if you want spaces in them. For example, type this in a textport:

```
message -b "Save and Exit,Discard and Exit,Cancel" -d 0 Your
   Choice?
```

Launching Houdini

Houdini takes many command-line arguments that can modify the session you are about to launch. Here are a few useful ones:

- You can start Houdini in a specific desktop with the "-s" flag. For example:

  ```
  % houdini -s Dynamics file.hip
  ```

 will open file.hip with the Dynamics desktop selected. Of course, you can also use this method to open a new Houdini session with a particular desktop.

- You can start Houdini with multiple hip files named on the command line – this will merge all of those hip files into one session. For example:

  ```
  % houdini torus.hip sphere.hip
  ```

 will create a single Houdini session with all of the nodes from both hip files. Where there are naming conflicts (such as with cameras), the names will be modified with numbers, such as cam1, cam2, etc.

- Some Linux users find that the Houdini window doesn't completely fill their screens. You can fix this by specifying the screen resolution on the command line, like so:

  ```
  % houdini -geometry 1600×1200+0+0
  ```

 assuming your display is 1600 by 1200, of course. Once you have a command line that works, you

(Continued)

```
% alias h houdini -geometry 1600X1200+0+0
```

and then you can just type:

```
% h
```

to launch Houdini.

The other possibility is to set the environment variables:

```
HOUDINI_OVERRIDE_XRES
HOUDINI_OVERRIDE_YRES
```

to the values you need. In the above case you would do:

```
% setenv HOUDINI_OVERRIDE_XRES 1600
% setenv HOUDINI_OVERRIDE_YRES 1200
% houdini
```

to get what you want.

- You can launch Houdini with a digital asset (or several) as the input argument, for example:

```
% houdini customStuff.otl
```

This is equivalent to loading the OTL file(s) via the *Install Digital Asset Library* ... option, but quicker and easier.

- Finally, you can launch Houdini with one or more .cmd files on the command line. This will launch Houdini, then run the hscript they contain, in order. This can be very handy for doing some tricky things, such as ensuring ports are opened on launch.

To see the complete list, type:

```
% houdini -h
```

And all of these options apply to hbatch as well (well, except for the ones that deal with the UI display, of course).

What Operators Do I Have?

Using the opadd command with no arguments will list all the available operators in that context. For example, open a textport and type the following:

```
cd /obj
opadd
```

The result will be:

```
Available operators
```

>chopnet	CHOP Network
>cop2net	COP2 Network
>popnet	POP Network
>ropnet	ROP Network
>shopnet	SHOP Network
>vopnet	VOP Network
>ambient	Ambient Light
>auto_rig_biped	Auto Rig Biped
>biped_animation_rig	Biped Animation Rig
>biped_capture_rig	Biped Capture Rig
>body_part_arm	Body Part Arm
>body_part_arm_hand_print	Body Part Arm Hand Print
>body_part_hand	Body Part Hand
>body_part_headAndNeck	Body Part Head And Neck
>body_part_leg	Body Part Leg
>body_part_spine	Body Part Spine
>body_part_spine_curve_end_cv	Body Part Spine Curve End CV
>bone	Bone
>cam	Camera

(Continued)

```
>ctrl_handle_auto_rig          Control Handle Auto Rig
>dopnet                        DOP Network
>fetch                         Fetch
>fog                           Atmosphere
>force                         Force
>geo                           Geometry
>light                         Light
>microphone                    Microphone
>muscle                        Muscle
>null                          Null
>path                          Path
>pathcv                        PathCV
>rivet                         Rivet
>sound                         Sound
>sticky                        Sticky
>subnet                        SubNetwork
>blend                         Blend
>handle                        Handle
>switcher                      Switcher
```

```
┌─────────────────────────────────────────────────────┐
│ ◎ Textport                              _ □ ✕        │
├─────────────────────────────────────────────────────┤
│ Director -> cd /out                                   │
│ Director -> opscript mantral                          │
│ # Automatically generated script: Tuesday March 20, 21:59 │
│ \set noalias = 1                                      │
│ set saved_path = `execute("oppwf")`                   │
│ opcf /out                                             │
│                                                       │
│ # Node mantral (Driver/ifd)                           │
│ opadd -n ifd mantral                                  │
│ oplocate -x 2.73357 -y 4.8112 mantral                 │
│ opspareds "" mantral                                  │
│ opparm mantral execute ( 0 ) renderdialog ( 0 ) trange ( off ) f ( 1 240 1 ) ta │
│ chlock mantral -*                                     │
│ chautoscope mantral -*                                │
│ opcolor -c 0.8 0.8 0.8 mantral                        │
│ opset -d off -r off -h off -f off -y off -t off -l off -s off -u off -c off -e │
│                                                       │
│ opcf /out                                             │
│ opcf $saved_path                                      │
│ Director ->                                           │
│                                              ◀ ▶      │
└─────────────────────────────────────────────────────┘
```

Using opscript to Discover Parameters

Frequently you'd like to script the change to a particular parameter, but you don't know what it's called. The standard way to find out is to use opscript to see the parameter names (and possible arguments) and then use opparm to set them.

For example, say you want to script the mantra1 Render Operator (ROP) to change the render resolution. First, in a textport, you'd do this:

```
/ -> cd /out
/ -> opscript mantra1
```

and the result would be a bunch of commands, including the opparm command, which stretches out horizontally. It looks like this (I've left out a lot of parameters to save space):

```
opparm mantra1 execute ( 0 ) renderdialog ( 0 ) trange
  ( off ) f ( 1 240 1 ) take ( _current_ ) … blur ( none )
  tres ( off ) res ( 320 243 ) resmenu ( "1920 1080 1.0")
  aspect ( 1 ) …
```

The one we want is "res (320 243)," and so we can change the value in our script with the command:

```
opparm mantra1 res 640 480
```

Monitoring Performance

There are several places in this book where we discuss ways to increase playback or interactive speed. A reasonable question would be: How do we know we are increasing performance, and how can we measure that increase?

The tool for this is the Performance Monitor (who would have thought?) which you will find under *Windows -> Performance Monitor*.

A quick introduction to this nifty tool would be to try the following:

● Open the performance monitor

● On the playbar, change the playback to Play Once

● Click on Enable Output in the Performance Monitor Window

● Hit Play on the playbar (or just the up arrow key).

When your animation has played once to the end, uncheck the Enable Output button.

You can look through the output to see what is going on. One very quick thing to look at, is to scroll near the end and find lines that look like this:

```
End Frame 239:        12.54 ms      79.74 Hz
Unaccounted Time:      7.41 ms
Average of 238:       18.81 ms      53.17 Hz
```

This tells you that, after 238 frames of playback, you were getting an update rate of 53.17 hz, or really just 53 frames per second. It also tells you that frame 239 was much quicker than that, with an update rate on just that frame of 79, nearly 80 frames per second.

(Continued)

You can use this information to measure the effect of various changes that you make, to see which ones are having a useful effect, and which are not, as well as to know how great that effect is.

The performance monitor is also very useful if you find yourself in a situation where Houdini just keeps cooking and never seems to stop and you have to kill it. In this case, what you want to do it set the Output to Standard Output, and everything Houdini is doing will be dumped to stdout (standard out), which on Linux is the shell Houdini was started in. You can then see where things stop happening.

Group Members

You can use the funny-sounding command "opglob" to print out the members of a group for further processing. You would use it in places where you might want a list of objects, for example, in a script where you want to go through the members of a group and do something to each. The syntax is simply:

```
opglob @groupname
```

which you are most likely to use something like this:

```
set mylist = `execute("opglob @groupname")`
foreach t ( $mylist )
        echo $t

end
```

Less Popup Help

When typing expressions or commands in the textport (and in the parameter fields), Houdini helpfully tries to pop up some context-sensitive help to guide you along.

And while this is well intentioned, it can get very annoying in the textport, where it has a tendency to hide the very text you are trying to type. Luckily, you can turn this off. Go to *Edit* → *Preferences* → *General User Interface*. The bottom half of the page is a bunch of checkboxes. Turn off the ones about Context Sensitive Popup Help, and you're all set.

Quotes for Efficiency

Using single quotes (') instead of double quotes (") in the expression library prevents the contents from having variables expanded. Because of this, the single quoted strings don't have to be scanned for variables and are slightly more efficient. For example, instead of:

```
ch("/obj/geo1/tx")
```

use

```
ch('/obj/geo1/tx')
```

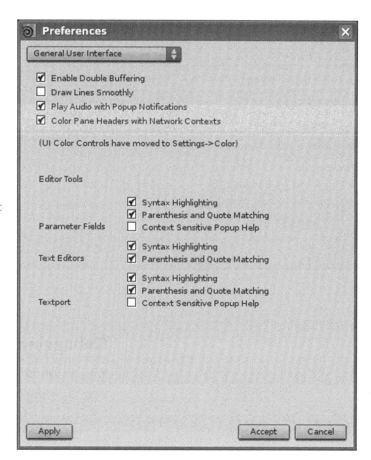

```
 Textport                                              _ □ X
Houdini Master Version 9.0.541 (Compiled on Mar 20 2007)
Director -> set var = "./tmp/ryan.cmd"
Director -> echo $var
./tmp/ryan.cmd
Director -> echo $var:t
ryan.cmd
Director -> echo $var:t:r
ryan
Director -> echo $var:s/tmp/usr/
./usr/ryan.cmd
Director ->
```

Variable Modification

New for Nine!

If you are familiar with shell scripting, you may have used variable modifiers. In Houdini 9, hscript also has these useful tools. The recognized operators are:

h (head), t (tail), r (root), e (extension), u (uppercase), l (lowercase), s (substitute)

Some examples:

```
set var = "./tmp/ryan.cmd"
$var       returns  ./tmp/ryan.cmd
$var:t     returns  ryan.cmd
$var:t:r   returns  ryan
$var:s/tmp/usr/      returns      ./usr/
ryan.cmd
```

Debugging Paths

You can use the textport to find out what the full path is to any operator. Just drag the node to the textport, and let go – it will print out the path to that node.

```
 Textport                                              _ □ X
/ -> cd obj/geo1/shop1
/obj/geo1/shop1 -> echo `opfullpath(".")+"/../"+chs("./surfpath1")`
/obj/geo1/shop1/../shop/g_cmarble1
/obj/geo1/shop1 ->
```

You can also use this to save typing – instead of typing out the path to a node, just type the part of the expression that you want, then drag and drop the node into the textport and let Houdini fill out the rest.

Also, if you are trying to figure out what the path is from one node's parameter area to another node's parameter area, you can use the textport to echo the result of the expression you are constructing and see if it

(Continued)

does what you want. For example, you are in a SOP, and you want to refer to the field of another SOP in a neighboring object. Then try echoing the expression to see if you get the right result. For example, something like this:

```
`opfullpath(".")+"/../+chs("../shopPath")`
```

can be tested in the textport with:

```
echo `opfullpath(".")+"/../+chs("../shopPath")`
```

You just have to make sure that your current location in the Houdini hierarchy is the same as your node's will be when the expression is executed.

Script Select

Every object level node, such as the Geometry Object, has a Select Script field where you can put some hscript commands (or the path to a file containing hscript commands), which will be executed whenever the object is selected interactively in the viewport.

As an example, try typing this into the Select Script field, and then go into the Pose state, and select the object:

```
message "Name: " $SELECT_NAME; message "Path: "
$SELECT_PATH
```

Here is a list of select variables to know about. These are set when a selection happens.

Select_name

The name of the currently selected object. Note that selecting an Object inside an HDA will return the name of that particular object and execute that object's select script and not the HDA's name. For example:

```
# Print out the name of the currently selected
  object then set both the
```

(*Continued*)

275

```
# picked flag and current flag for the currently
  selected object
opset - p on -C on /obj/$SELECT_NAME
```

Select_path

The path to the currently selected object. Note that selecting an Object inside an HDA will return the correct path to that particular object and not the HDA path. Example:

```
# Print out the path to the currently selected object:
message $SELECT_PATH
```

Select_move

When unset, allows you to move the object selected in the viewport immediately and still execute the select script. Pickscripts by default turn off direct manipulation in the viewport. Without unsetting this variable, you have to first select, lift, then move the object with its handle to avoid re-executing the select script. For example:

```
# Add object when selecting a node:
setenv -u SELECT_MOVE
opcf /obj
# Fetch a unique name for the current operator beginning with
  myObject.
# The uniquename.cmd script is very handy for setting the
  name for
  your
# new object without any name collisions.
uniquename.cmd myObject myUniqueName
opadd geo $myUniqueName
setenv SELECT_MOVE = 1
```

(Continued)

Select_pick

When unset, allows you to select other nodes including the currently selected
node that executes the pick script. Without unsetting this variable, any nodes
that you select in the script are deselected upon completion of the script. For
example:

```
set -u SELECT_PICK
opset -d toggle /obj/geo_2
opset -C toggle /obj/geo_2
opset -p toggle /obj/geo_2
set SELECT_PICK = 1
```

Select_shift, Select_alt, Select_ctrl

These variables are used to tell when the user has pressed one of the three
standard modifier keys, Shift, Alt or Ctrl, when selecting the object to execute
the select script. When any of the variables above are set to 1, this means that
the user has selected the object while holding down one of the modifier keys.
This can be used to provide additional functionality. For example:

```
# If shift button is held down during picking of an object,
the
# channels will be added to the current channel selection or
scope:
if ("$SELECT_SHIFT" == "1") then
    set CHOICE = +
    echo "adding channels"
endif
```

Magic Path Expansion

If you're trying to construct the correct pathname to reference an operator in another network, at another level, then a simple way to find out what the path is to drag the node to a textport, and then drop it there.

This will magically print the full path to the node in the textport, which you can then retype, or even copy and paste into the expression you are creating.

Alternatively, type:

```
> opcd
```

in the textport first, *don't* hit <enter> yet, then drag "n" drop the node into the textport and the path will be filled in. Now hit <enter>, and you'll go directly to it.

Using Timecode

A useful but obscure hscript command is ftimecode, which sets or gets the current frame, in timecode format. For example:

```
ftimecode 00:00:00:20
```

will set the current frame to 20. And if the current frame is 126, then the command:

```
ftimecode
```

with no timecode given, will print the current frame in timecode format – in the current example, it would print:

```
Frame 126 (00:00:05:06)
```

assuming that the current FPS setting was 24.

Getting Property Parameter Values

New for Nine!

There are four new expression functions:

① property(string path, float default)

② propertyf(string path, float frame, float default)

③ propertyt(string path, float time, float default)

④ propertys(string path, string default)

```
Textport                                          _ □ X

Houdini Master Version 9.0.541 (Compiled on Mar 20 2007)
Director -> cd /obj/geo1/shaders
Director -> echo `property("standard/vm_refractlimit", 5)`
10
Director ->
```

These behave just like the ch(), chf(), cht() and chs() expression functions, but if the parameter isn't found, then the default value (passed in) is returned.

Understanding Ranges

The syntax for specifying ranges in Houdini – for example, lists of points or primitives in the Delete SOP – is this:

```
{from}-{to}[:{every}][,{of}]
```

Some examples of valid ranges:

```
range : 1 2 3 4
result: 1 2 3 4
range : 1 3-15 16 8
result: 1 3 4 5 6 7 8 9 10 11 12 13 14 15 16
range : 1-234 820-410 235-409
result: 1 to 234, 820 to 410 (in reverse
        order), 235 to 409
```

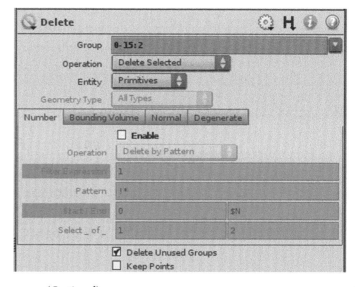

(Continued)

```
range  : 0-15:2
result: 0 2 4 6 8 10 12 14
range  : 0-15:2,3
result: 0 1 3 4 6 7 9 10 12 13 15
```

Remember that this also works as a filter in any SOP – for example, to modify the color of a range of points in the Point SOP, you can simply specify the range in the Group field, like so:

Referring to Myself

It often comes up that you need an hscript expression that references the input to the current node, because you are interested in the incoming geometry before it is modified by the current node. The expression to get this is:

```
opinput(".", 0)
```

which gives you the name of the first input (inputs are numbered from 0). This is often used in conjunction with the string "../" to create a relative path to an operator. For example, if a node called torus1 is connected to the first input of the current node, then the expression:

```
point("../" + opinput(".", 0), $PT, "P", 0)
```

will be the equivalent to typing:

```
point ("../torus1", $PT, "P", 0)
```

But this way, you don't have to know the string "../torus1" in advance, that is, you don't have to know the name of the node that you are connected to. Which is handy, because you don't want to know that – that way, if your node network ever changes, your expressions don't have to.

HDK User Reference

Users writing plugins may appreciate a key for the library prefixes used in the HDK:

Prefix	Meaning
AU	Audio
FS	File System
GB	Geometry Base Classes
GD	Geometry Domain (2D profile curves)
GDT	Geometry Delta. This is for the efficient representation of the differences between two geometries. It is used by the Edit, Paint and similar SOPs.
GEO	Geometry (3D)
GOP	Geometry Group Operations. Has the pattern matching code used by SOPs.
GP	Geometry Pasting (used for NURBs pasting)
GQ	Geometry Quad Edge library
GU	Geometry Utility (derives from GEO through multiple inheritence)
GVEX	Wrapper for VEX to access Geometry
KIN	Kinematics
SYS	System Dependent
TS	Metaball Library
UT	Utility

If none of this means anything to you, don't worry about it. Just move on to the next tip!

Embedded Functions

With Houdini 9, this becomes slightly old school, but you may find it useful anyway. When you are putting expressions into parameters, you can embed complex functions into parameters by putting them inside backquotes and curly braces, like so:

```
`{
string impactP = dopoptions(".", $OBJID, "Position", "t");
return impactP;
}`
```

This becomes a complete expression block. (*Side note*: You don't need the backquotes unless the field the expression is in, is a string field. But they don't hurt in numeric fields.) And here's a neat thing: if you are trying to debug this expression, and want to check the return value before it returns, add a line like:

```
execute("message impactP: " + impactP);
```

right before the return statement.

Expression Parameters

New for Nine!

In Houdini 9, all parameters can be defined by expressions. As is already the case with float parameters, all parameters can now be edited using an "Edit Expression" dialog. String parameters can be toggled between their value state and their expression state using the left mouse button (LMB) on its label. Expressions, of course, must be entered in accordance to proper expression syntax. Middle mouse button (MMB) on string labels while in the value state – this will toggle between non-expanded and expanded mode where variables and expression functions enclosed in back ticks are expanded (evaluated).

(*Continued*)

All types of parameters can now be keyed, but this option is only available where it makes sense. Still, you can have the contents of a string parameter change at every keyframe. That means you can animate, for example, the choice of shaders to use.

You can also animate toggles. One tip here: the default channel type for an animated toggle appears to be an ease curve. You don't want that – you want a constant curve. That way, the toggle value can be set to either 0 (off) or 1 (set). Just set keyframes on the toggle parameter the same way you would for any numeric value.

ON THE SPOT

Standalone Tools

Houdini ships with more than just the Houdini program. There are dozens of other useful applications that come standard. This chapter looks at some of them, and explains some useful tips for getting more out of them.

What Have I Got?

To see the full list of application programs that ship with Houdini, look in $HFS/bin. Here is the list for Houdini 9, as of version 9.0.535:

aclip	easy	hcompile	hrender	icp	mids
acombine	gconvert	hconfig	hrmanpipe	idiff	minfo
aconvert	gdxf	hcpio	hrmanshader	iflip	mplay
ainfo	geodiff	hcustom	hscript	ihot	mview
aplay	geps	hdkinstall	hselect	iinfo	proto_install
arecord	gfont	hescape	hserver	ilut	proto_install.sh
areverse	gicon	hexpand	hview	ilutiridas	redit
chchan	giges	hexper	hwish	imdisplay	rmands
chcp	ginfo	hhalo	hython	iprint	rscript
chinfo	glightwave	hhalo-ng	i3dconvert	iquantize	sesitag
claudio	gplay	hidx	i3ddsmgen	isixpack	spiff
clchan	gply	hkey	i3dgen	izg	spy
clchn	greduce	hmaster	i3dinfo	izmatte	vcc
clcp	gstl	hmaster-ng	i3diso	mantra	vcrypt
cldiff	gwavefront	hot1	ic	mcacclaim	vmantra
clinfo	hbatch	hot1view	icineon	mcbiovision	wren
clphone	hcollapse	houdini	icomposite	mcmotanal	xpidl
dsparse	hcommand	hremove	iconvert	mcp	zmore

(Continued)

Here is a rough guide to what these groups of commands do or deal with:

Tool basis	Deals with
"a" tools	Audio (for example, aconvert, areverse)
"ch" tools	Channel files and data
"cl" tools	.clip files
"g" tools	Geometry
"h" tools	Houdini and Houdini files
i3d	Image 3D files (point clouds for volumes)
"i" tools	Images
"mc" tools	Motion Capture files
"m" tools	Movie files

There are other tools that are not covered in this table, such as mantra and redit. Many of the more important ones of these have their own entries in this chapter. For most of these tools, you can get some usage information by just typing the command name.

For example:

```
% clinfo
```

gives

```
Usage: clinfo [-r rate] file.clip [file2.clip...]
-r rate    Specify an animation frame rate
```

However, this is not completely consistent. Some tools, such as mantra and greduce, require typing "commandname -h" in order to get help. For example:

```
% mantra -h
```

prints out a bunch of usage information.

License Use

The command:

```
% sesictrl -i
```

shows the total licenses available (of each kind), the licenses in use and who is using them. You don't have to be root or an administrative user to run this command. The output looks like this:

```
----- SERVER 127.0.0.1 --------

Lic 520341fb:   1 "Houdini-Master 7.0    " Generic      16-nov-2006 +.+.+.* otter
   1 licenses free

Lic 7fae4581:   1 "Houdini-Master 8.0    " Generic      16-nov-2006 +.+.+.+ otter
  195 by localhost.localdomain       Oct 11 22:44

Lic 641bdfa0:   1 "Houdini-Master-NG 7.0" Generic      16-nov-2006 +.+.+.* otter
   1 licenses free

Lic e265fcc5:   5 "Render 7.0            " Generic      16-nov-2006 +.+.+.* otter
   5 licenses free

Lic 88cad518:   1 "Render 8.0            " Generic      16-nov-2006 +.+.+.+ otter
   1 licenses free

Lic 05729c6b:   1 "Houdini-Render-Script 7.0" Generic   16-nov-2006 +.+.+.* otter
   1 licenses free

Lic 5e70c6d0:   2 "Houdini-Render-Script 8.0" Generic   16-nov-2006 +.+.+.+ otter
   2 licenses free
```

Other Resources

There are lots of places to pick up more useful tips and general help about Houdini. Here are the ones that Side Effects provides:

❶ The Forum. At www.sidefx.com, go to *Community->Forum*. This is the official SESI community gathering place, where users help each other with questions. And the Side Effects team also pitches in.

288

(Continued)

② Mailing List. Users learning Houdini can subscribe to one of several mailing lists where users discuss techniques. Visit lists.sidefx.com for more information.

③ The Exchange. This is a publicly available spot where users can share Houdini hip files, digital assets and other data. At www.sidefx.com, go to *Learning->Houdini Exchange*.

④ The Journals. Unlike most other software manufacturers, Side Effects creates a new version of Houdini almost every day, and then posts it on their website. You can go read the Journals, which describe that day's changes, and decide if you want to update your version (*Note*: This may apply to customers only). At www.sidefx.com, go to *Services->Journals*.

⑤ OdForce. Go to http://odforce.net to explore the forum and wiki pages there, as well as download shaders and generally wallow in all things Houdini. This site is maintained by Houdini customers, not by Side Effects.

Mplay Comments

New for Nine!

Now when you save individual images from mplay, you can add comments to any file format that supports them (such as tiff and openEXR). Go to *Tools ->Add Comment...*

Exporting Layers

New for Nine!

The little-used command icp can now save out individual layers from image files. Even better, the new file doesn't have to be in the same format as the image it came from. For example, this line:

```
icp -P layername foo.pic foo.tiff
```

will export the layer named "layername" in foo.pic, to a file called foo. tiff. To see what layer names you can use, just look in the mplay menu.

Csh with Windows

Many Windows users also install cygwin, so that they have a shell from which to launch some of the Houdini command-line tools. But while you may want to do this for other reasons (like just writing scripts and generally doing shell-based things), you don't have to.

Houdini ships with a win32-native version of tcsh named csh.exe, which you can run. From there, all of the Houdini command-line tools are available, just as if you were running on Linux.

Mplay is Scriptable

Mplay is an application that can also be scripted. If you go to *Tools->Textport*, you'll get (surprise!) a textport. Type "help" in it, and you'll see a list of commands that mplay understands. But why would you want to do this?

Well, one purpose would be to utilize the commands are loadseq, appendseq and prependseq. With these, you can specify a list of frames to load. For example, say you create a file called playlist.cmd, and put these lines in it:

```
loadseq $BASE/act1/shot45/*.pic
appendseq $BASE/act1/shot46/*.pic
prependseq $BASE/act1/shot44/*.pic
```

Then run:

```
mplay playlist.cmd
```

and you'll get those shots loaded up automatically.

Mplay Launch Options

You can force mplay to use any given frame rate when it opens. To do this, in *Options->Profiles*, in the field labeled Command Line, put the option:

```
-r 24
```

Note that if you have the environment variable $FPS defined, the Command Line option will override the environment variable.

Another option you may want to change is the default setting for keeping the Mplay window above all the others. To stop this behavior, remove the "-T" option from the Command Line options string (this option only applies to Windows XP).

You can get a list of other possible Command Line options to use here, or on the actual command line, by issuing the command:

```
% mplay -help
```

Ramps

One of the applications that ships with Houdini is redit, the ramp editor. This is a standalone version of the ramp editor you can find in Houdini itself, with one exception – it allows you to save the ramp as a file.

(Continued)

And why would you want to do this? Because ramp files can be used anywhere in Houdini that image files are. So you can create ramps that will be used as reflection maps, for example. The only slight catch is that the file browser for images doesn't recognize the .ramp suffix, so you'll have to type in the name yourself.

If you want to use ramps as images for compositing or some other purpose, there is the standalone program iramp, which converts ramps to images. This is part of the Houdini distribution. The usage would be:

```
% iramp -H -w 512 -h 256 in.ramp out.jpg
```

where of course you substitute the image size you want for the numbers shown. The -H argument creates a horizontal ramp, which corresponds to the look of the ramps in the ramp editor. By default, the image created is a vertical ramp, which you can specify with -V.

Hotkeys for Multiple Planes

When you load a regular color/alpha image into mplay, you can use the hotkeys "C" and "A" to see the color and alpha planes, respectively. But if you have more planes than that, because you have a deep raster image, then you can use <shift>-[and <shift>-] to move up and down through the extra planes. This is the same as, but quicker than, using the dropdown menu.

A good way to demonstrate this to yourself is to create a sixpack image (see next tip) and then load it into mplay. You'll have Right, Left, Top, Bottom, Back, Front as image planes, and then you can step through them with these keys.

Using Sixpack Images

A particularly useful image form for environment and reflection maps is the "sixpack," which is a set of six images representing the top, bottom, left, right, front and back of a scene, as viewed from a point in the middle of the scene. These are especially common in High Dynamic Range (HDR) images, which are used to provide environmental lighting for renders.

The utility "isixpack" will convert a set of six images to a .rat file that encodes them for use by Mantra. It will also take a single image into which the six sub-images have been embedded in a cross shape, and covert them to a .rat. Finally, it will also take a .rat file and convert it to a single cross image. For example, say you have the cross image.

Then the command:

```
% isixpack cross.pic imagecube.rat
```

would arrange the images appropriately in the .rat file. Do this:

```
% isixpack -h
```

for more detailed information.

Editing in Mplay

If you're rendering test image after test image to mplay, you may find that some of them are duds that you don't want to keep in your sequence. You can get rid of individual frames, by going to *Images→Remove Frame*.

The current frame will be deleted from the sequence, and the sequence will be renumbered. In other words, there won't be a gap there, but instead you will just jump past that frame as if it had never been there.

Comparing Geometry

There is an interesting utility shipped with Houdini called geodiff. This will take two geometry files (in any combination of .bgeo, .geo or .obj formats) and compare them, printing out the ways in which they are different.

This can be handy when you have two pieces of geometry that look the same, but act differently, and you want to know why. Finding out that, for example, they don't have the same point counts, can save a lot of head scratching.

Polygon Reduction

A useful standalone tool is greduce, which reduces polygon complexity while trying to retain the basic topology of the model. This is the command-line version of the Polyreduce SOP (Surface Operator), except that it isn't – it presents different methods for reducing geometric complexity. The other thing to know about this tool is that, while it doesn't run in Houdini, it's still interactive – it puts up a graphical interface for polygon reduction. That makes it easier to use, but not so hot for embedding in scripts.

Converting Point Clouds and i3D Files

Houdini creates and uses several different file format that area all related. There are point clouds stored as .bgeo files (just points in space), there are point clouds for rendering, stored as .pc files, there are .i3d files (volumetric information) and .tbf (tile block format) which is a more efficient, more general version of both .pc and .i3d files. In fact, .tbf is actually a generic format which is used for .rat textures, deep shadow map files and IPR files as well as point clouds. The fact that TBF files are used for all these different file formats means that efficient caching of data can be performed since the cache is shared between geometry (point clouds), and images (textures, DSM, IPR, etc.).

You can convert between these formats in a few different ways, using some standalone tools. For example, you can do this:

```
% gconvert foo.tbf foo.bgeo
```

Which will let you visualize the contents of the tbf file. And you can do this:

```
% i3dconvert -c pointCloud.bgeo pointCloud.tbf
```

Which will turn the geometry into a point cloud, for use in some other context (say, photo maps or some other trickery).

Creating LookUp Tables

You can use one of Houdini's to create a LookUp Table (LUT) for Houdini's viewers. In Channel Operators (CHOPs) create a channel that has the appropriate shape, then write it out as a .chan or .clip file. Then run this through the "ilut" program:

```
% ilut input.chan output.lut
```

It's even easier to create LUTs using Composite Operators (COPs) – there is an explanation of how to do that in chapter 9, COPs Hacks.

295

Index